IMAGES
of America

ROCK ISLAND

ALL AMERICAN CITY

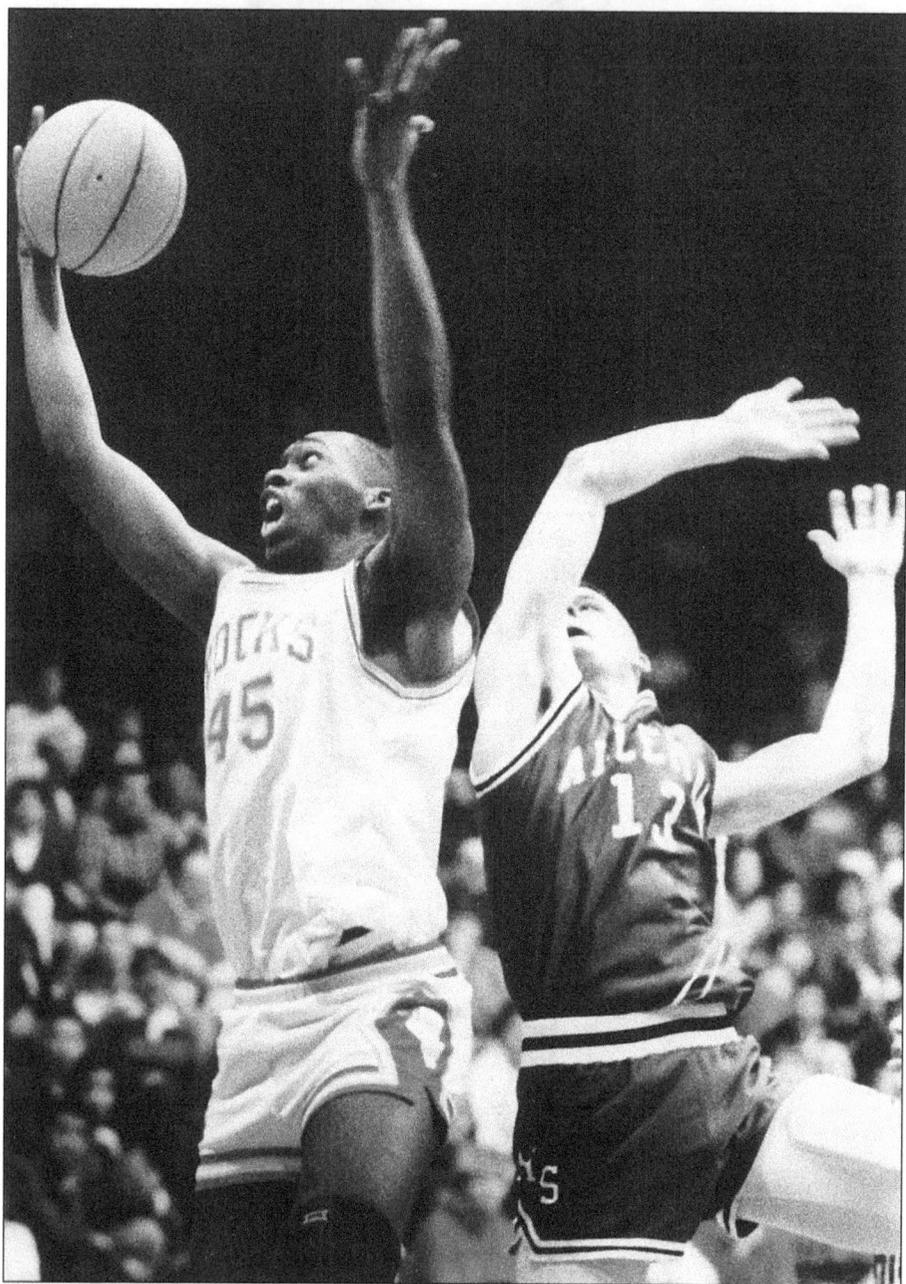

Few athletic rivalries match those of the Rock Island Rocks and the Alleman Pioneers. Whatever the sport, whichever the gender, when the Crimson and Gold take on the Green and White, there is sure to be top level sports competition. It's been that way for 50 years, and it shows no sign of lessening. "I think both schools pride themselves on displaying spirit and character, the athletes and the spectators," said the late Don Morris, Alleman coaching great, whose basketball teams were tops in talent and in class. "Fight on, Rock Island, win this game . . . Hail to the Pioneers, cheer them along the way . . ." Let the singing and the competition continue into the new millennium. Here, Rocky's David Robinson snags a rebound sought by Alleman's Tony Huntley in a 1991 contest.

IMAGES
of America

ROCK ISLAND
ALL AMERICAN CITY

David R. Collins, Bj Elsner,
Rich J. Johnson, and Bessie J. Pierce

ARCADIA
PUBLISHING

Published by Arcadia Publishing
Charleston, South Carolina

Library of Congress Catalog Card Number: Applied for.

For all general information contact Arcadia Publishing at:
Telephone 843-853-2070
Fax 843-853-0044
E-Mail sales@arcadiapublishing.com
For customer service and orders:
Toll-Free 1-888-313-2665

Visit us on the Internet at www.arcadiapublishing.com

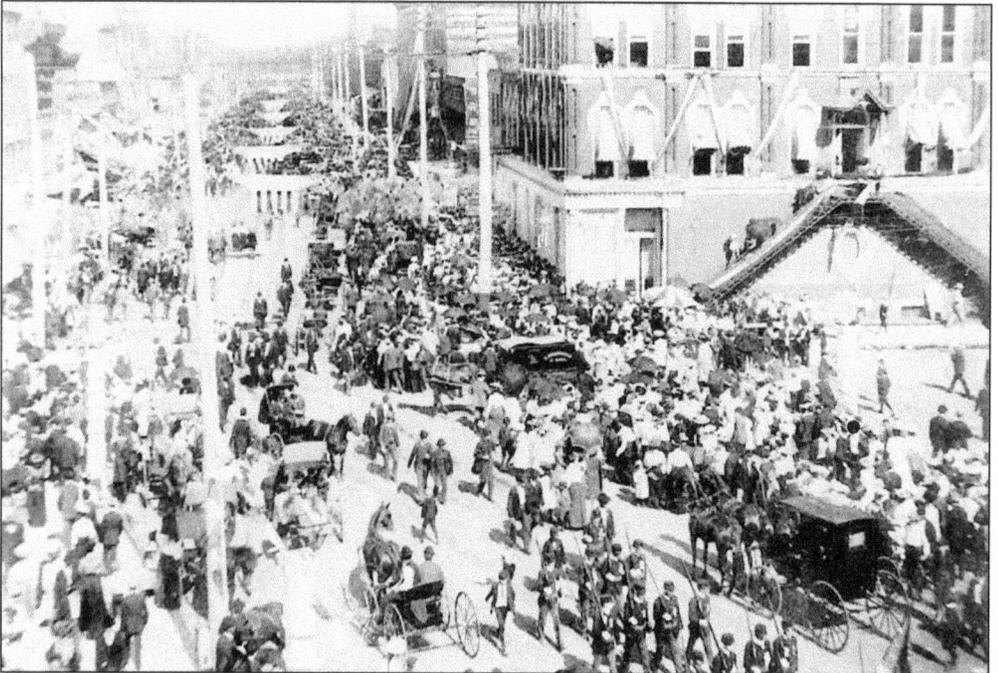

"Seventy-six trombones led the big parade" could be the caption for this photograph. This view is actually pre-Meredith Wilson and his "Music Man," but 2,000 former Union soldiers marched on this day. As a matter of fact, the year was 1902, and the place was Rock Island's Second Avenue. What was the occasion? The parade was held as part of the G.A.R. (Grand Army of the Republic) Encampment. It's clear by the size of the crowd that Rock Islanders have always enjoyed a good parade.

CONTENTS

ACKNOWLEDGMENTS

On the pages that follow, you will find the story of a city, its beginnings, and its growing years— what it was and what it is now. This book has no real end, for the city's progress continues, each day bringing new challenges and changes. Of course, it was impossible to include every notable person and memorable event, every church and school, and every aspect of the city that made it what it is today. Instead, this book represents an overview of a unique place with an exciting background, a glimpse of some interesting people, and a glance at some important moments in time. This book seeks to offer a fun read that makes the history of a mighty river town come alive.

Many people, past and present, have helped make this book possible. Whether they provided photographs or information, the authors of this volume say thank you to the following: the Charles P. Ainsworth Collection; the Arzdorf Photo Collection; Judy Belan, Augustana Special Collections; Kenneth Bostrom; Patrick A. Catel, Arcadia Publishing; Alan Carmen, Jill Doak, City of Rock Island; Susan K. Collins; Community Caring Conference; Deere and Company Archives; DeLaCerta House; Frederick C.A. Denkmann Collection; Martha Moody Eaves; Carol Eisentrager; Freddie Frankbill; H.E. Francis; Gene Hast, Backwater Gamblers; Elinor Hild, Alleman High School Library; *The Historical Encyclopedia of Illinois* and *History of Rock Island County*; John Hauberg Collection; Historical Office, ARRCOM; Gail Johnson; Robert E. Lempfert; The Leta Lester Collection; Martin Luther King Jr. Center; Julie Jensen McDonald; Chuck Mulkey; Marjean O'Brien, Friendship Manor; Gene Oliver; Richard Pierce; Roy Plasschaert, Main Camera Shop; Rainbow Skip-A-Long II Child Development Center; Roy Booker, Quad-City Times; Lois Reimers; The Rock Island Board of Education; The Rock Island Chamber of Commerce; Harriett Shetter, Nonie Leithner, The Rock Island Women's Club; Rock Island Parks Department; Dr. William Roba; Sue Ann McMaster, James and the late Lucille Sampson, Rock Island County Historical Society; Gerald Taylor, JoAnn Parmley, *The Daily Dispatch* and *Argus*; Claudia Griffith, Pip Printers, City Line Plaza; Vince Thomas, Project NOW; Marjorie Sullivan Tobin, Picturesque Tri-Cities, Upper Rock Island County Chamber of Commerce; U.S. Army Corps of Engineers; *Views of Moline*; Sue and Greg Vogele, Chippiannock Cemetery; John Vize; Ray Voss; Karen Williams, Broadway Neighborhood Association; WHBF-TV; and Robert Yapp Company.

INTRODUCTION

What defines an American city? The answer varies with time. Take Rock Island, for example. *Life* magazine named it an "All American City" in 1955. Back then it was a factory town with Case and Farmall working three shifts to produce farm machinery. *Life* featured Rock Island children with their wood and crepe paper creations for the annual lantern parade. There was a boat marina in the works, and housing developments were popping up out in the cornfields. The city had just built its new downtown post office, and plans were being made for a centennial celebration for the Rock Island Railroad Depot.

Three blocks west of the depot nearly two centuries ago, the scene was one of wagons and stagecoach arrivals at a two-story building that served as boardinghouse, saloon, and trading post. Called Farnhamsburgh, the building stood on the Mississippi shore beside the Mesquakie village of Chief Wapello. Down river, at the mouth of the Rock River stood Saukenuk, a village of upwards of 11,000 residents.

It was here in 1780 that a troop of colonial soldiers tracked a band of British sympathizers, burning the village in retaliation. Thus, Saukenuk went down in history as the westernmost battleground of the American Revolution.

Black Hawk was only 13 years old at the time. In the War of 1812, the Sauk warrior led a band of British allies against the Americans. Again the soldiers came, this time led by Zachary Taylor, and again, Saukenuk was burned. A boundary line surveyed after the war divided Illinois between the United States and the tribes of the Upper Mississippi Valley. Saukenuk, south of what is now Rock Island's Ninth Avenue, was safe for the time, but not for long. The beginning of the end came around noon on May 10, 1823, when the *Virginia* arrived at Fort Armstrong. The sternwheeler already had made history by successfully navigating this far north of St. Louis. Ahead lay the most treacherous stretch along the Mississippi: the Rock Island Rapids.

The crew needed help. It came by way of a river pilot named George Davenport. A British-born entrepreneur, he'd come with the soldiers in 1814. Davenport sold provisions at Fort Armstrong and went on to establish a fur-trading business in partnership with Russell Farnham, an agent of John Jacob Astor's American Fur Trading Company. It took three days for Davenport to maneuver the *Virginia* through the rapids. His success proved to be his friend Black Hawk's demise.

With the coming of the steamboats on the Upper Mississippi, more and more white settlers began moving into the area. Wapello's village gave way to Stephenson, which was platted in 1836 as the county seat. It merged with Farnhamsburgh in 1841 and was renamed Rock Island.

It might have been named for Davenport, but that distinction went to the town growing up across the river in Iowa. Davenport did leave his mark, if not his name in Illinois, with one last enterprise prior to his death in 1845. A meeting at his island home prepared the way for the coming of the railroad.

At 5 p.m. on Washington's birthday in 1854, the first train arrived. Thus was born the legend of the Rock Island Lines. Two years later, the first bridge to span the Mississippi River was opened between the cities of Rock Island and Davenport. Two young Kentuckians rode the train into town in 1856 with $80,000. They took turns staying awake to guard the money. When they reached Rock Island, Philemon Mitchell and Philander Cable bought a small banking firm. That bank remains the oldest, continuous financial institution in Rock Island County.

Another man, a German immigrant with only $6 in his pockets, came to Rock Island in 1912. Sam Weisman spent his first night sleeping on a park bench in Spencer Square and, in time, built several housing developments and some of the city's nicest apartment buildings, including Longview Apartments. Two other German immigrants, brothers-in-law F.C.A. Denkmann and Frederick Weyerhaueser bought a Rock Island sawmill and went on to build an empire.

Rock Island has nurtured modest dreams as well. In the 1840s, when a black couple opened their restaurant in the Island City Hotel, Mr. and Mrs. Butcher were touted as the best caterers between St. Louis and Chicago. Near the turn of the century, a widow with seven children to support bought a ribbon factory and moved here to be close to her major accounts, Modern Woodmen and Royal Neighbors. Lily Eucheldoerfer's Regalia Manufacturing Company continues to this day. It has been 175 years since that first log building was constructed in Farnhamsburgh. Neighborhood by neighborhood, Rock Island grew until 1915. It had risen up the bluff and down again, annexing Searstown on the former site of Saukenuk.

When it was said that Rock Island had no place else to grow, we jumped the Rock River to South Rock Island. As this volume goes to print, a new processing plant for rolled steel is opening in Rock Island's Southwest Industrial Park. Steel Warehouse Inc., headquartered in South Bend, Indiana, was founded by a Rock Islander named Nathan Lerman. When the company looked to expand, the owner came home.

Black Hawk understood the true meaning of "home." Rock River was a beautiful country, he said. "I liked my town, my cornfields, and the home of my people. I fought for them." The warrior's words remind us of the legacy that is ours now to preserve.

In the 1980s, when the factories were closing down, we still raised the money to expand our library, the oldest free library in the state of Illinois. And when the department stores moved out, we built our downtown back up into an arts and entertainment district. The Rock Island Line no longer rides, but plans are in the works to convert the old depot into a restaurant, perhaps a museum. Many old homes in Broadway, Greenbush, Old Chicago, and Keystone have been restored; through grassroots agencies like Community Caring Conference and Project NOW, we are reclaiming our neighborhoods. Rock Island, oldest of the Quad-Cities, is headquarters to Churches United of the Quad-City Area, Bi-State Regional Commission, Quad-City Development Group, and United Way of the Quad-Cities—organizations that see the whole as better than its parts.

What will we become in the next millennium? The answer is in the dreams of our youngest citizens. They may envision something beyond our 20th-century concept of hometown. In their hands, the American dream is boundless.

One

BEGINNINGS

Between the bluffs of leafy trees
A mighty snake of water flows.
Proud Indians fish with baited hooks
and hunt with arrowed bows.
Then white men come with hopes and dreams,
and family folk and wagons filled. . .
A fight for land, and when it's done
Sad people mourn those killed.
When quiet once again returns
log cabins sprout, and barns do too. . .
stores are opened, church bells chime,
This is the place, this is the time. . .
A city is born.

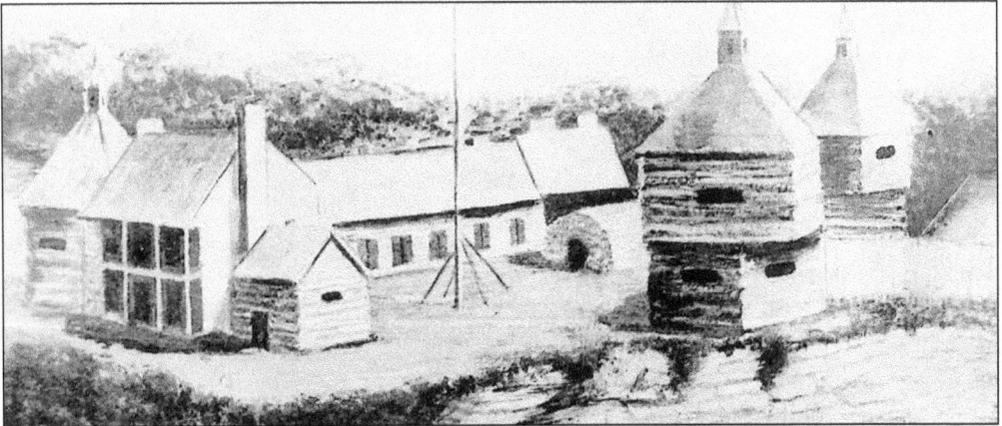

Constructed in 1816, the original Fort Armstrong offered a fine vantage point along the Mississippi River. Military leaders kept a close eye on the movements of Black Hawk and his band, both on the river as well as in the bluffs overlooking the far shore. The commandant housed his family near the fort before it was destroyed by fire in 1855, some six years before the Civil War began.

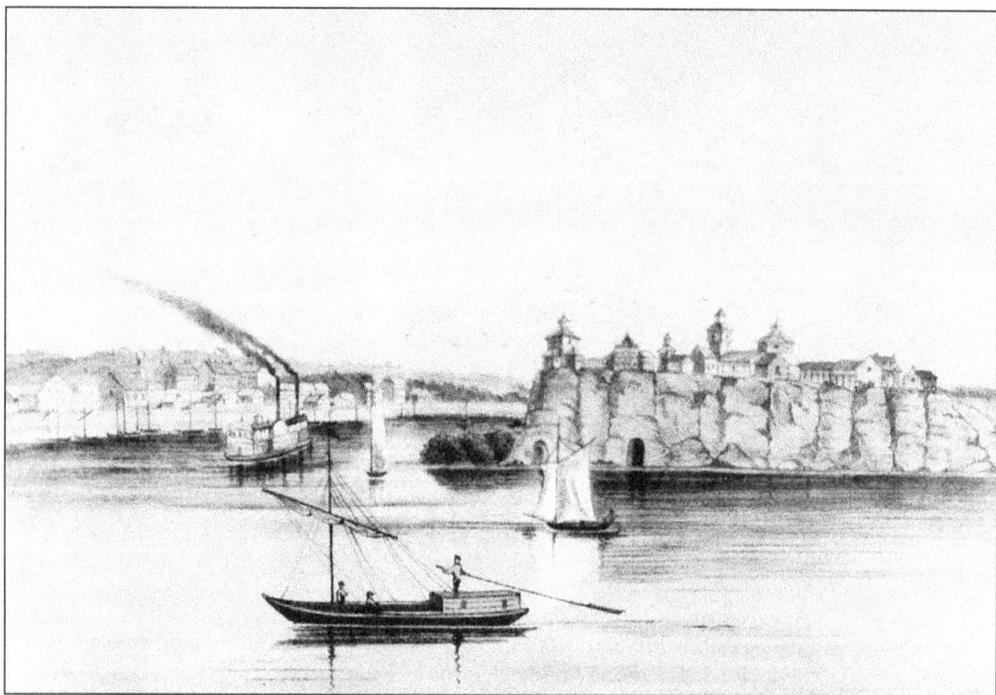

"Oh, Great White Spirit, protect our land and the people of the Sac Fox Nation." The larger cave on the right was believed to be the home of their Great White Spirit and the island their summer playground. The smaller cave just to the left is said to have been the home and shop of a shoemaker at a later time. This 1841 lithograph from the Arnz Company of Dusseldorf, Germany, clearly shows the protection of the high cliffs for early Fort Armstrong and one of the reasons settlements grew steadily along this part of the river.

This 1831 etching depicts Black Hawk and his band of warriors standing at the Watch Tower bluffs, looking to the northeast high point from the river crossing. White settlers were already beginning to arrive and settle in the area. Tension was in the air and blood would be shed before the conflict over the upper Mississippi Valley lands would be resolved.

10

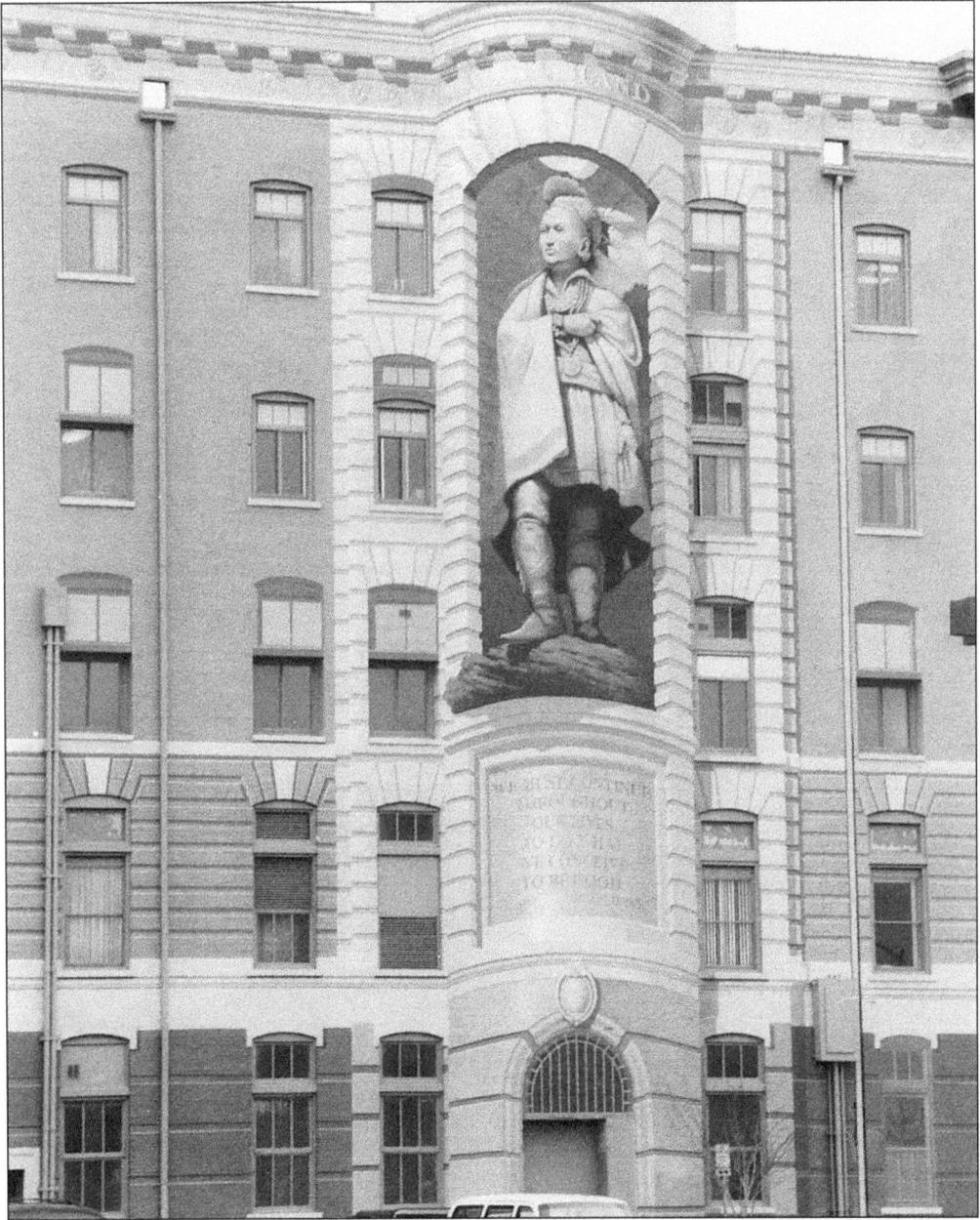

Gone for over 160 years, no other resident has been memorialized in so many ways as Black Hawk, Sauk warrior and defender of tribal lands. He claimed that government representatives plied Native American delegates with whiskey at a meeting in St. Louis in 1804, then virtually stole the lands east of the Mississippi River. For years Black Hawk tried to run white settlers off the land formerly lived on by his tribe. For a time he led his people north, only to return and be captured. He was taken to Washington, D.C., under heavy guard, where he had a personal conference with Pres. Andrew Jackson. Ordered to be returned to his people, Black Hawk wrote a moving autobiography that revealed him to be modest, intelligent, and moral. This three-dimensional mural, painted on the back wall of the Quad City Arts Council offices, looks out over the Mississippi.

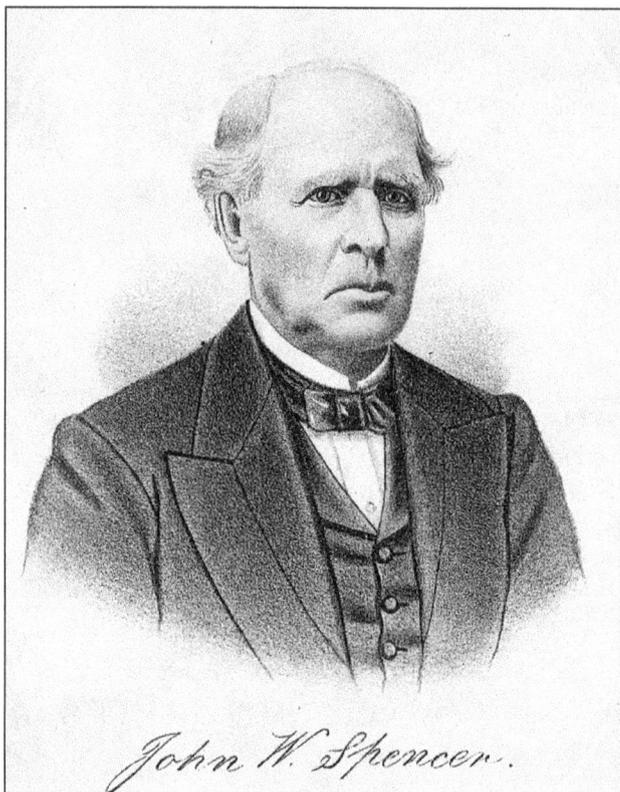

One of the earliest settlers in the area who later became one of the most prominent was John W. Spencer. He arrived during the winter of 1828 and took residence in Black Hawk's lodge while he was away on a winter hunt. Spencer was sympathetic to the American Indian leader's objections to land acquisitions, but felt there was little that could be done. Spencer Square, opened in 1890, honored the early pioneer of Rock Island.

John W. Spencer.

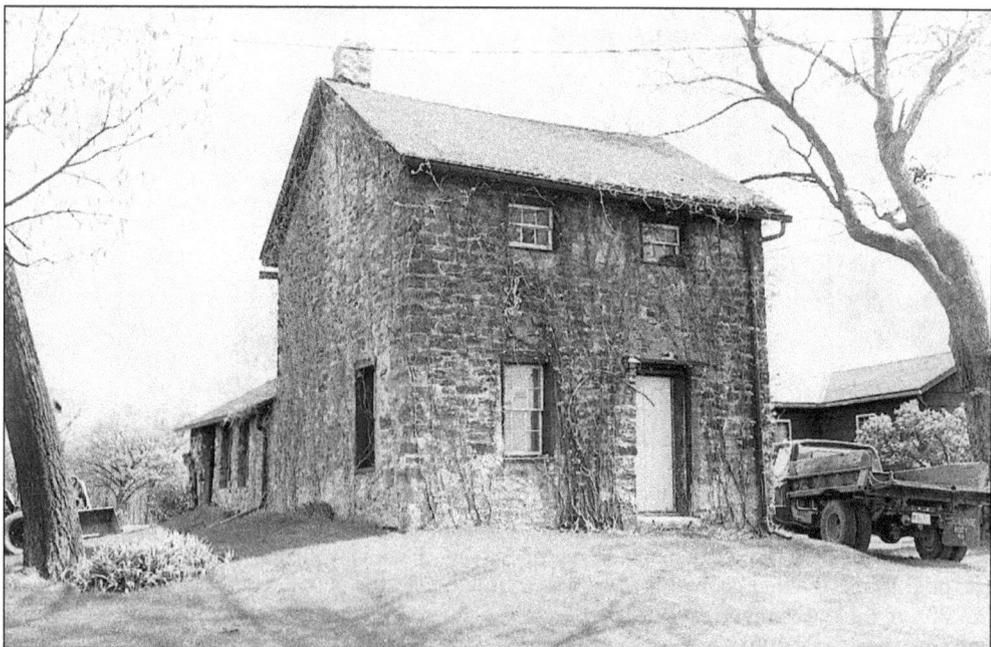

Today, the structure is known as "the Little Stone House" on Saukie Golf Course, where author Helen Burkhiser conducts her classes about Laura Ingalls Wilder. Originally, the building was constructed by William Carr in 1845 and his daughter's family lived there.

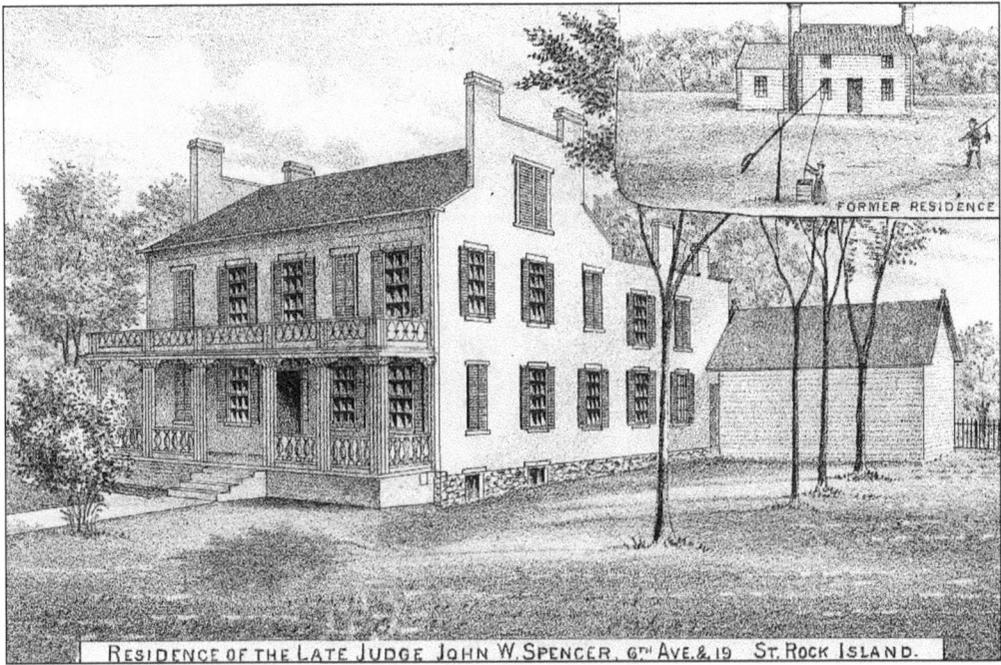

RESIDENCE OF THE LATE JUDGE JOHN W. SPENCER, 6TH AVE.& 19 ST. ROCK ISLAND.

As a man gains importance and stature (and, of course, money) within his community, he tends to like to show it off a bit. Judge John W. Spencer was that kind of fellow. The photo here shows Spencer's first home, built soon after his arrival in 1828. His second residence at 16th Avenue and 19th Street suggests his growth in status—and in family, too!

It was a young, unbearded Abraham Lincoln who traveled northward from New Salem, Illinois, as a member of a federal militia troop in the early 1830s. There was no telling what Black Hawk and his warriors would do after being ordered away from the upper Mississippi River territory. Popular and respected, Lincoln was unanimously elected captain of the men who accompanied him. Fortunately, Lincoln's troop returned South without engaging in active service.

13

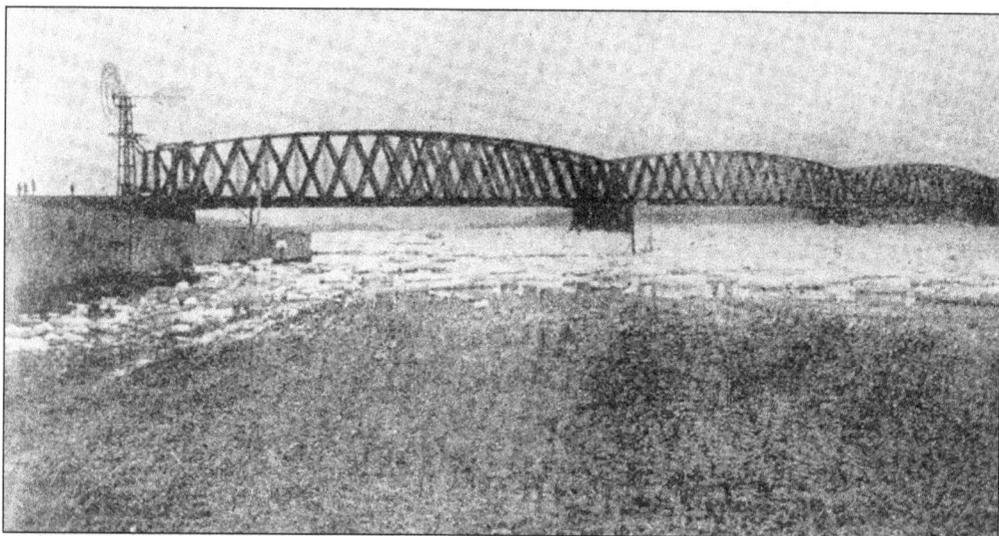

Talk about wind power! This generating tower was no competition for the easily accessible water power on the Illinois side of the Mississippi in Sylvan Slough and on Rock River. This first bridge to span the Mississippi between the island of Rock Island and Davenport became famous because of its defense by Abraham Lincoln.

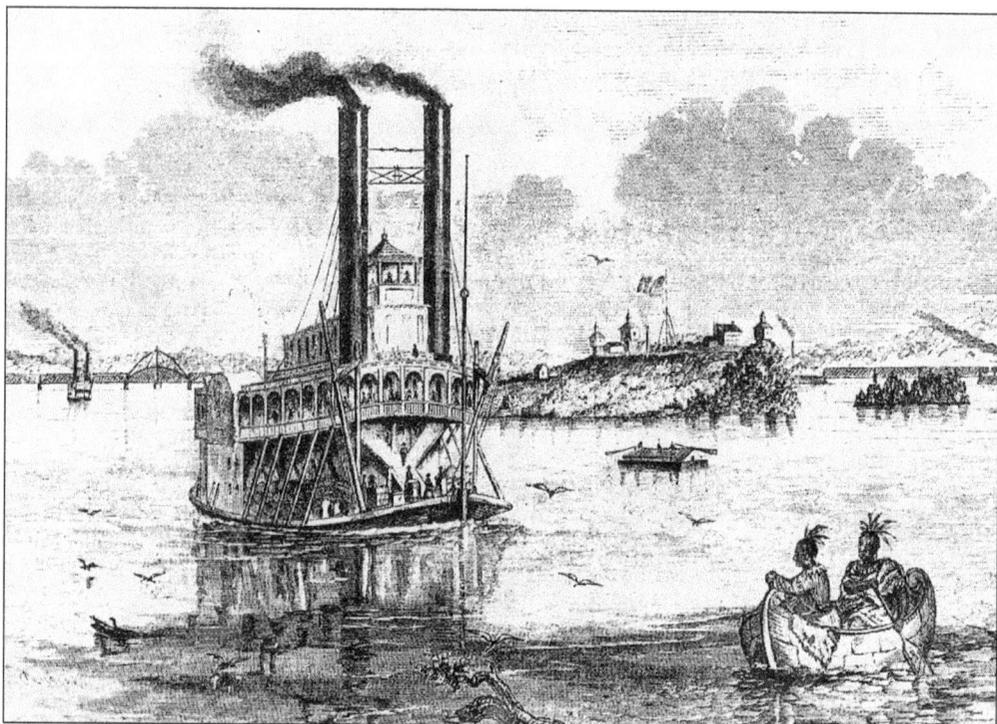

The Mississippi River port off the Rock Island shoreline was one of many shared by steamboats carrying passengers and freight, raft floats, and canoes. This early etching is representative of the daily view from Rock Island.

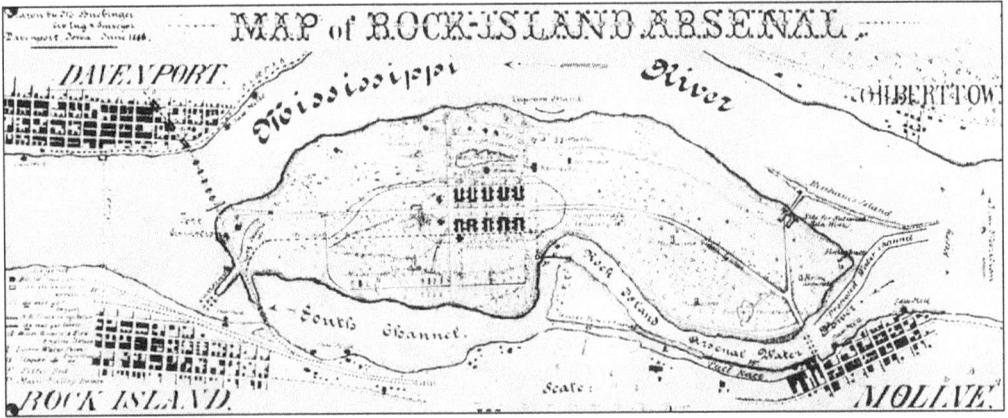

MAP of ROCK-ISLAND ARSENAL.

Few geographical spots have proven more strategic to the history of the Mississippi River and the Midwest itself than the Rock Island Arsenal. Its location offered a fine vantage point of Native Americans coming and going, and later, the island housed Confederate prisoners during the Civil War. More recently, the island has functioned as one of the country's major military manufacturing centers.

Eighty years was a long lifespan during the 19th century, and David Sears used every year he was given. After coming to the area in 1836, he and partners Spencer White and John W. Spencer built a dam across the Mississippi. Later, Sears moved to the Rock River, where he established a town and a multitude of businesses like this brickyard.

Chicago inventor Cyrus McCormick had many business ties with David B. Sears, one of Rock Island's early forefathers. The two men bought and exchanged land together, and when McCormick put together his first reaper in the 1830s, he sent one West to be demonstrated on Sears's property. The land eventually became the Dingeldein and Dasso farms.

Two

GROWTH

Mighty river, wide and proud
Waves flow silent, then pound loud
Source of power, source of dreams
Carry well those boats of steam.
And giant logs on waters ride
While on the shorelines engines glide
Pulling train cars loaded high
Their weary wheels, an aching cry.
Rock Island is the name they chose
All folks are welcomed, none refused…
Family homes climb up the bluff
Roads are smooth that once were rough.
A city grows.

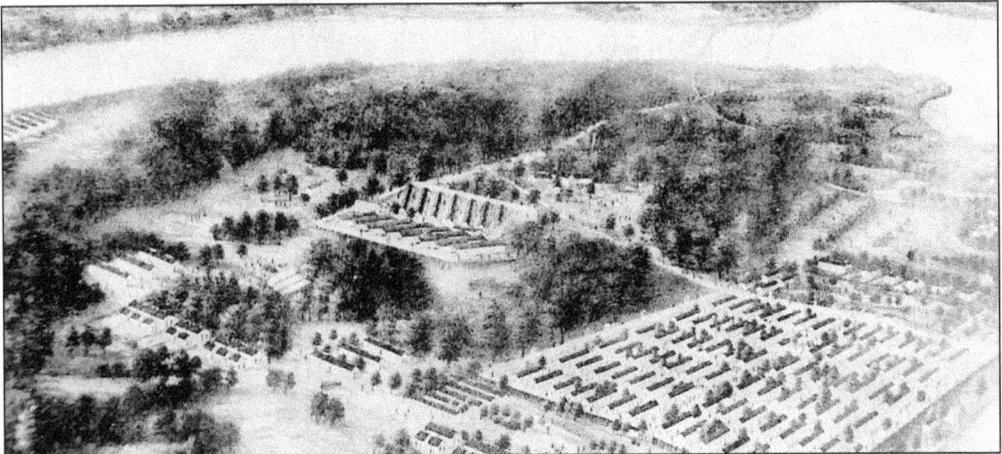

This aerial view of the Confederate Prison at the Rock Island Arsenal offers some idea of the various buildings housed on the location. In addition to the military prison, there were two hospitals (one for the "rebels" and the other a post facility), a barracks for the Union soldiers, and an officers' quarters. Females posed as men soldiers during the war, and one night, much to the surprise of the prison staff, an inmate gave birth.

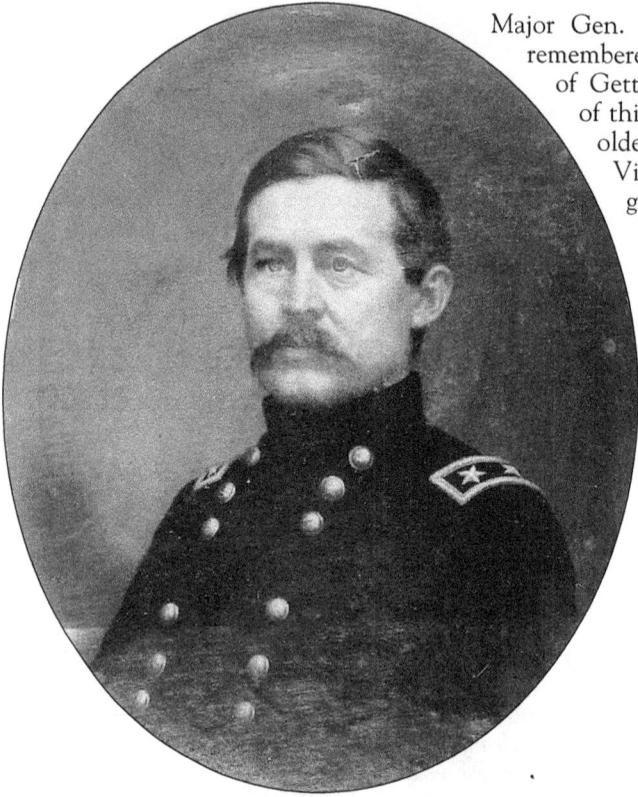

Major Gen. John Buford of Rock Island is remembered with a statue at the entrance of Gettysburg, where he chose the site of this famous Civil War battle. John's older brother, Napoleon, fought at Vicksburg. He, too, was a major general, and both brothers were West Point graduates. Their father, Basil, opened the first store in Rock Island levee in 1838. Two younger Buford brothers served as mayors, and one, Thomas, also served in the state senate.

It was not only the mail that had to be delivered; groceries were delivered, too. This is A.C. Dart, a Rock Island grocer who made regular deliveries to the Rock Island Prison Barracks from 1863 until 1865. Dart is the wagon driver in this 1864 photo, and it seems that his arrival turned out quite a crowd.

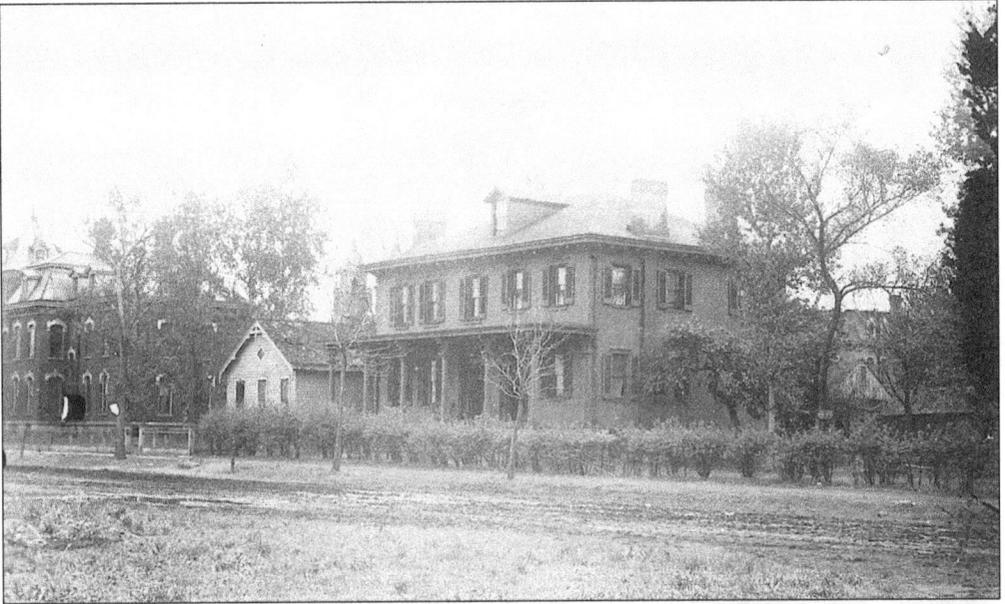

The Bufords were among Rock Island's most prominent families in the mid-1800s operating a variety of stores and farms in the area. Real estate was another family interest, and the Bufords loved big homes. This mansion, located at 1210 First Avenue, belonged to Thomas Buford, who served a term as both mayor of the city and as state senator.

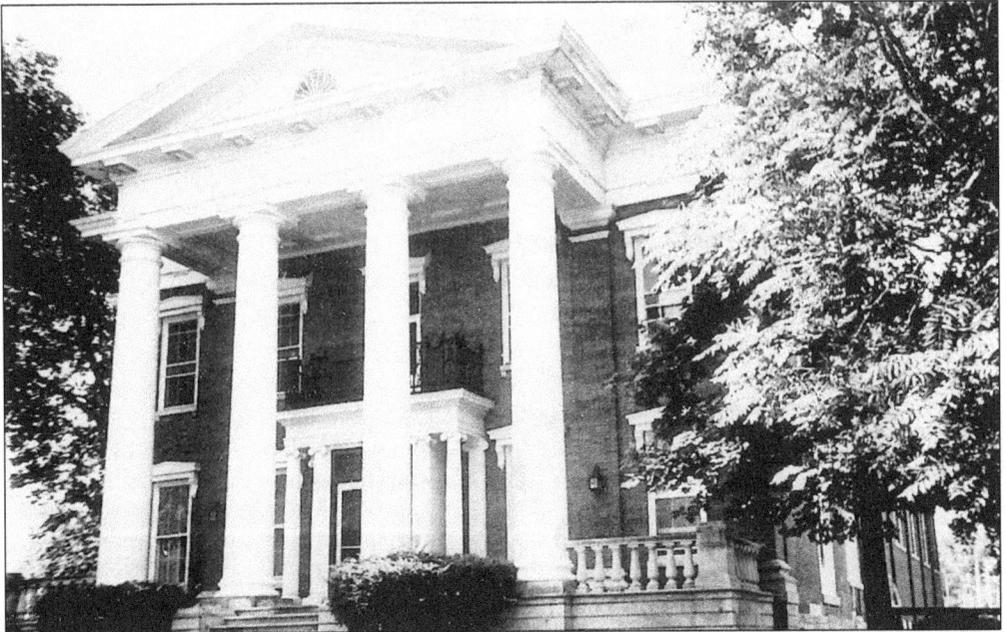

When businessman Charles Buford built his home in 1864, he not only imported marble from Italy, but also brought over stonecutters to do the work on the premises. After being passed through his family, the home went to prominent Rock Islanders E.W. Hurst and Walter Rosenfield. In 1936, the house became the Tri-City Jewish Center. The Word of Life Christian Center took over the property in 1977.

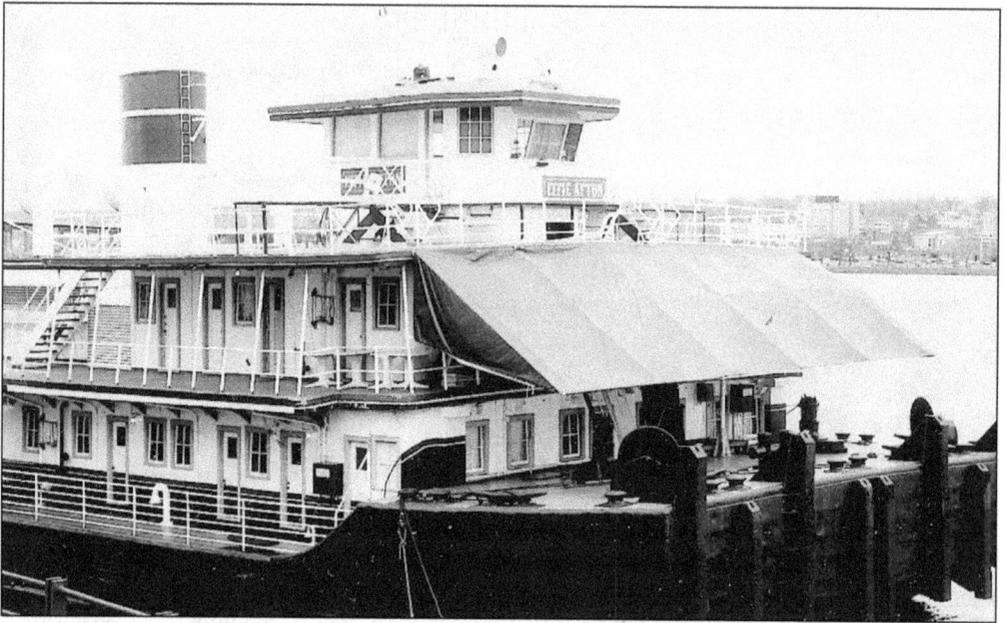

Is this a ghost on the Rock Island river front? Didn't the *Effie Afton* make its maiden voyage on the Mississippi River in May of 1856? And didn't the steamer lose its chimneys in an accident and catch fire? Yes, that's what happened. Even Abraham Lincoln was involved in the legal proceedings that followed. Some people claim the future president came here for the trial, but others disagree. One thing is for certain: this is not the original *Effie Afton* but a far newer craft.

During the Civil War years, 1861–1865, Illinois' own Pres. Abraham Lincoln struggled to keep the states of the Union "united." Across the country, young men marched off to battle, as did Rock Island's own Pvt. George P. Kelly. There was no "Saving Private Kelly," however, for he returned in a coffin and was buried in Chippiannock Cemetery. Enyo Dewith brought the memory of the tragic young war figure back to life during the annual walk through Chippiannock.

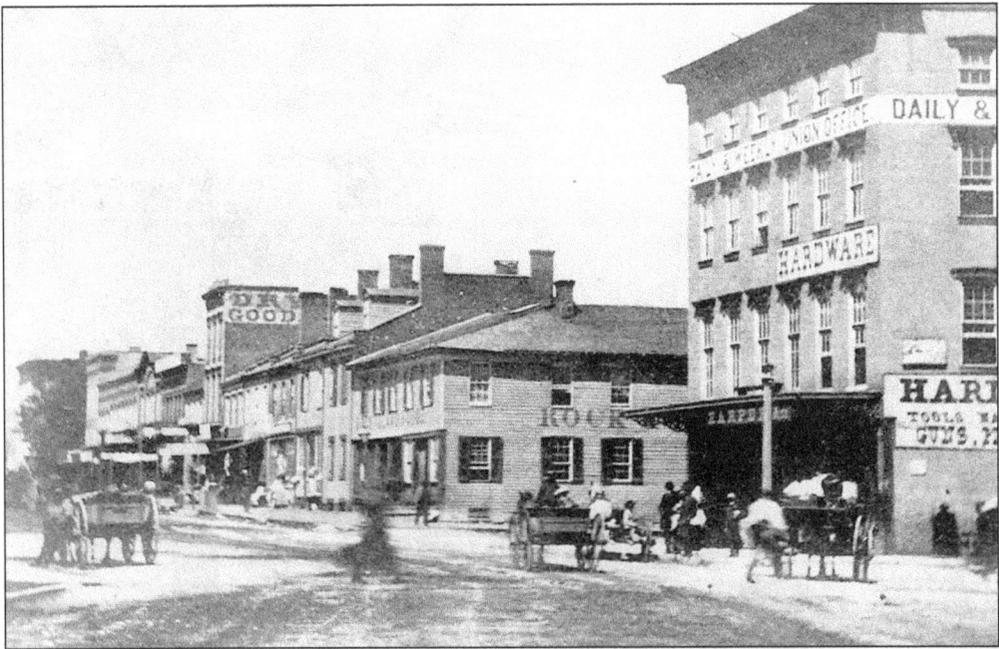

Gid-dy-yap! Move that carriage along, now, ya hear? This 1873 photo is looking west on Second Avenue with Harper's Hardware and Daily Union on the right. The Rock Island House Center is also visible. There was controversy among city residents as to whether or not carriage drivers should carry shovels in case of their "horses having accidents in the streets."

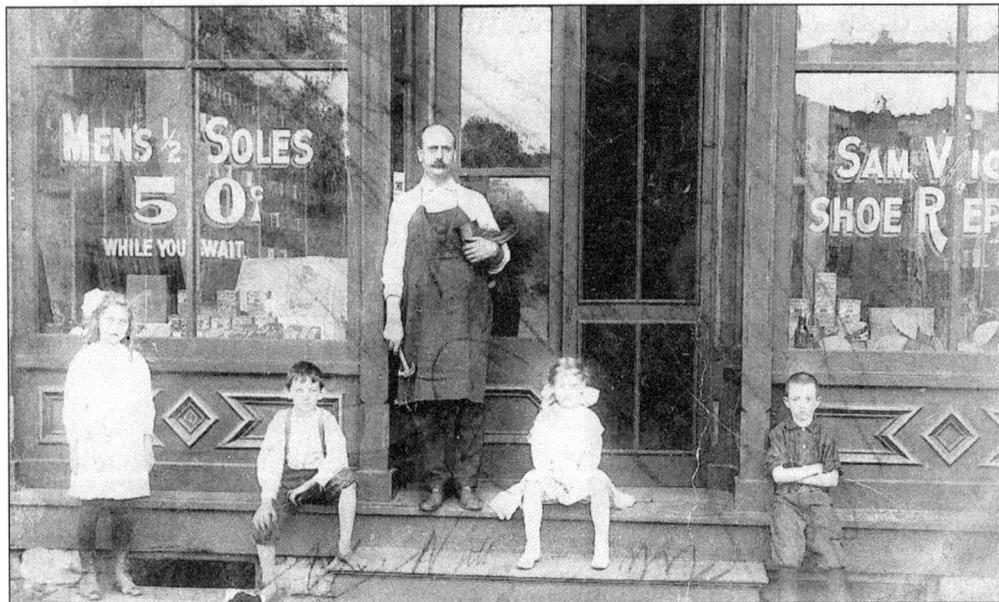

Waiting for business on the doorstep of his store, Sam Victor entertained neighborhood youngsters. The two little girls are Helen Mohl Henneman (left) and Ethel Mohl Sommers (right). Half soles could renew a pair of oxfords and provide months of wear. With the price of men's shoes at $3 or more, that was quite a bargain.

Dr. Samuel Plummer came to Rock Island in 1845 at the age of 24. A Union volunteer in the Civil War, he was deafened in one ear by a shell explosion in Vicksburg. The physician later became chief of the 5th Army Corps, 1st Division. As was often the custom of the times, his spouse, Mrs. Plummer, posed some distance away from her husband. Plummer built up a respected practice in the city before he died in 1900.

Lincoln School was constructed in 1872 and was so well built that it still stands today. Inside the building, a grand wooden stairwell headed up to the second floor, and people remarked that it was "like walking up to heaven," for the rich, hand-carved wooden banisters were impressive. Lincoln survived a fire in December 1949, shortly after its next-door neighbor, Central Junior High, burned to the ground.

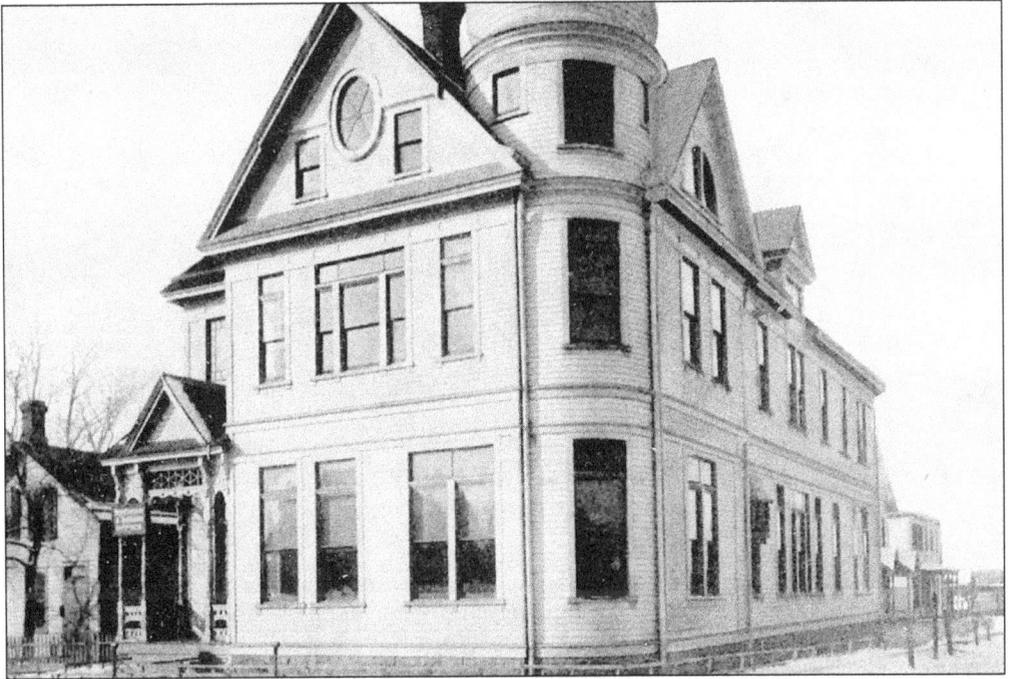

Few names were better known in Rock Island in the latter half of the 1800s than Weyerhauser and Denkmann. Their offices sported an onion-head dome. Inside the walls of the structure were negotiated some of the biggest lumber deals ever made in the country. The partners were respected for their environmental concerns as well as their giant business dealings.

"If you can't buy it at McCabe's, it's not worth buying" was the motto for this business. Many Rock Islanders felt that way, and when the department store closed its doors in 1985, after 115 years of satisfying customers, the loss was keenly felt. L.S. McCabe opened his "plunder shop" (household and personal items) in 1870, and people came on horseback and by carriage. The business thrived, and by the mid-1900s, retail Dollar Days has attracted thousands of customers.

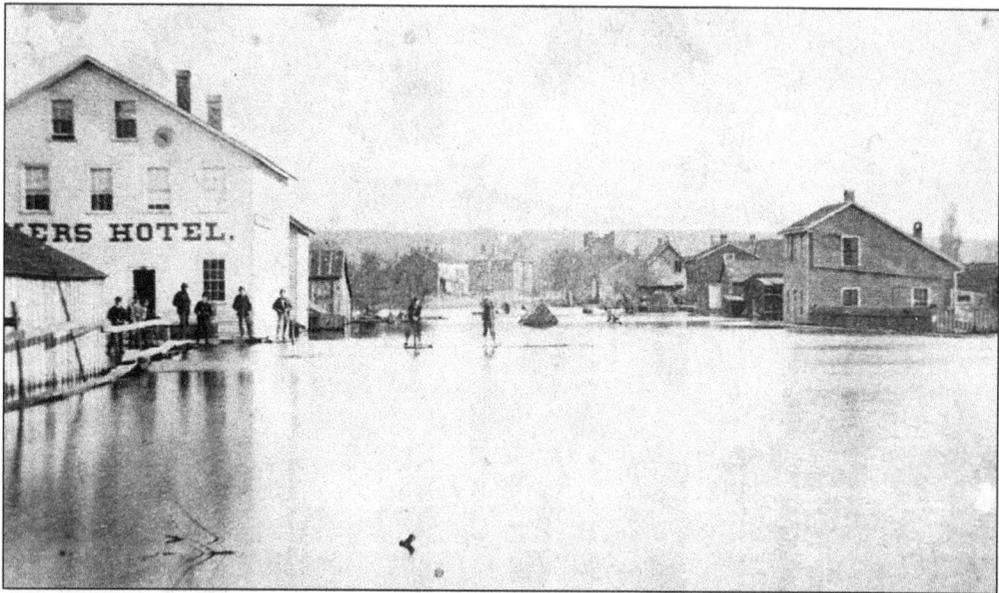

This image, which depicts the only way to travel at the time of the Mississippi flooding in 1880, brings to mind the lyrics of the children's song, "Row, Row, Row Your Boat." Sightseers are gathered at the Farmers Hotel at the northeast corner of Fourth Avenue and Ninth Street.

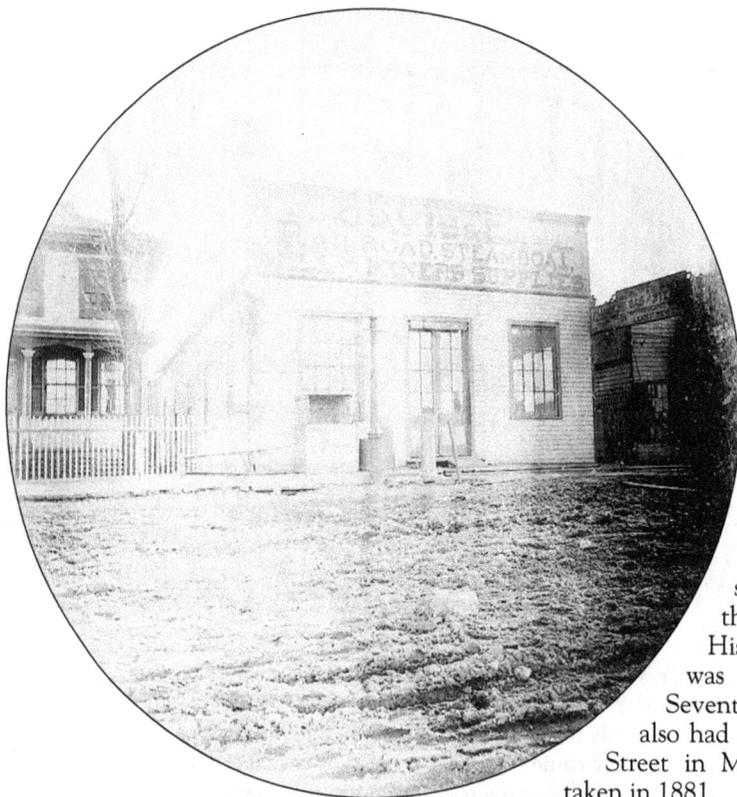

From railway and steamboat supplies to millwork and printing services, Thomas B. Davis was a man for all seasons and reasons at the turn of the century. His Rock Island shop was located at 112/114 Seventeenth Street, and he also had offices at 520 Sixteenth Street in Moline. This photo was taken in 1881.

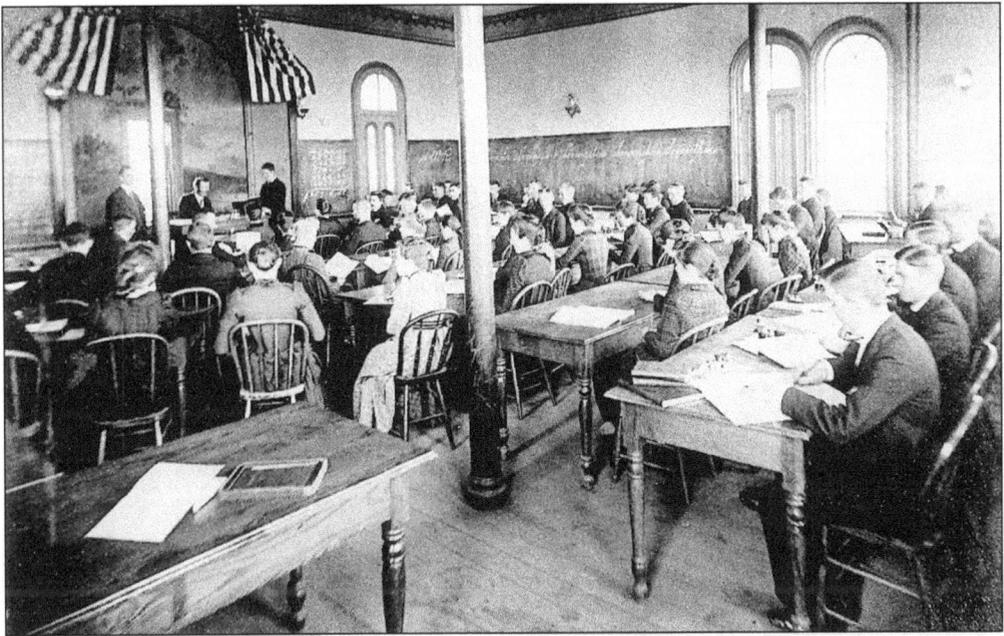

"All right, you in the fourth row, second seat from the left side, eyes on your own paper." Students who gathered in the first Augustana classroom hardly received one-on-one attention, but this 1886 photo clearly shows an atmosphere of learning and decorum. Whatever happened to handwriting via the Palmer method? Note the script on the chalkboard.

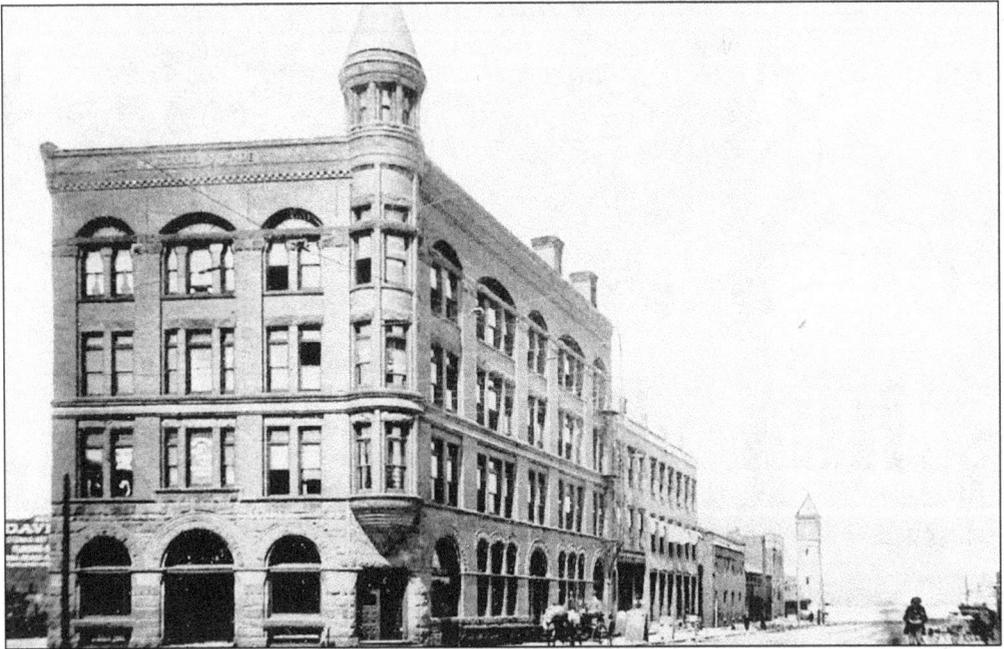

Mitchell and Lynde (Phil and Cornelius) were two well-known and highly respected Rock Islanders in the latter part of the 19th century. Mitchell and Lynde was also the name accorded to a block downtown where many professional men kept their offices. Notice the turret top, a popular architectural effect on many buildings of the time.

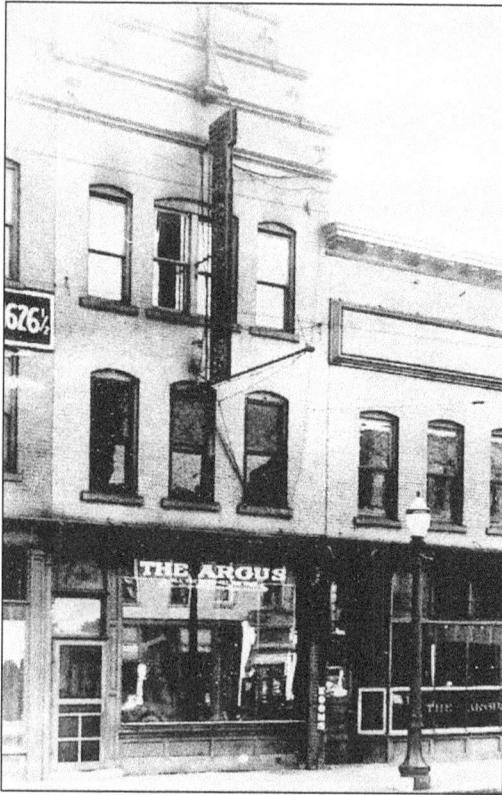

Distant shouts of "Paper! Get your daily paper!" linger in the air, recalling long-ago times in downtown Rock Island. J.W. Potter purchased *The Argus* in 1882, and the newspaper remained in the family for almost a century. First located on the east side of a building between Sixteenth and Seventeenth Streets, the newspaper moved to new accommodations in 1925. Small Publications purchased *The Argus* in 1985.

The family of John Potter was comfortably housed in this handsome structure located on the southeast corner of Seventh Avenue and Nineteenth Street. A third-floor ballroom offered a chance for dancing lessons among children. Some say the girls couldn't wait for the weekly sessions while the boys required a bit more encouragement.

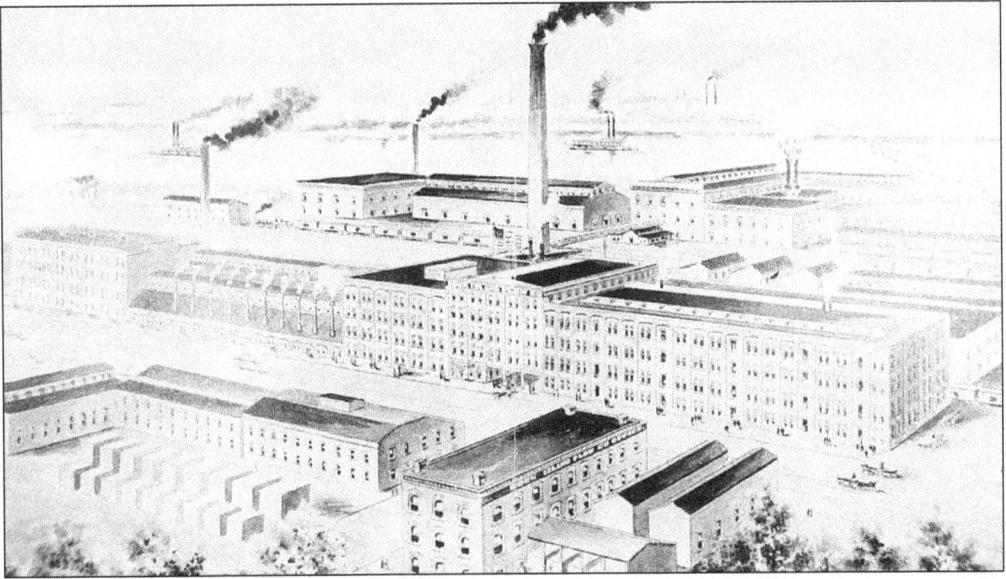

Rock Island Plow Company grew out of the ashes of Buford Plow, which was destroyed by a mysterious fire on New Year's Eve in 1880. Its president, B.D. Buford, claimed the fire sprang up at three different places at one time. "Some enemy started this fire," Buford declared. In 1884, the Rock Island Plow Company started operations, continuing until 1937, when it was sold to J.I. Case Company.

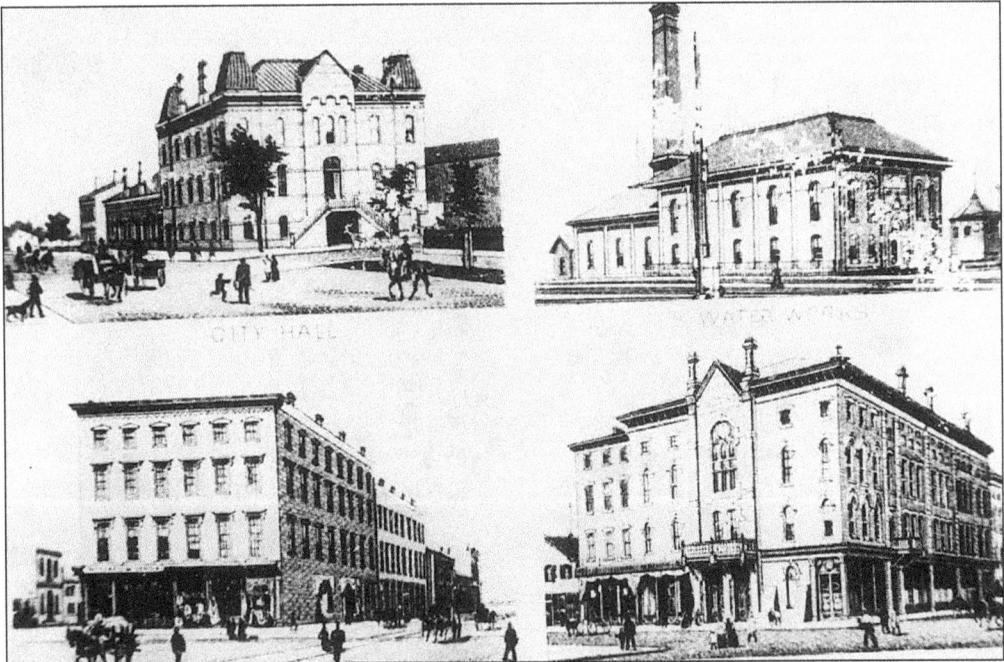

"Postalviews" or picture postcards were popular in many cities across the country at the turn of the century. These Rock Island sites on a four-feature card included the city hall, water works, post office, and Harper's Theatre. That's a lot of fun viewing for 2¢!

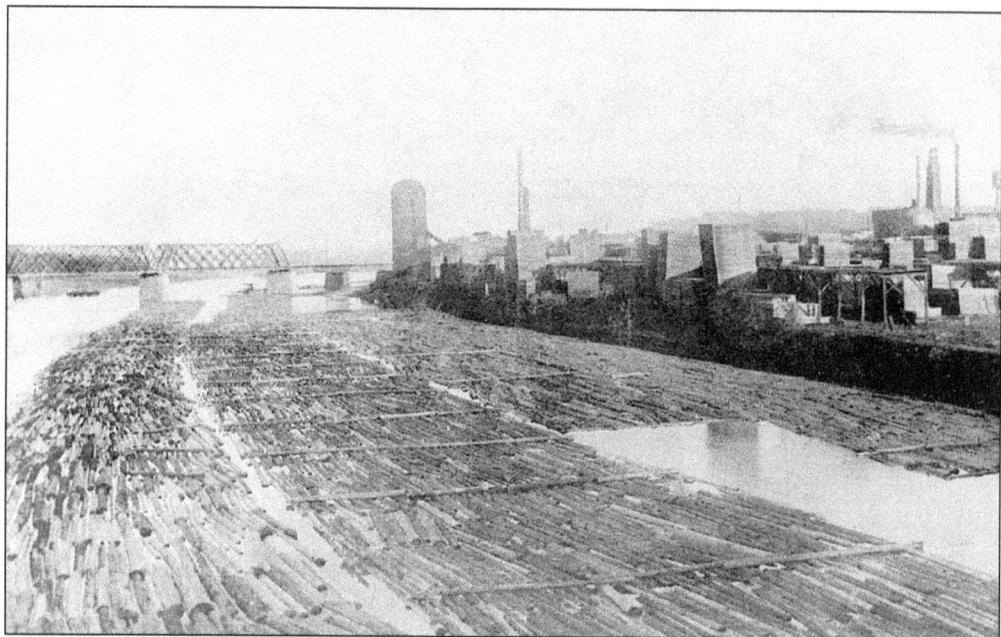

This photo, taken in the late 1800s, emphasizes the importance of both the Mississippi River and lumber to the growth of Rock Island. This scene is not unusual; this was a daily occurrence. Frederick Weyerhauser and Frederick Denkmann were America's leading lumbermen and were often called to Washington, D.C., for top-level conferences. In 1908, a fire destroyed 20 acres of the levee property.

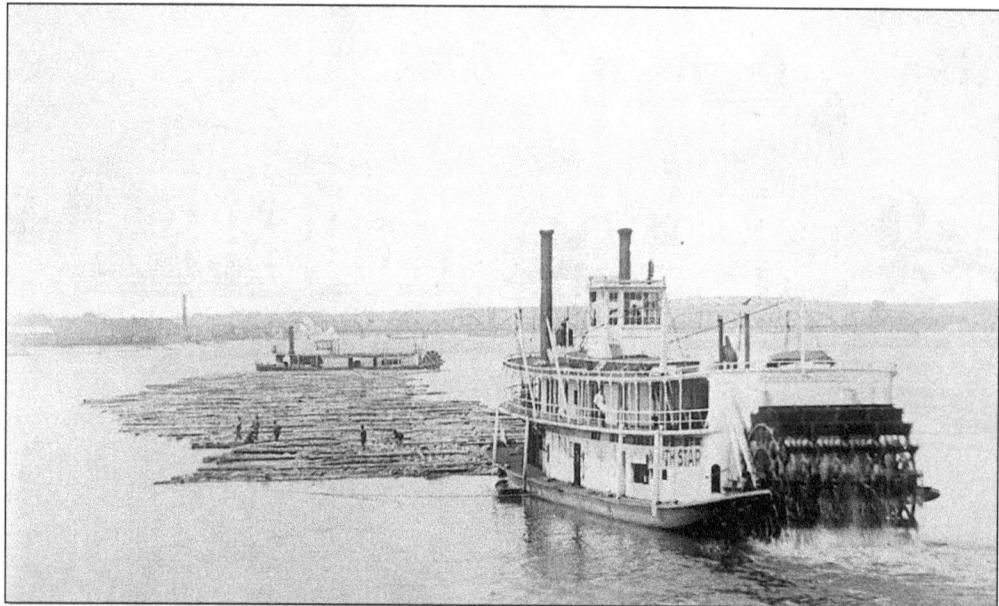

Log rafting on the Mississippi River was a major contributor to Rock Island's growth during the second half of the 1800s. In 1840, the upper-river area boasted two sawmills. Some 30 years later, there were 100 mills dotting the river fronts. In 1884 alone, 741,837,000 logs were processed. Frederick Weyerhauser and Frederick Denkmann became national lumber icons, while the name Fred Kahlke equated quality-built steamboats and boatyards.

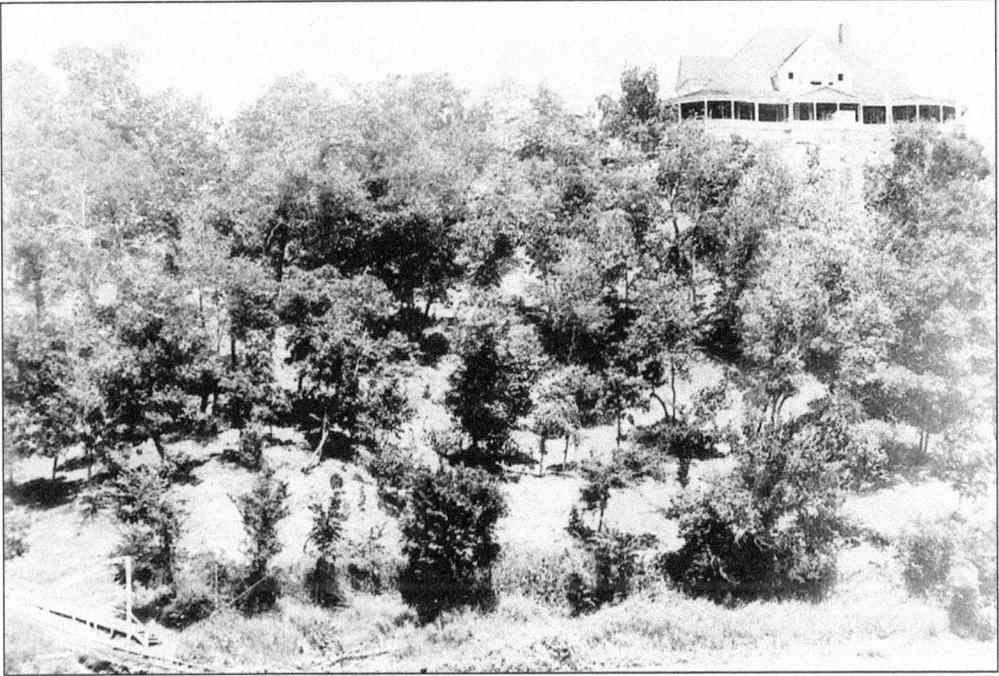

Rock Island's favorite location for family entertainment at the turn of the century was the amusement park at Blackhawk's Watchtower. Those who were daring enough paid a dime to "Shoot the Chutes," a daring, flat-bottomed boat ride that started at the top of the hillside on a greased, double track and ended up in the Rock River. Tamer visitors settled for the merry-go-round.

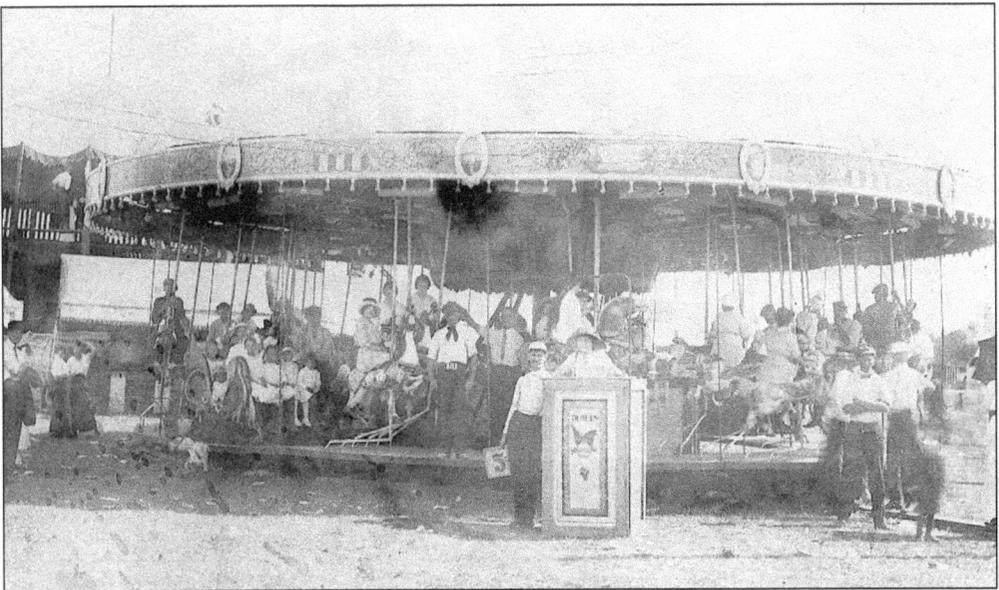

How about a ride on the merry-go-round? It's only 5¢. That's 5¢ less than the Shoot the Chutes. The merry-go-round was one of the most popular rides at the Black Hawk Amusement Park, particularly among the older set. "It's just more ladylike to ride," observed one female customer. "One feels graceful and comfortable."

The year was 1895, and Rock Island was shooting skyward in the area of new buildings. With shade trees forming a leafy camouflage, construction workers were putting the final touches on the county courthouse. You certainly did not have to go far to board the trolley! Streetlights had to be lowered each night for carbons to be ignited by hand.

Few cities in the country have done more to preserve and protect historic properties than Rock Island. The old Spencer home, located at 705 Twentieth Street, is one of many structures carefully looked over by the Broadway Preservation Society. "Once a place is gone, there is no bringing it back completely," asserts Tim Bell, a Rock Island native and former state representative.

From the moment he arrived in Rock Island in 1895, John Looney created trouble. He became a state-certified attorney, then broke every law he'd studied. While illegally trafficking booze and babes, he bribed and blackmailed anyone he could. As editor of *The Rock Island News*, he printed slander and rumor. Gunfire rang through city streets as Looney lieutenants battled their enemies. In 1925, Looney was found guilty of murder and was sent to Joliet.

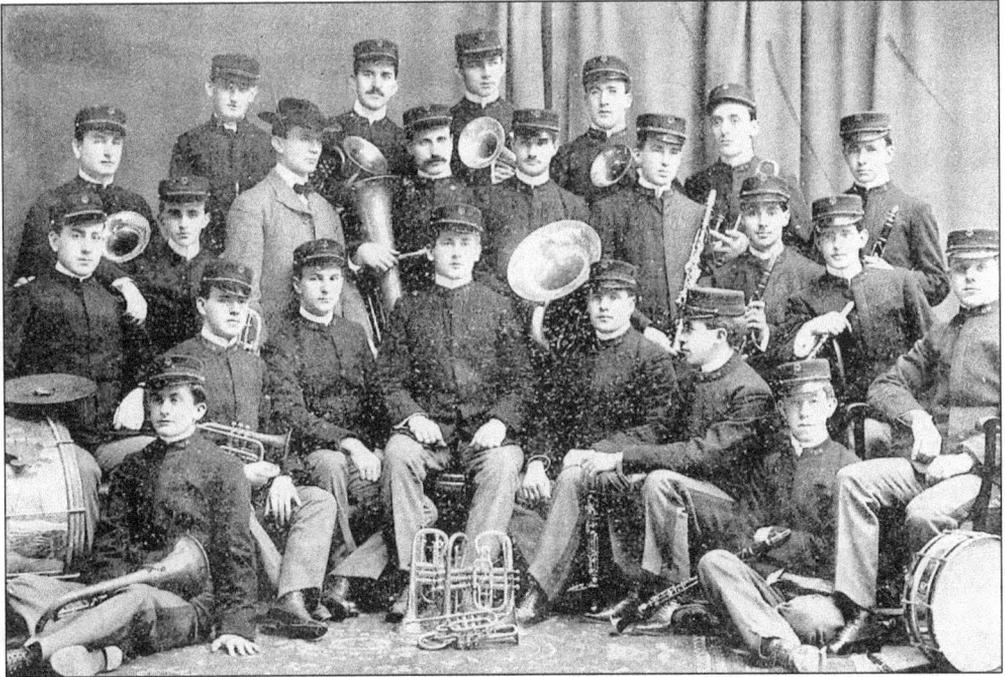

In the late 1800s, Rock Island music men gathered to share their music and what emerged came to be known as "Bleuer's Band." The Black Hawk Inn was their favorite location, and more than one Rock Island couple claimed that a wedding proposal came while the Bleuer "boys" provided background accompaniment.

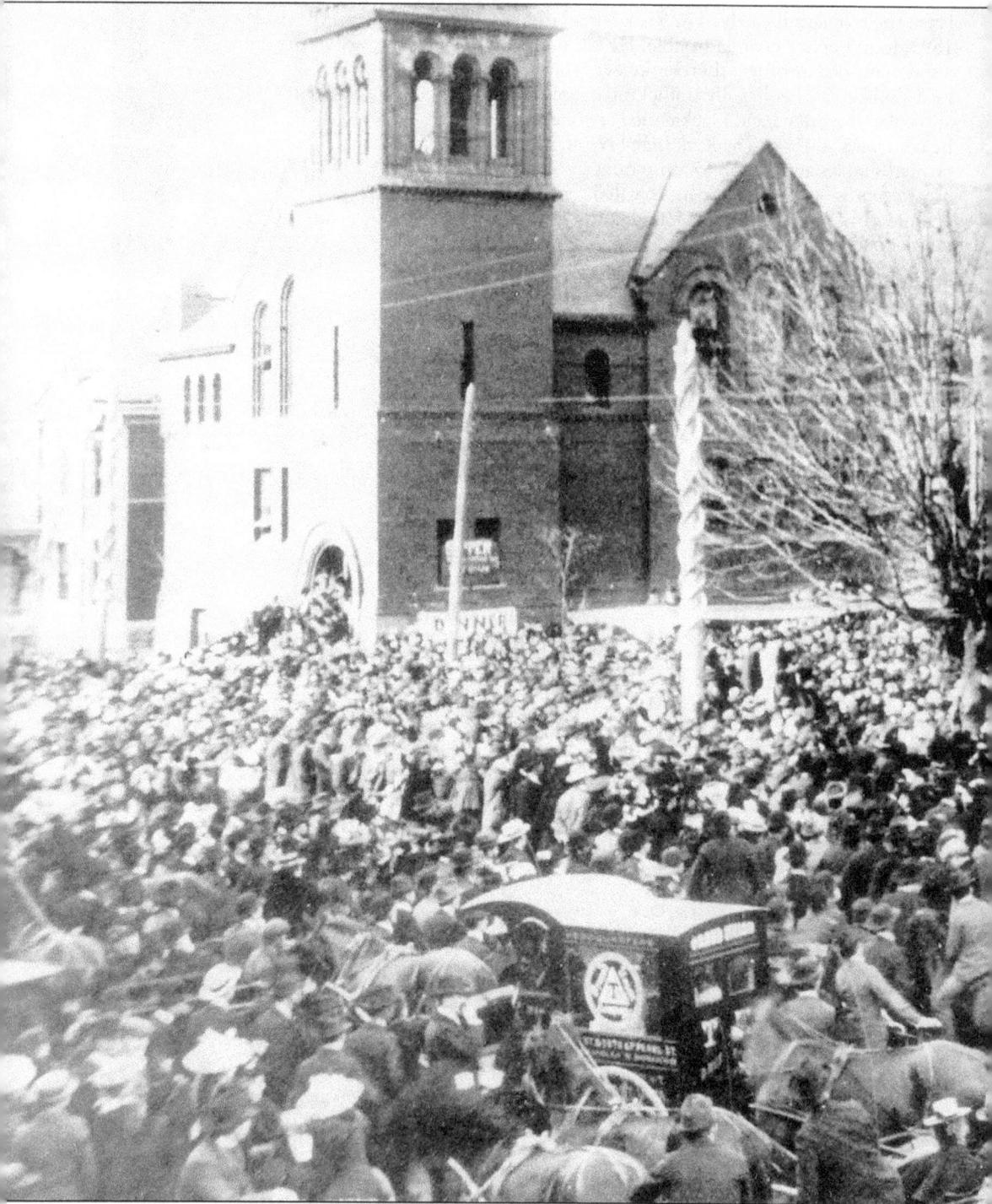

"Here, as we stand in God's sunlight, the waves of the mighty Mississippi River roll in the background." The laying of the cornerstone for the Modern Woodmen Headquarters on April 27, 1898, brought no less than the country's "silver-tongued orator," William Jennings Bryan (white arrow in picture) to speak in Rock Island. Over 15,000 people took part in what was

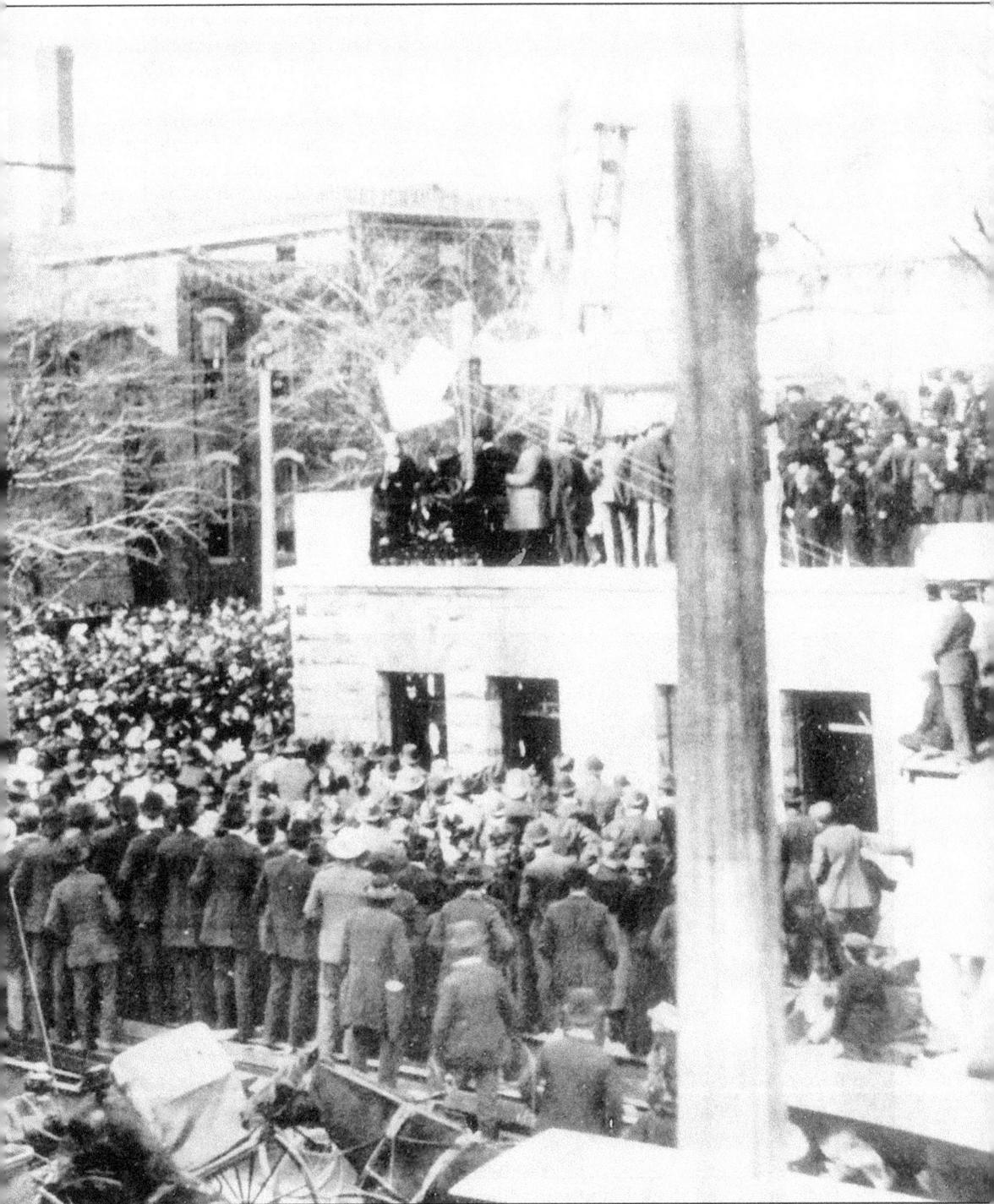

called "The Woodmen's Great Day." Yet, in addition to it being a parade and celebration in honor of a major Rock Island building project, it was a patriotic rally for the nation. Two days earlier, America had declared war against Spain.

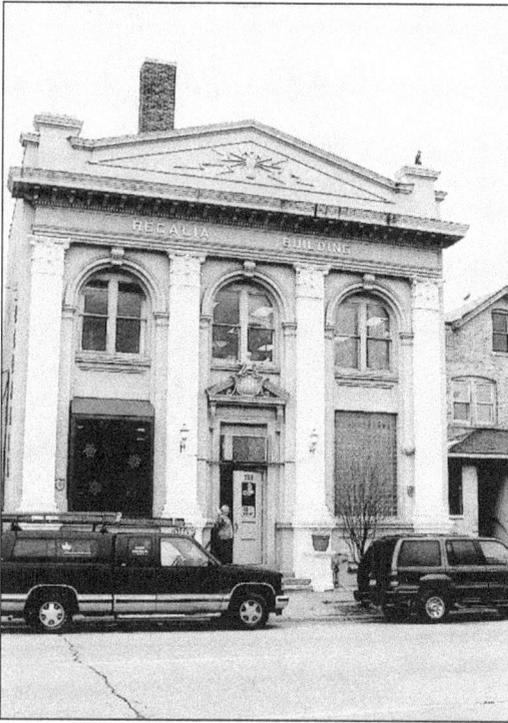

There's something on a windy day that will definitely not sag—around the world, it stays unfurled—it's a proud Regalia flag! One of Rock Island's most uniquely designed buildings is housed in one of the city's oldest businesses. Founded in 1897, Regalia offers a distinct line of quality memorabilia. "Come on in," welcomes company owner and president Pat Jahn.

Ellen Gale, appointed Rock Island's first librarian in 1868, was only 15 years old when she started work. She served for 65 years, until 1937, the longest record of service for any library director in America. In 1997–98, Rock Island residents celebrated the 125th year of the library's operations with a year long series of activities. Rock Island Library benefactor Ruth Evelyn Katz stated, "It was a grand birthday party."

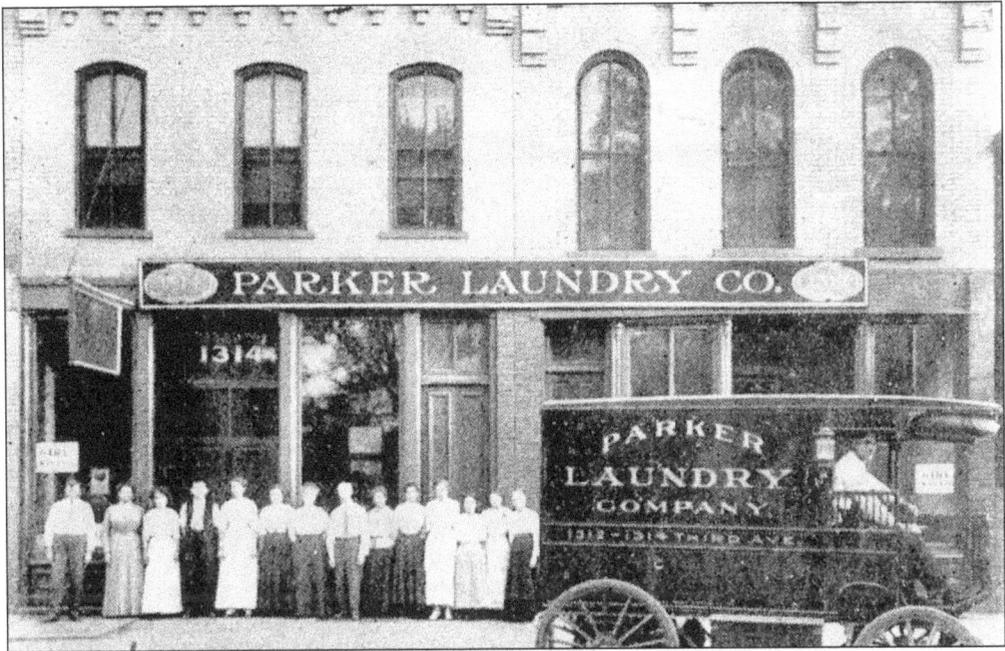

Who needs a horse when Parker Laundry's electric truck could go 50 miles on one charge? Then again, the delivery driver would often forget how many stops he'd made, and more than once they'd have to send a team of horses out to pull the truck back to town. Parker's celebrated 100 years of business in 1988. They do a lot more than clean the cuffs and collars that were the mainstay of the trade in the 1800s.

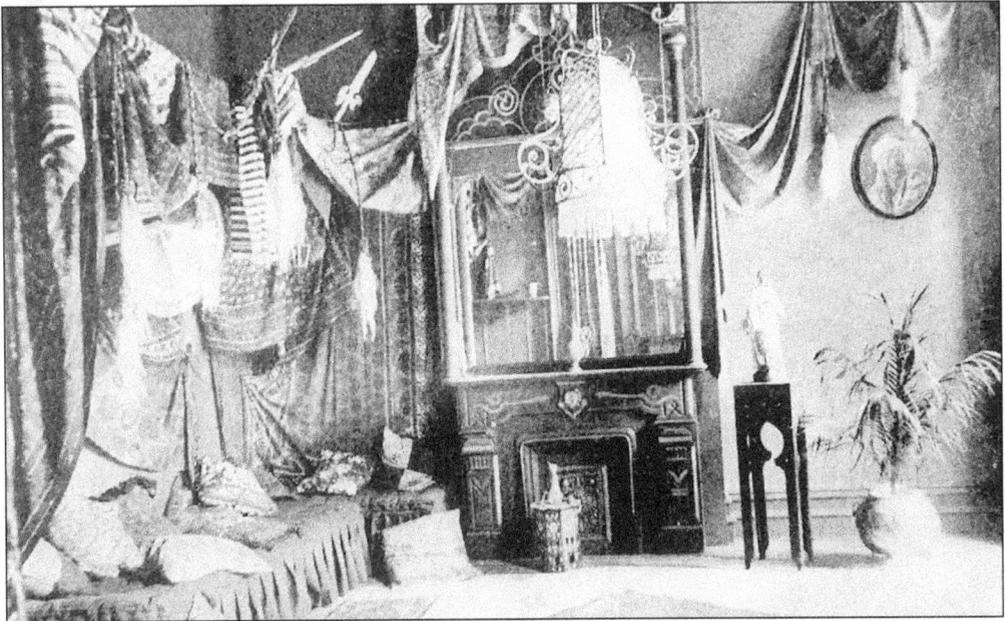

Individual rooms inside Rock Island's ornate Harper House allowed visitors to select the motif of their choice. Among the most popular was this Oriental parlor, complete with incense-burning canisters, which provided the fragrance to complement the decor. Travelers came from as far as Chicago and St. Louis in the late 1800s to enjoy the luxury of the Harper House.

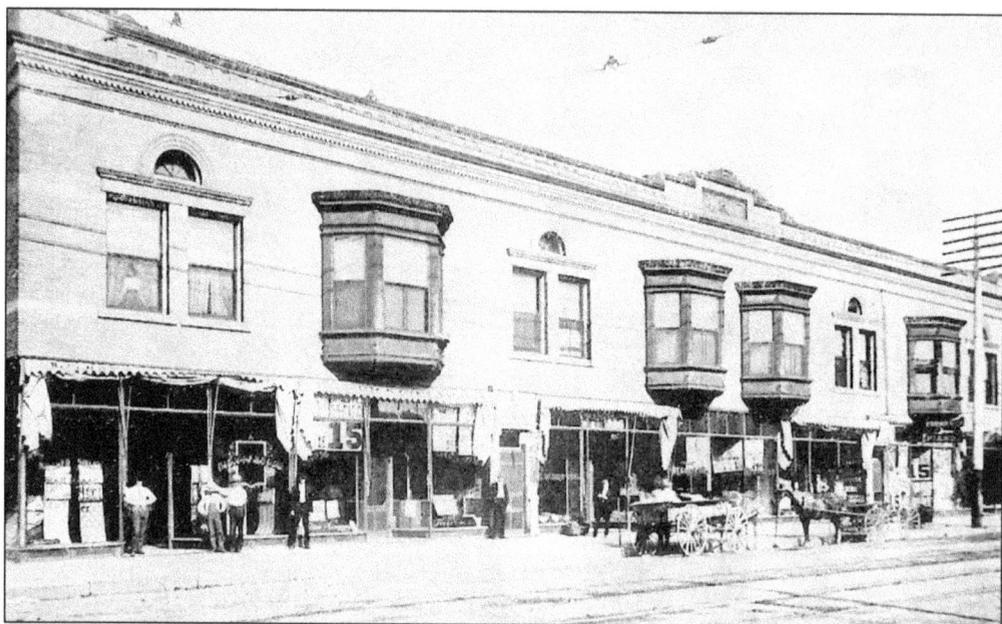

Some merchants pushed their carts while others had faithful steeds to carry their wares. This August 1900 scene at Twentieth Street looks north from Fourth Avenue in downtown Rock Island. Note the number 15 on many storefronts. Merchants were advertising that Buffalo Bill was coming to town on that day. It appears that the lady in the upstairs apartment is keeping an eye out for him.

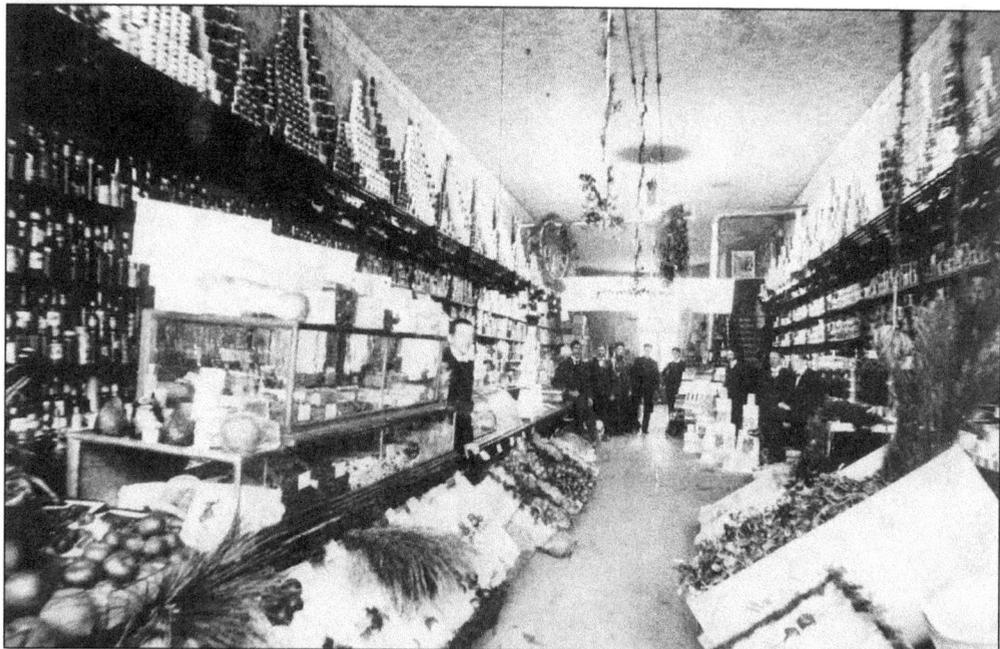

Rock Island's Hess Store offered every imaginable foodstuff (and a few unimaginable items too!) in the late 1800s, but you had to be able to navigate one aisle to select your purchases. Rumor has it that a card game went on constantly during the store's open hours, but the gentlemen in the back were kind enough to come out for the photographer.

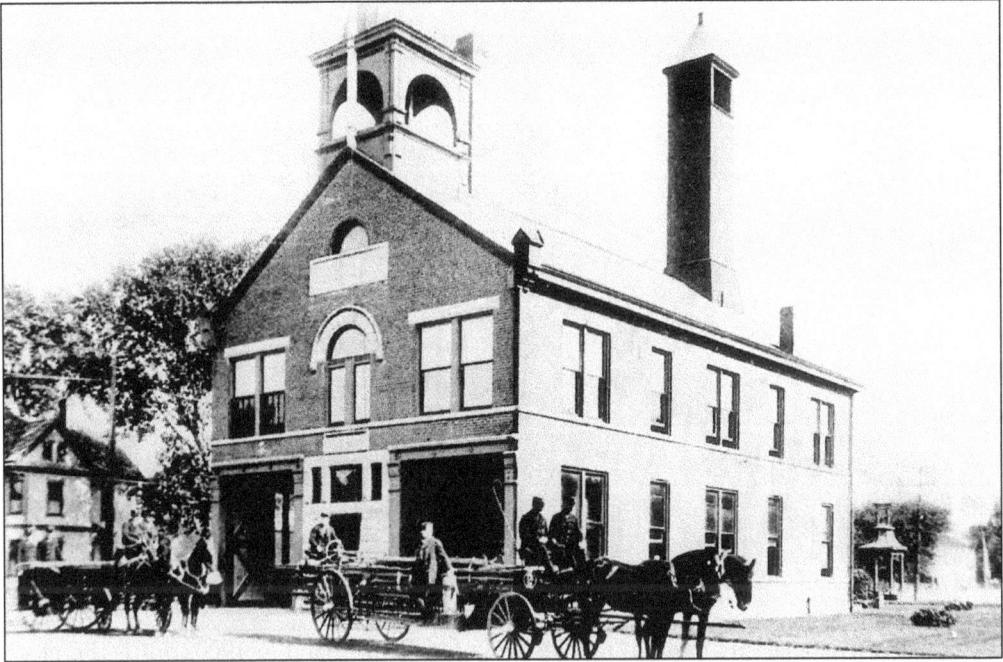

"We're city servants who never tire, we're always ready, now where's the fire?" By the late 1800s, volunteer firefighters were being replaced by paid firemen, complete with handsome uniforms. Here, members of Rock Island's Central Fire Station display their rigs and gear.

Try this riddle: What do strawberry, lemon, root beer, cream, ginger ale, birch beer, sarsaparilla, and sparkling water have in common? Here's a clue: all those flavors could be found at 1822 First Avenue, Rock Island, before the end of the last century. If you guessed that they were all among the soft drinks flavors offered by A.D. Huesing at his bottling works, you'd win the prize. The business is still in operation.

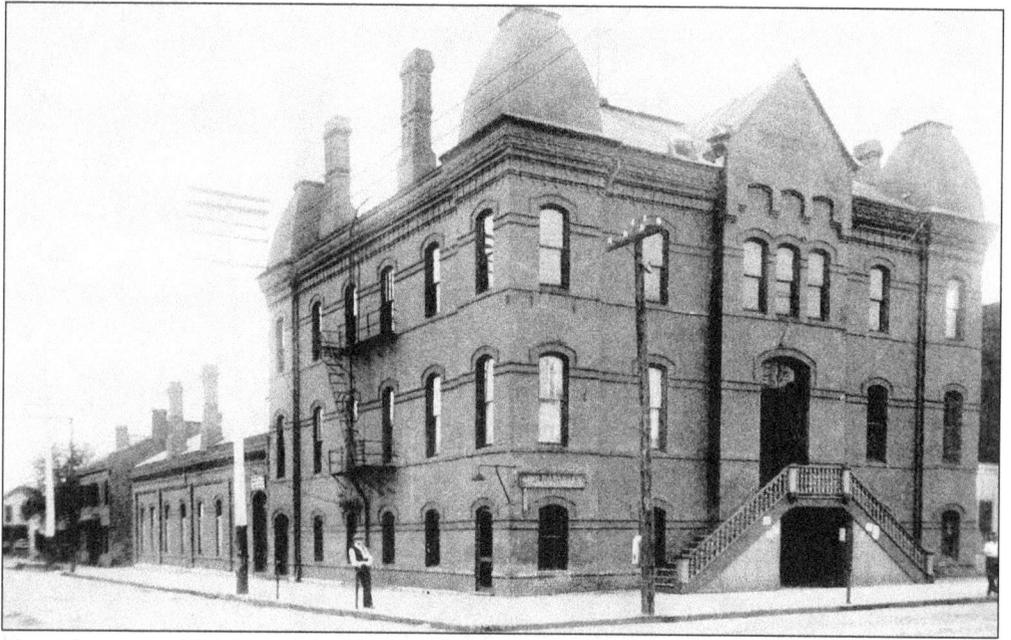

If you had any official city business to take care of in Rock Island in 1900, this is the place you would visit. City hall was rather gloomy and dismal, and one wonders about the two men lingering outside the building. Could each be contemplating purchasing a marriage license? One thing's for sure. Neither gentleman had come to pay a parking ticket!

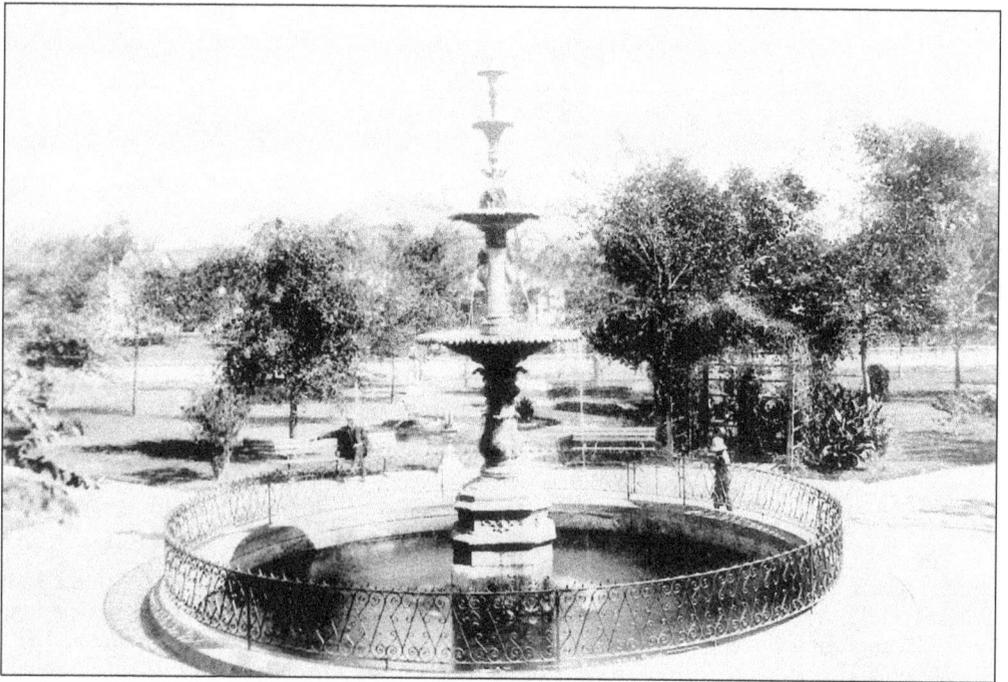

In this scene of peace and tranquility, the sound of a fountain's water spraying into a surrounding pond can be heard at Rock Island's Garnsey Square in 1899.

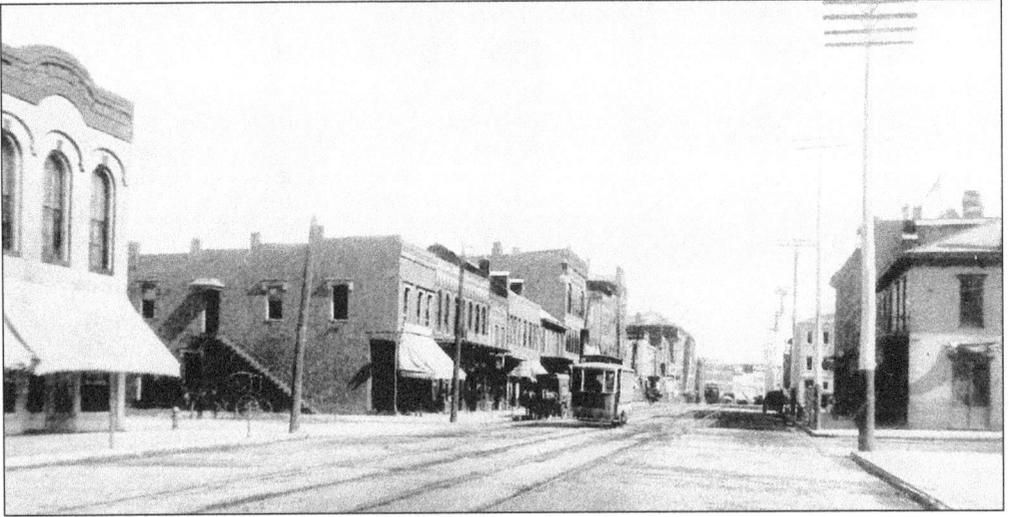

The trolleys that rolled along Second Avenue in downtown Rock Island boasted a fine safety record. This 1898 photo looks east along the trolley lines.

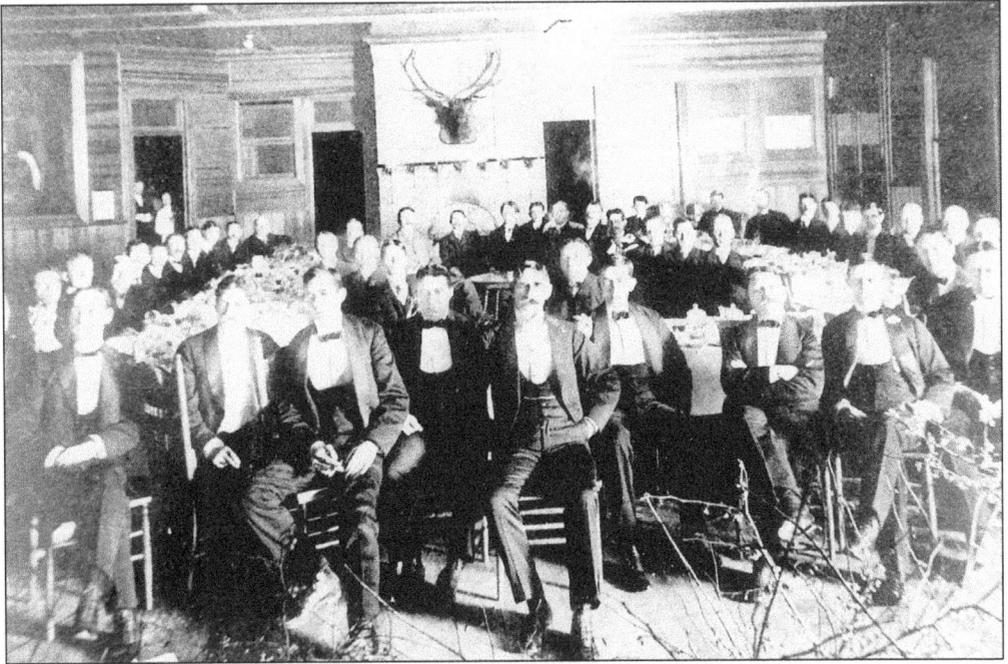

Is this a meeting of the Rock Island Rotary Club, c. 1900, or perhaps these gentlemen are the city's millionaires of the time? Actually, this is the annual banquet of the Tri-City Press Club, held at Black Hawk's Watch Tower. It's difficult to tell the editors from the reporters, but one thing is for certain—Nellie Bly is nowhere in sight!

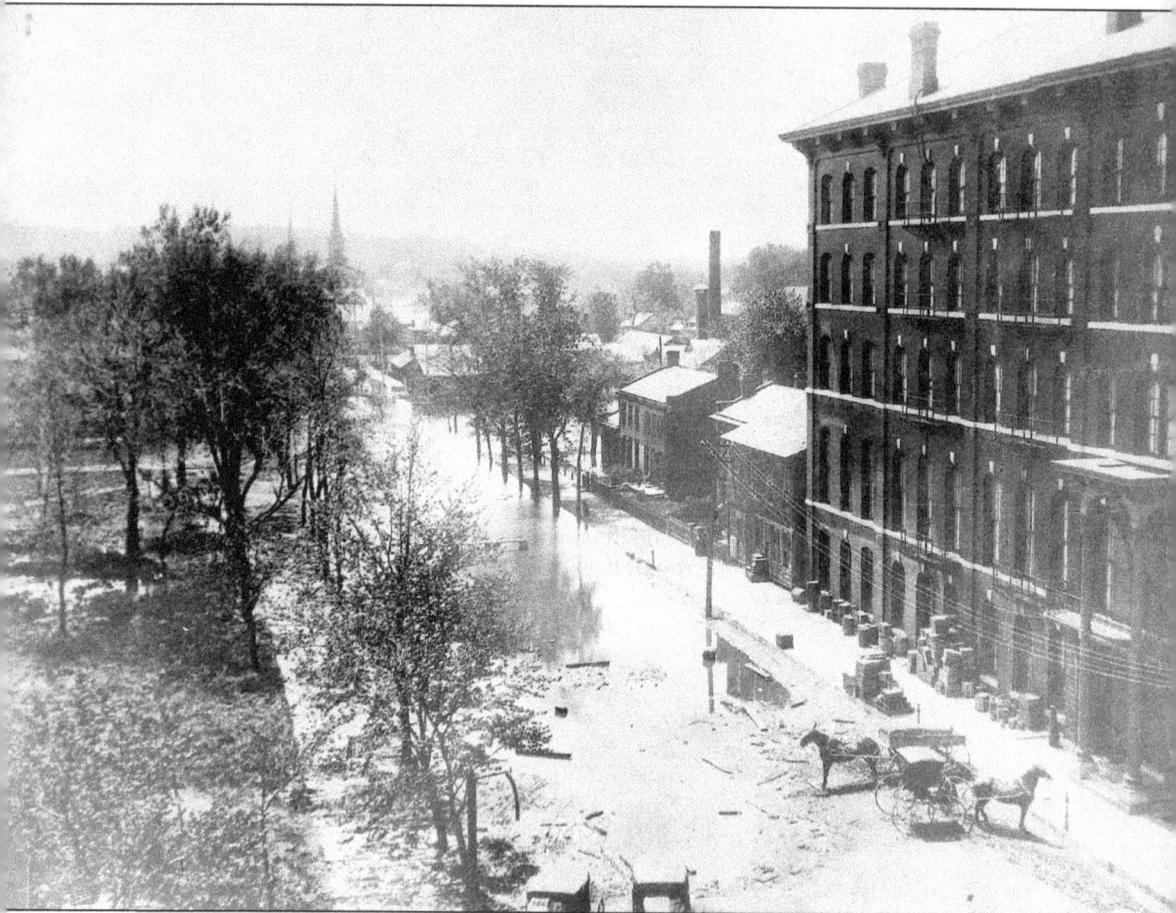

Flash flooding was a major problem in downtown Rock Island in the late 1800s. Boxes drying out in the sun line the side of the Harper House across the street from Spencer Square. Two church steeples can be seen in the background. The closer one is that of the Methodist Church on Fifth Avenue; one block south is the Trinity Episcopal tower on Sixth Avenue.

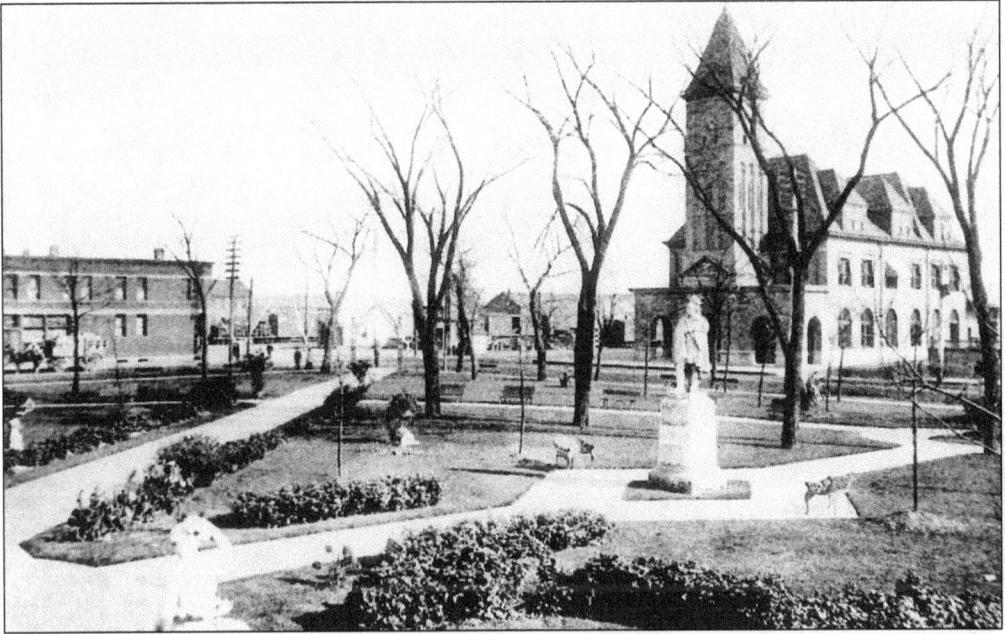

Dedicated in 1890, Spencer Square featured a bandstand, statuary (including the Black Hawk statue now located at the state park), trimmed shrubbery, and park benches. Rock Island city government sold the land to the U.S. government in 1954, and Spencer Square gave way to mortar, granite, and glass in the form of a post office.

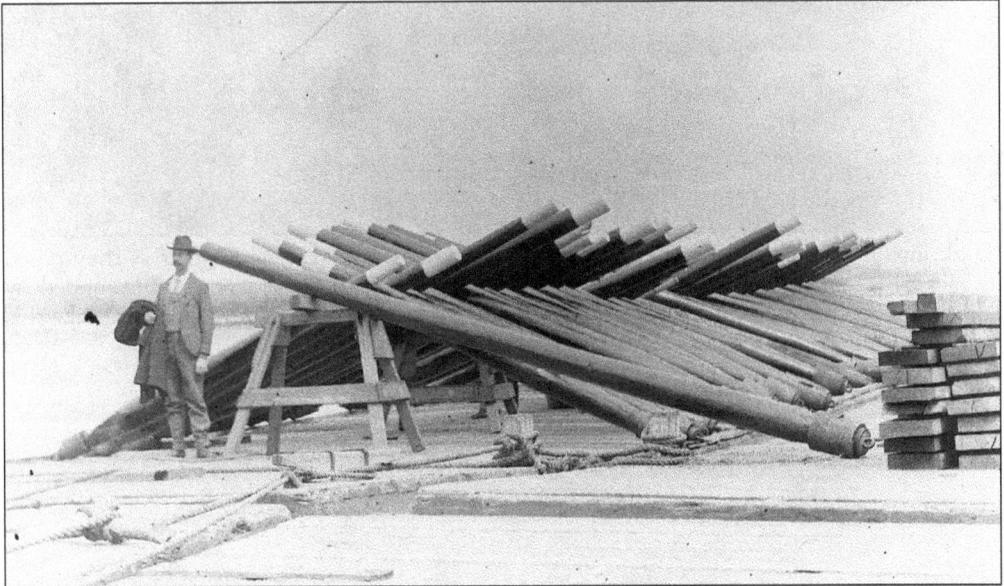

Oh, buoy! In the early 1900s the government guaranteed only a four-and-one-half to six-foot channel on the Mississippi. This barge of marker buoys was only one of several used in this upper stretch of the river.

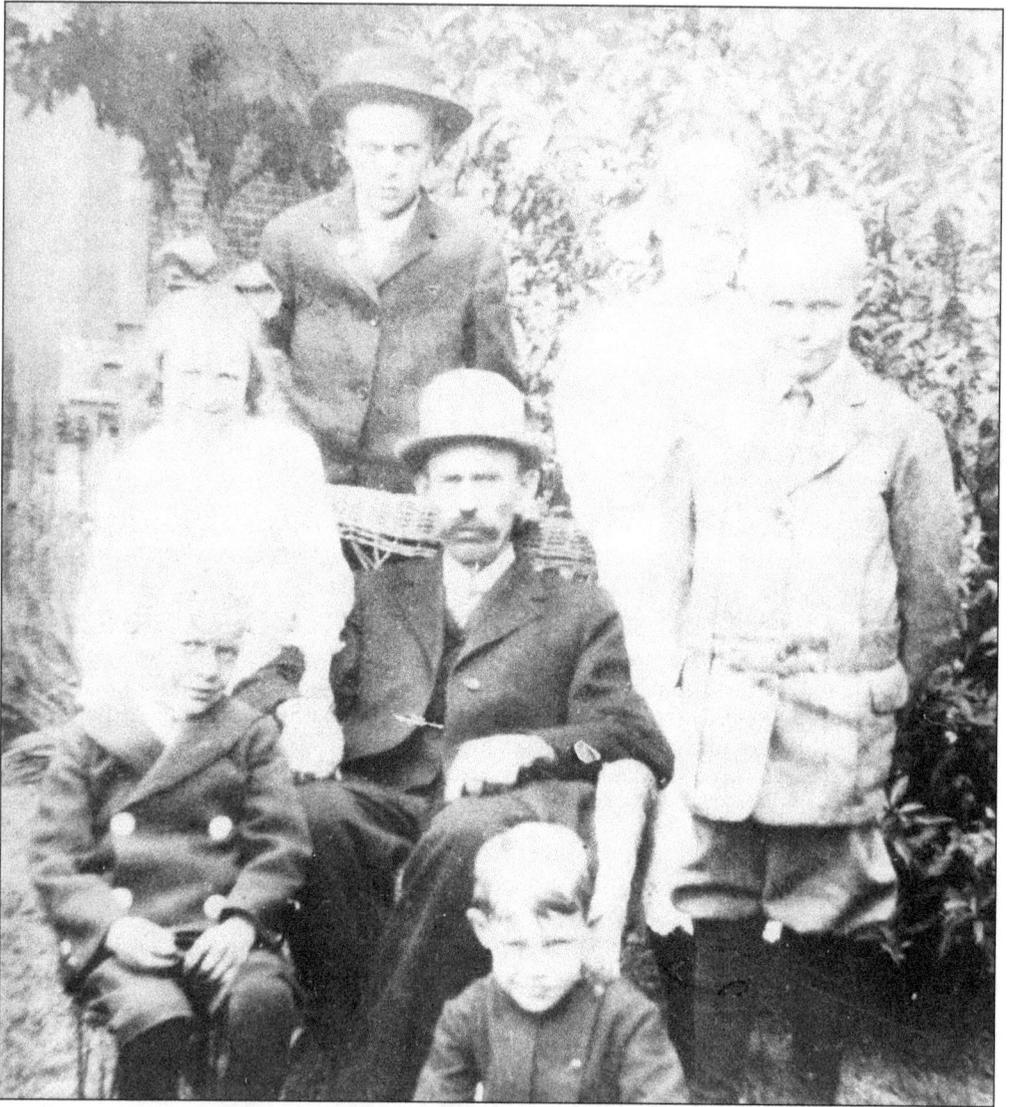

"Look into the camera and smile," traveling photographers told their subjects as they posed in backyards and on porches. This is the Moody family, with father Francil, surrounded by Frank, Anna, Chris, Martha, Roy, and Herbert, after the death of their mother. Photos like this become treasured family heirlooms with the passage of time.

Three

CHANGES

Ever changing, river city....
 Another century, another style
 No more horses pulling buggies
 Concrete roads? Just wait a while.
Supermarkets, talking films,
 A world war, and then another…
 The Charleston and Jitterbug
 "Kilroy's Been Here!" and "So's Your Brother!"
Schoolrooms filled with girls and boys
 Births and weddings, special joys…
 Loved ones exit, move and die
 The "river folk"—they laugh, they cry.
 A city changes.

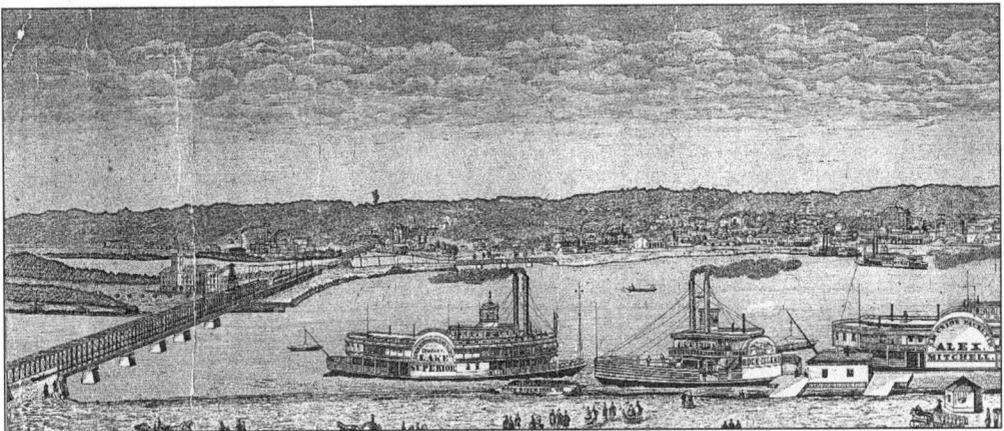

Anyone questioning the liveliness of the Mississippi Riverboat towns had only to stroll along the levees of one of the area cities. This panoramic view of Rock Island in the early 1900s, as seen from the Davenport shoreline, captures a scene of the bustling river traffic. The bluffs behind Rock Island were covered with trees that were later cut down and replaced with houses.

If this were the state of Virginia, this building might pass as Mount Vernon! Actually, it is the original Black Hawk Inn, its pillars beaming under an autumn sun in the early 1900s. Decorated in an elegant country-club style inside and out, the inn was open to the public. Meals served there were advertised as being "the finest in one hundred miles."

As the 20th century opened its doors, Rock Island boasted a "state of the art" medical facility in St. Anthony's Hospital along the Thirtieth Street incline. The Franciscan nuns who ran the facility served as nurses, cooks, housekeepers, and ambulance attendants, using their horse and wagon to transport accident victims. This original structure was razed, and its replacement was converted into a Continuing Health Care facility in 1972.

As people welcomed the new century, the students and staff at Augustana College bid farewell to an old friend. A long funeral cortege carried the body of Pres. Olof Ollsson along Seventh Avenue in front of the college buildings on May 16, 1900. Among Olsson's many accomplishments at the school was initiating the annual performance of *The Messiah*.

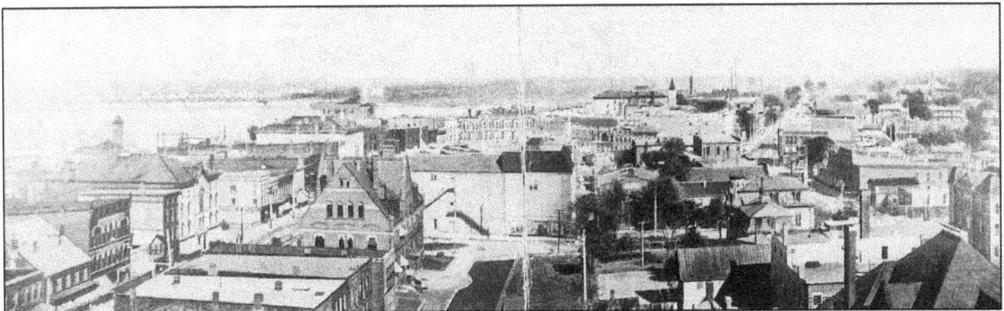

Did you know that at the turn of the century, Rock Island could be mailed to anywhere in the world for a paltry 1¢? Well, actually it was this postcard featuring a "panoramic view" of the city that could be sent anywhere for a penny!

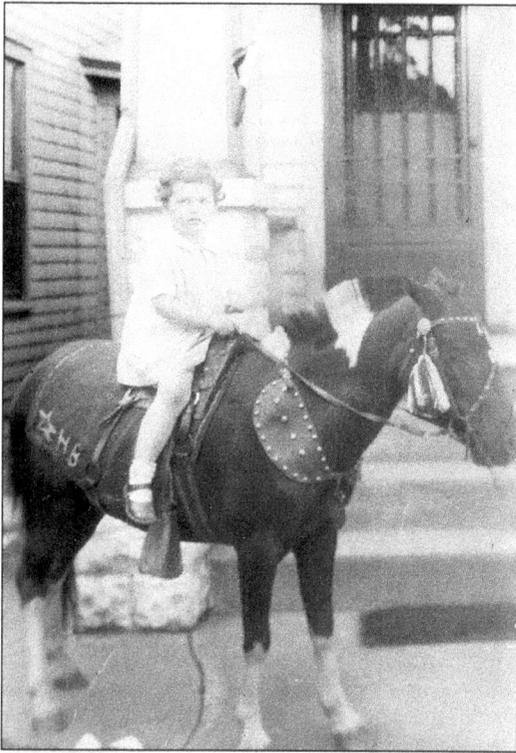

Lois Sommers Reimers looks ready to ride off into the sunset on "Ole Paint." During the first half of the 20th century, photographers roamed through Rock Island neighborhoods, leading their ponies and carrying their heavy cameras in hopes of finding parents willing to pay for a photo of their children riding the pony. All too often, the children weren't as content as Lois. Many of them cried and refused to sit for the photo.

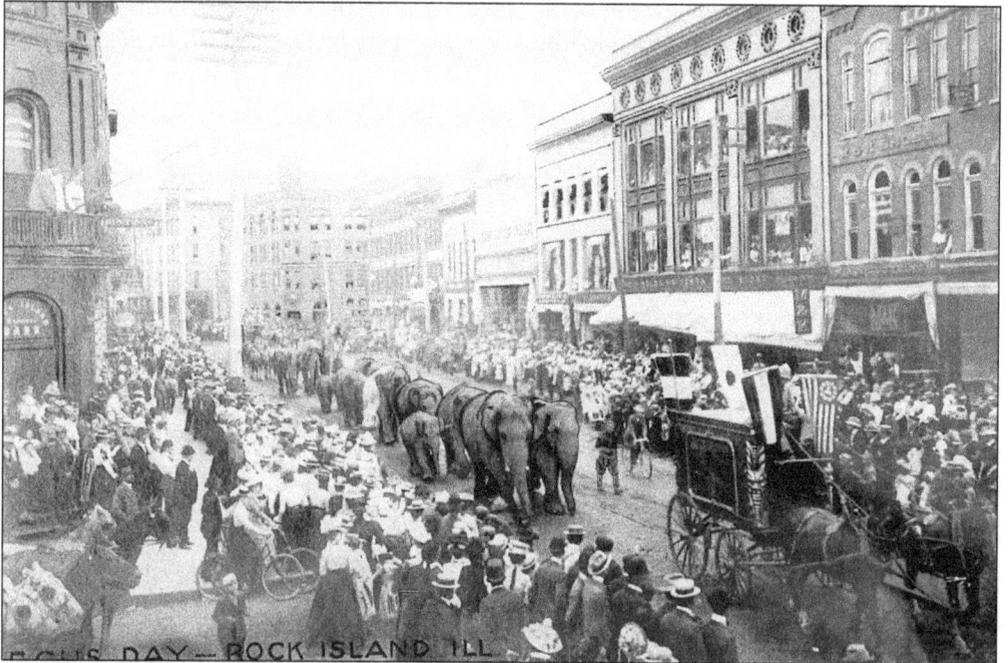

No, it's not the opening of the National Republican Convention. These marching elephants, trumpeting their arrival to Rock Island, signal the eagerly awaited annual Circus Day. Schools dismissed early so kids could watch the parade. Circus Day was an exciting event for Rock Islanders in the early 1900s.

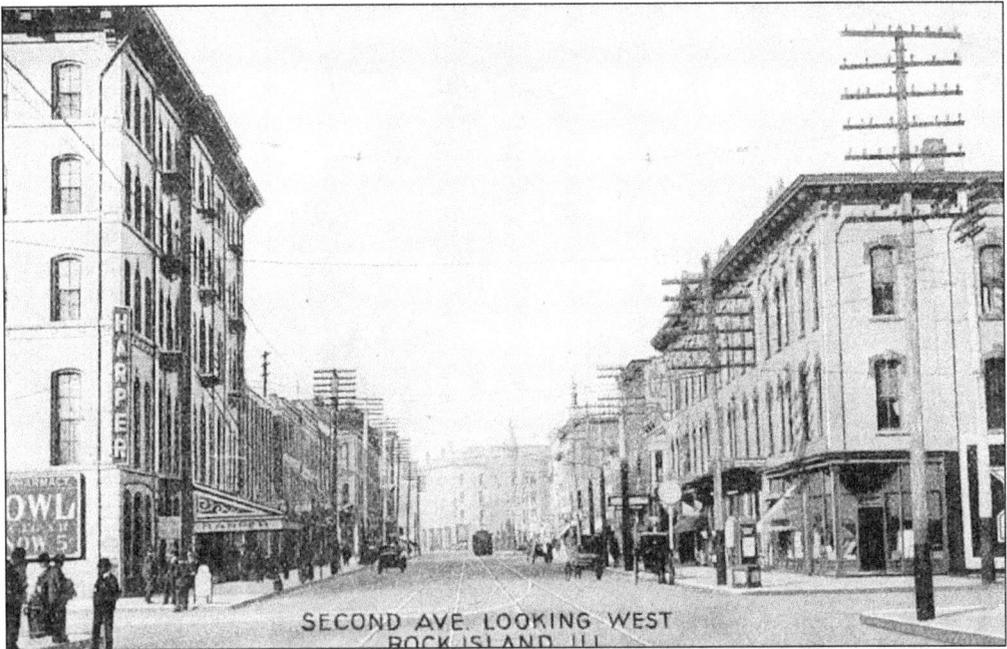

SECOND AVE. LOOKING WEST
ROCK ISLAND, ILL.

There was a time in the early part of the 20th century when trolley cars, automobiles, and horse-drawn carriages used Rock Island's main thoroughfares like Second Avenue. There were 22 places where you could buy cigars, too. The Harper House with its 5¢ White Owls had a running competition with Hickey Brothers, which was located one block to the south.

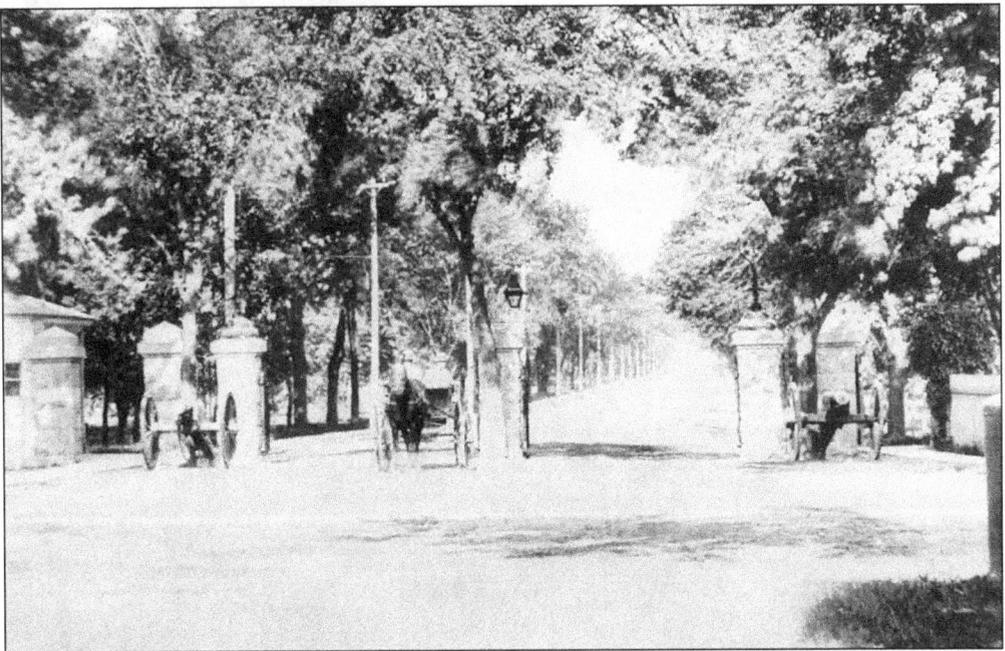

If one was looking for a shady drive beneath a healthy umbrella of Mother Nature's famous foliage, the entrance to Government Island was just the spot! Security was tight, though; even at the beginning of the 20th century, you had to have some form of official status to enter. Those who did were in for a beautiful ride!

47

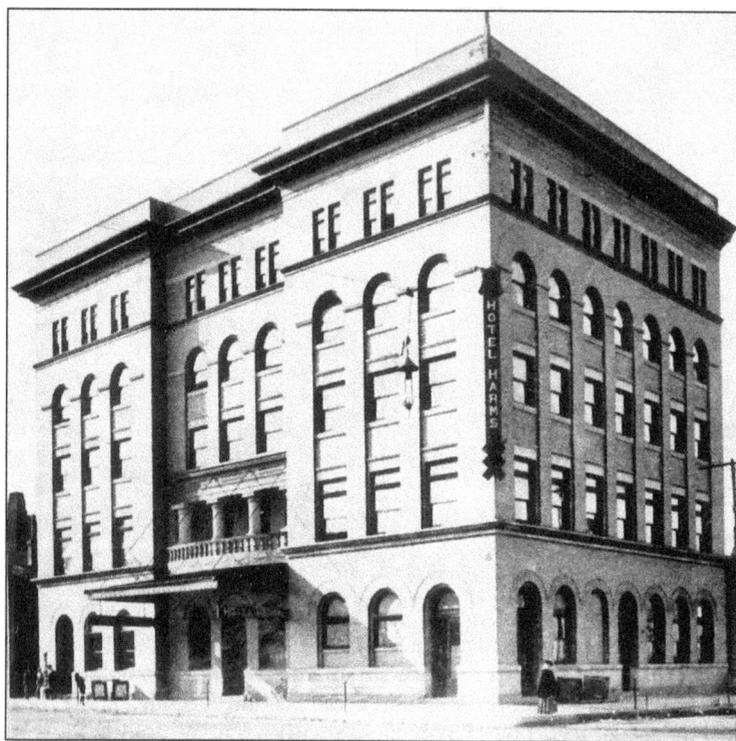

The Hotel Harms did a brisk business at the turn of the century in Rock Island. It also played a significant role in the city's communication history. Radio entrepreneur Calvin Beardsley secured the call letters WHBF in 1927 and was moving his station facilities from place to place. On January 11, 1932, the broadcast came from the Harms with Mayor Chester Thompson giving a civic address. The Potter family bought the station the same year.

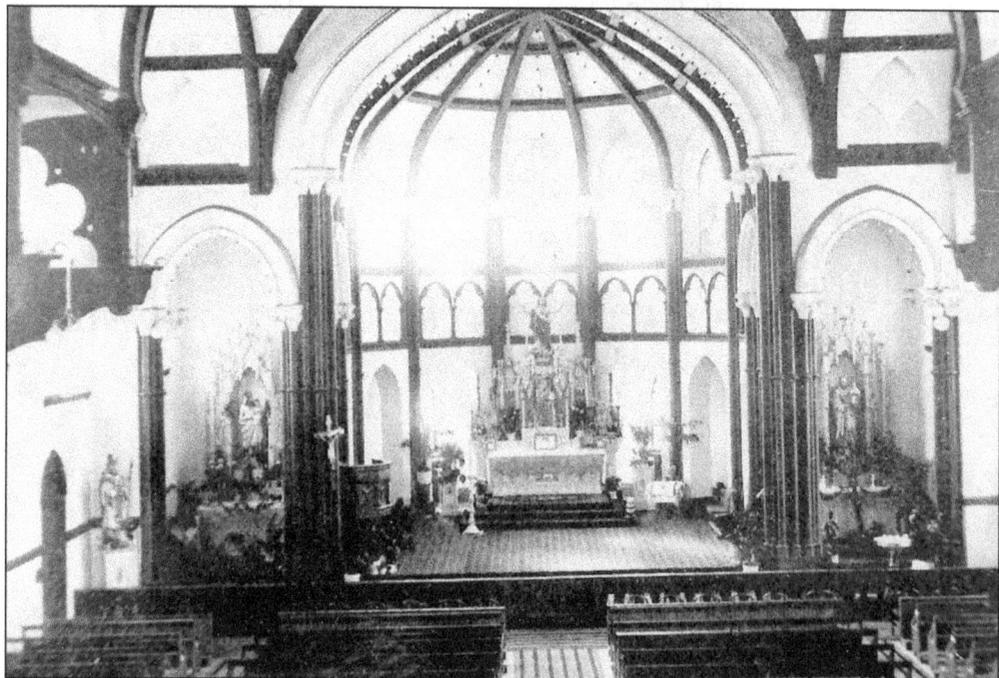

Catholics came for many miles to attend Mass at Rock Island's Sacred Heart Church in the early 1900s. The church's interior design carried much of the spiritual flavor of European structures. "It is a big church," observed longtime Rock Islander Alphonse Engles, "and yet there is a special closeness when you are there, a feeling that it is just you and God in the place."

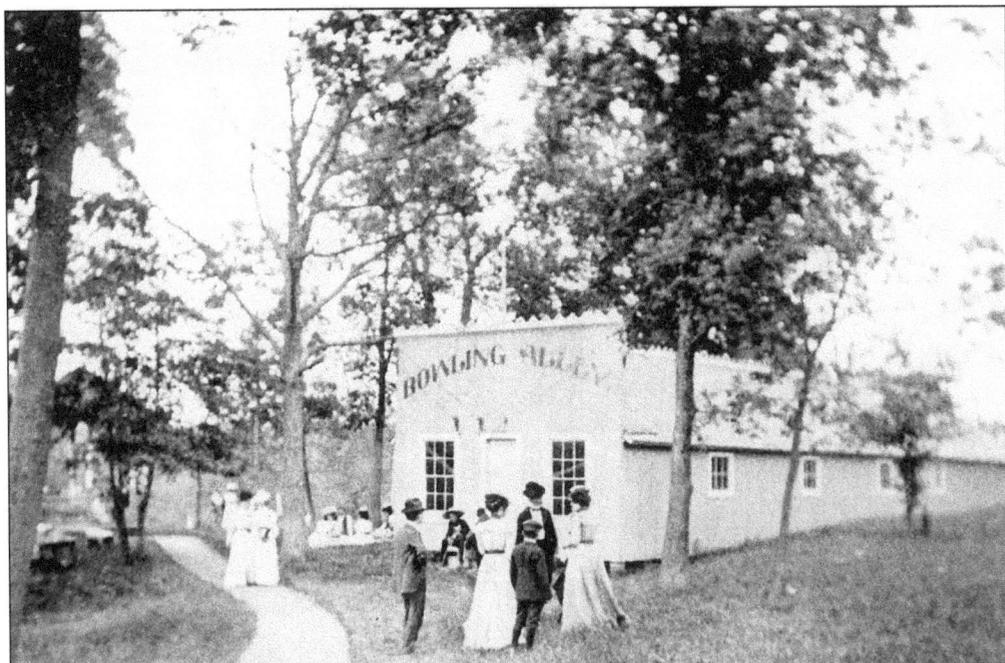

Not only did the Watch Tower Amusement Park feature slides and a merry-go-round, those who desired could bowl a game or two at the alley. The sport was largely enjoyed by gentlemen; the dress styles of the early 1900s posed some difficulties for the ladies in their lengthy skirts.

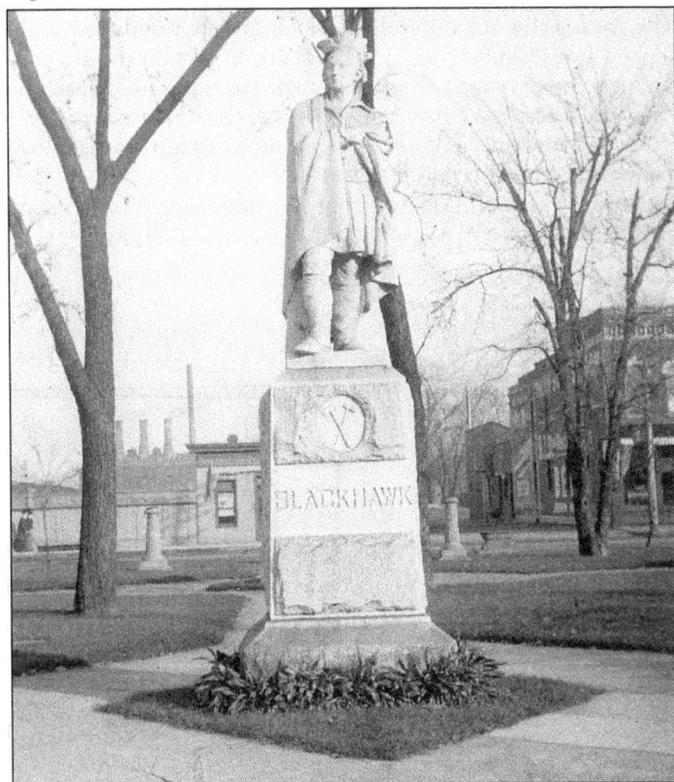

This is a 1904 photo of the famed Black Hawk statue sculpted by David Richards of Chicago. It was a gift of Otis Dimick, a Rock Islander who loved horses and built a track at Ninth Street and Eighteenth Avenue in 1876. The statue enjoyed its Spencer Square home for 66 years. It was moved to Black Hawk State Park in 1954 when the U.S. Post Office and Federal Building was built downtown.

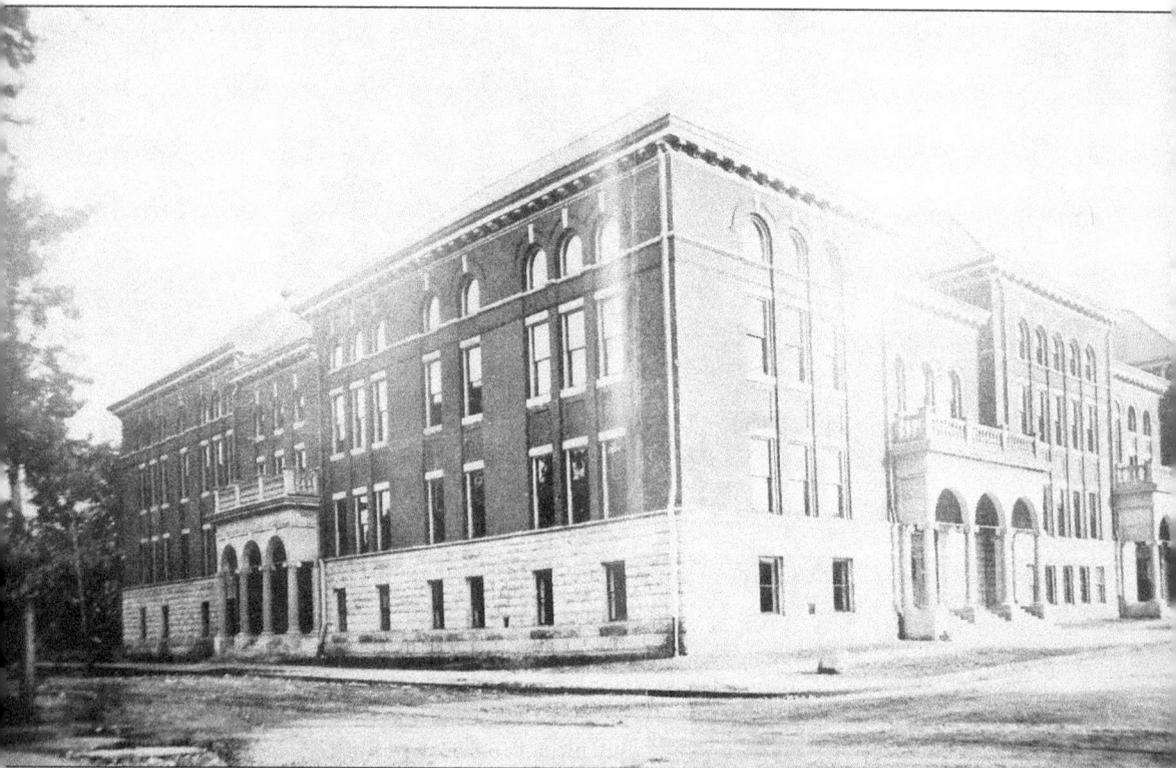

The days of the old high school building were numbered as the final days of the 19th century slipped away. On February 15, 1901, fire erupted in the chemistry lab, and flames spread swiftly through the dry-wood interior. By the time the final spark flickered out, the entire building had been destroyed. "A person could feel the heat from the building for blocks away," observed Cornelius Carson. "The fire brought an interesting collection of spectators, especially among students at the school. Most were sad, many crying. Then there were those who cheered. You could tell the good students from the troublemakers." The present high school building was dedicated in March 1937 and has had several additions.

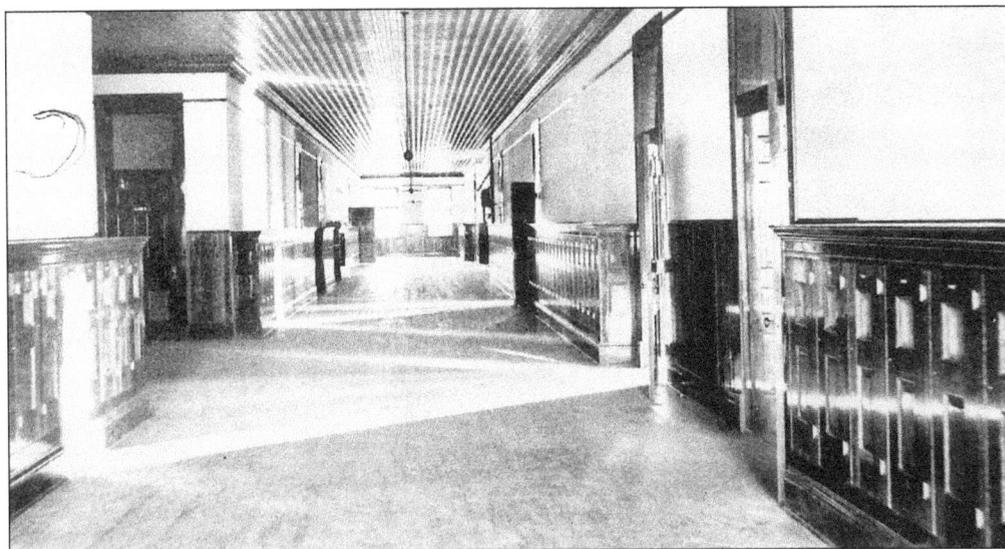

This glance down the first-floor corridor of Rock Island High School before the disastrous fire of February 15, 1901, offers some explanation of why the building burned so quickly. Virtually all materials, including the floors, walls, and ceilings were inflammable, causing the fire to spread with great speed.

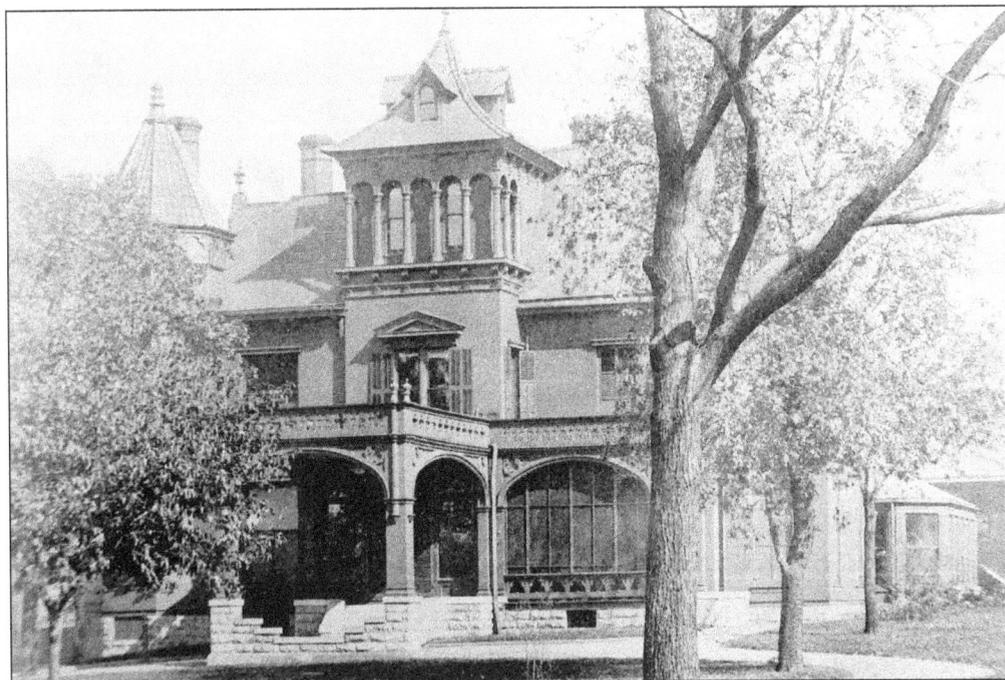

Could this be Shangrila? It's either that or the home of U.S. Congressman Ben T. Cable. The prominent Rock Islander's residence was located at Fifth Avenue and Twenty-Eighth Street and was used for entertaining any social and government dignitaries who ventured into the city. It's a grand house to behold, but there is no sign of a "Cable car." The building was razed in 1941, shortly before World War II began.

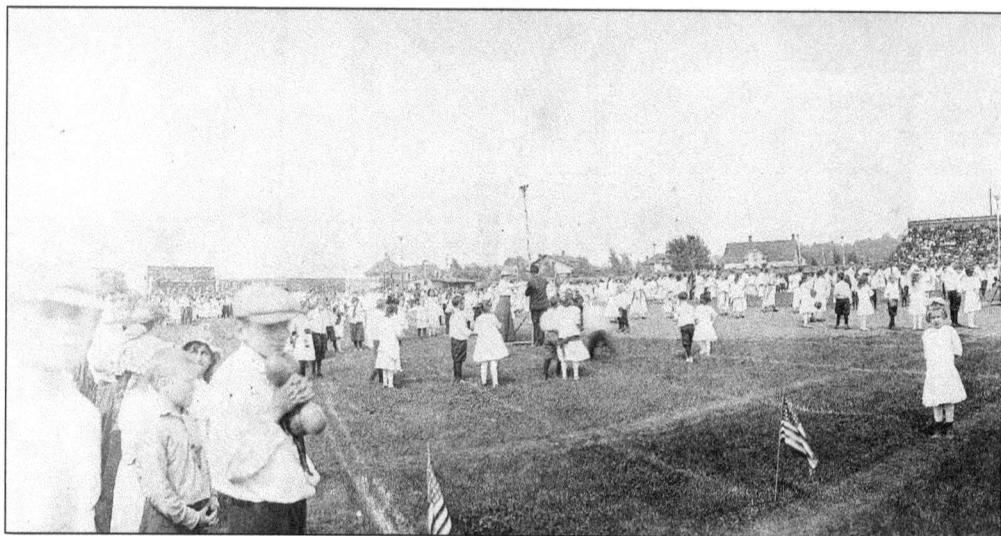

Since its official opening day in the spring of 1905, Douglas Park on Ninth Street offered fields for competitive sports events for men and women. This Sunday afternoon scene, photographed in 1908, was Kids Day. It featured games, choral singing, and a patriotic pageant. One wonders how many of these clean, white outfits went home the way they arrived.

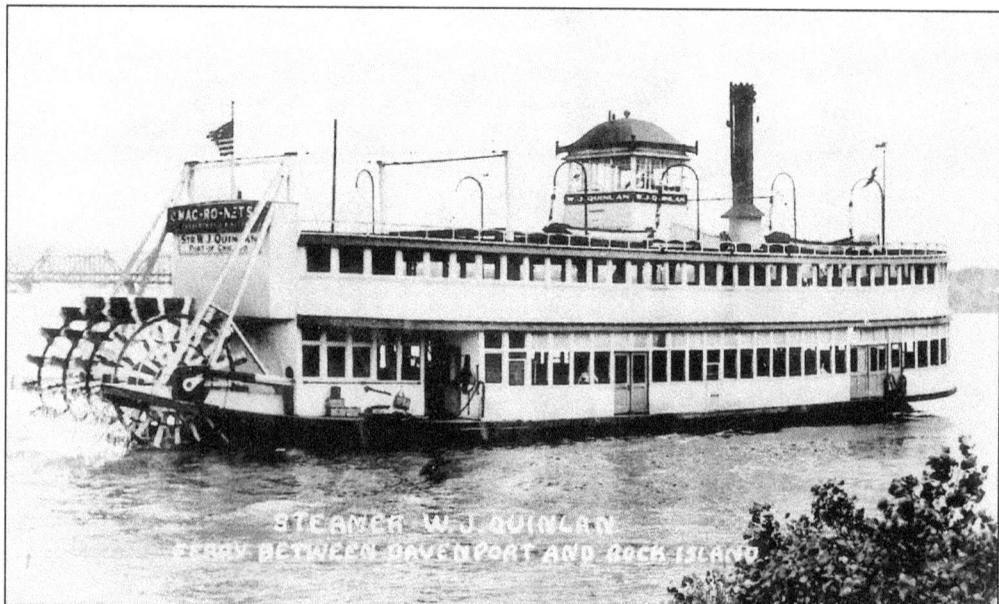

Probably the most famous landmark of the area wasn't a building or a park, but the stern wheeler, the *W.J. Quinlan*. It crossed the Mississippi between Rock Island and Davenport and was affectionately referred to as "the ferry." Boarding fee was 5¢ and passengers could ride all day for that fare if they wanted to. With the growing popularity of cars, the ferry became too expensive to operate and was replaced with a smaller boat in the late 1940s.

52

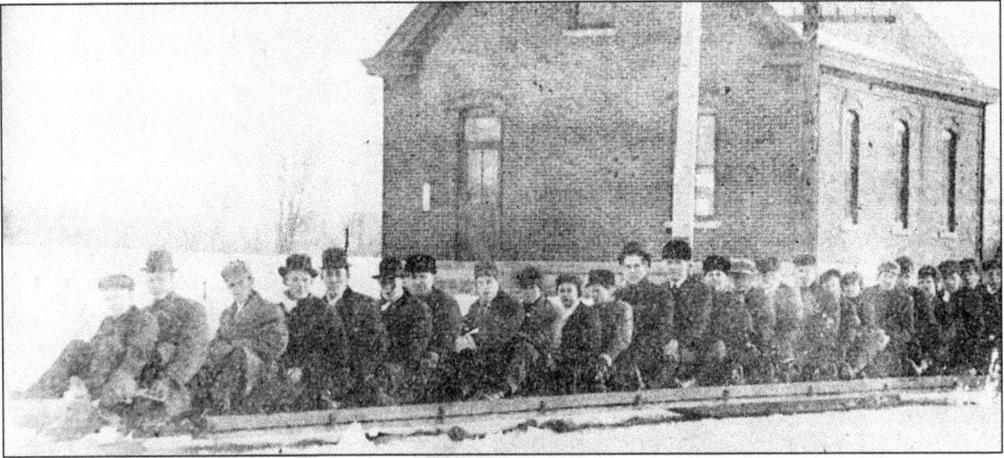

Call the *Guinness Book of Records*. This has got to be the longest bobsled in the world! Built by Walter and Fred Strayer during the winter of 1905–06, this 32-1/2-foot-long vehicle navigated down Rock Island slopes and hillsides with 25 bodies aboard. The sled weighed one ton empty, two tons loaded.

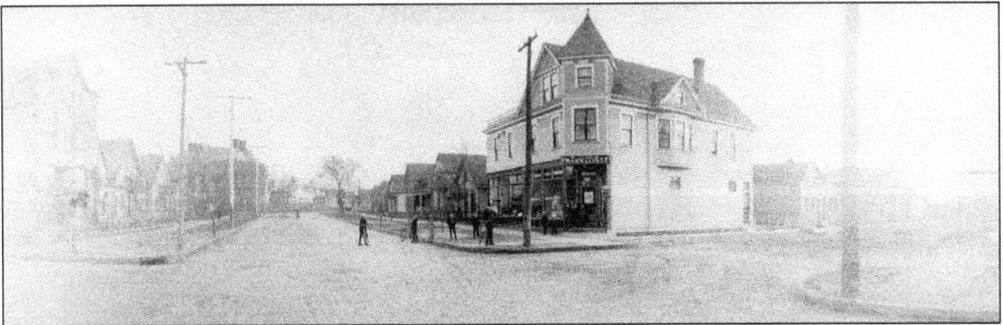

"Hey, head on down to Fluegel's Grocery and pick up a loaf of bread and a bottle of milk. Then stop at the pharmacy across the street and get some of Dr. Smith's cough syrup for Grandma." It was September 1903 when this photo was taken in west end Rock Island. Corners were popular gathering spots for youngsters, and traffic dangers were clearly not as threatening.

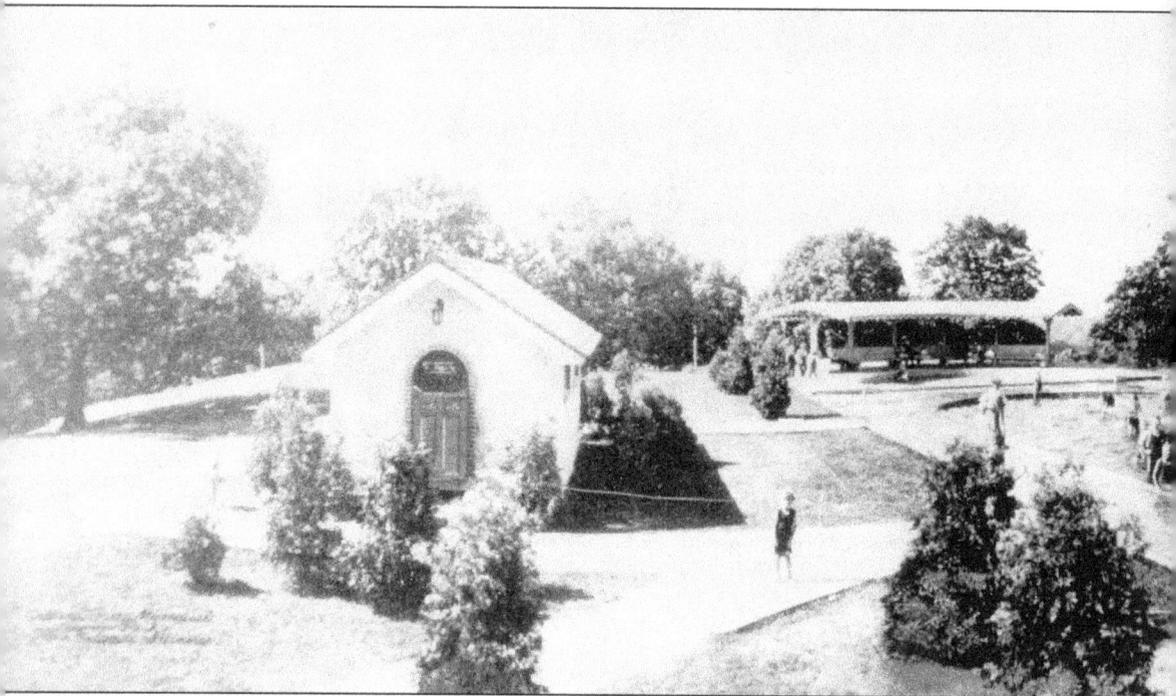

Set in the heart of Rock Island, Long View Park has been a beehive of activity since it was officially opened in 1908. The lower-level pool attracted Rock Island children every summer, who delighted in the mini-geyser as it spouted its steady stream. Admission was free and those not wanting to be "roasted like wienies" sought the shady shelter at one end of the pool. At the

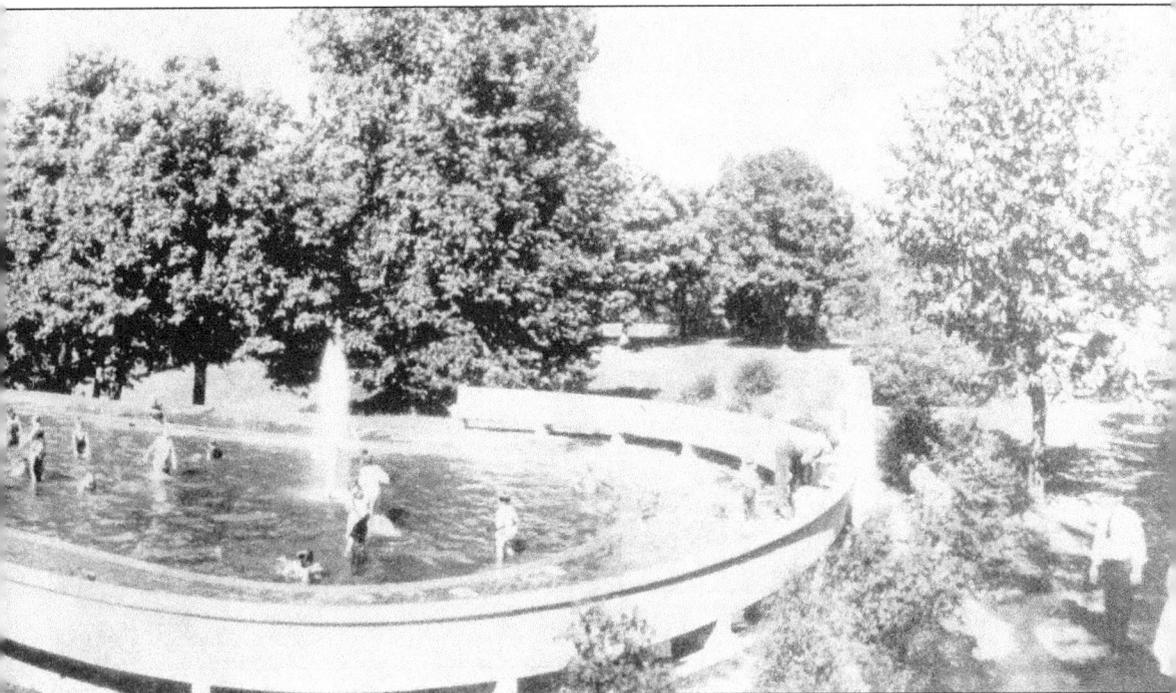

opposite end was wrap-around seating, but the rays of the sun made such visits brief. All the games played in yards and on playgrounds took on twice the fun in the water. "Run, Sheepie, Run!" and "Button, Button, Who's Got the Button?" had kids splashing and laughing, enjoying the golden days of summer that would be gone all too soon.

Rock Island's own "Jane Addams" was Susanne Denkmann, the daughter of lumber icon Frederick Denkmann. Just as Addams pioneered social services in Chicago's Hull House, Denkmann brought improved living to Rock Island's west end. Located at Fifth Street and Seventh Avenue, the West End Settlement featured a two-story building that included a children's clinic, a full-time nurse, two social workers, vegetable gardens, bathing areas, a gym, a sewing center, and a milk station.

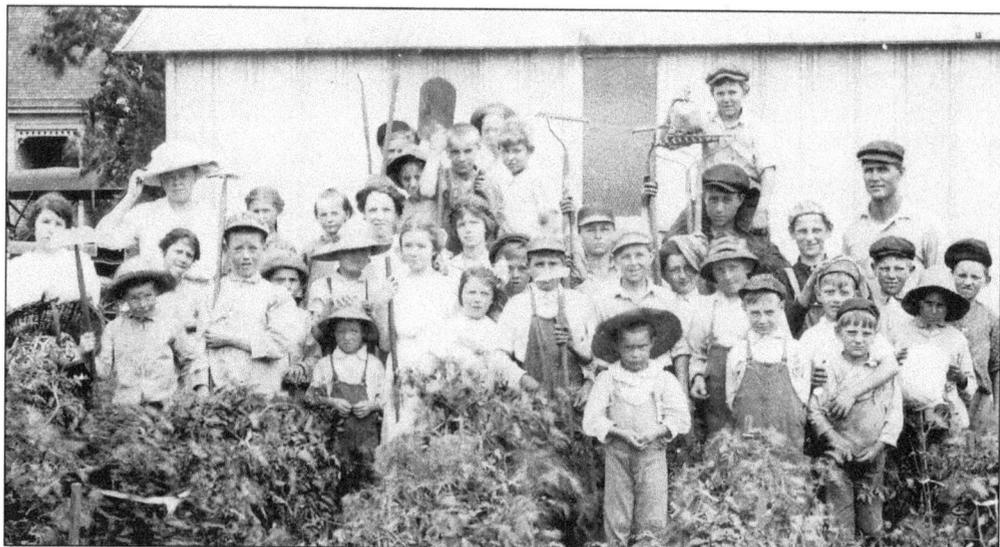

For 13 years, from 1909 to 1922, the West End Settlement offered a variety of services to people living around Fifth Street and Seventh Avenue in Rock Island. Boys and girls fought over the tools used to raise vegetables in the large, outdoor garden, and the benefactor of the project, Susanne Denkmann, enjoyed visiting the thriving enterprise to see firsthand what the junior greenthumbs were growing.

Franz Jackson, born November 1, 1912, in Rock Island, was three years old when his father died and his mother began supporting the family with her earnings from dress making. When the family moved to Chicago, Franz began playing clarinet and saxophone. He later attended the Chicago Musical College and became proficient on both instruments. Through the years, he played with jazz greats such as Roy Edlridge, Fats Waller, Cootie Williams, Fletcher Henderson, and Earl "Fatha" Hines, to name a few. Today an established composer, arranger, and jazz legend, Franz currently leads his own group in a Chicago Jazz Club.

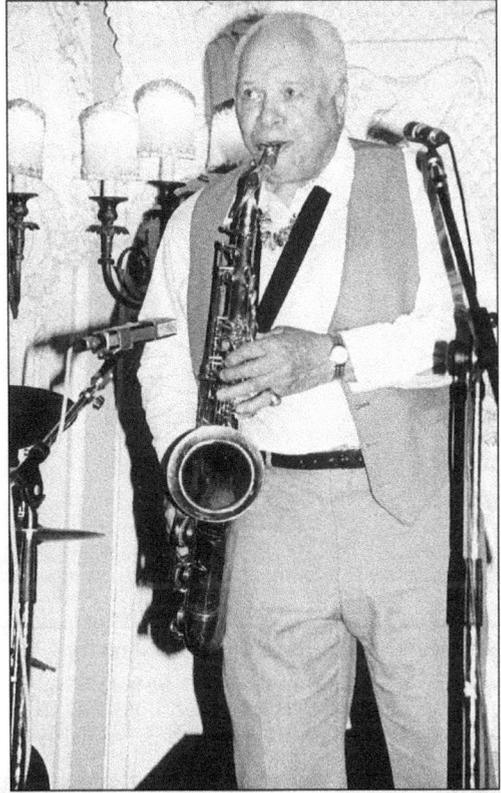

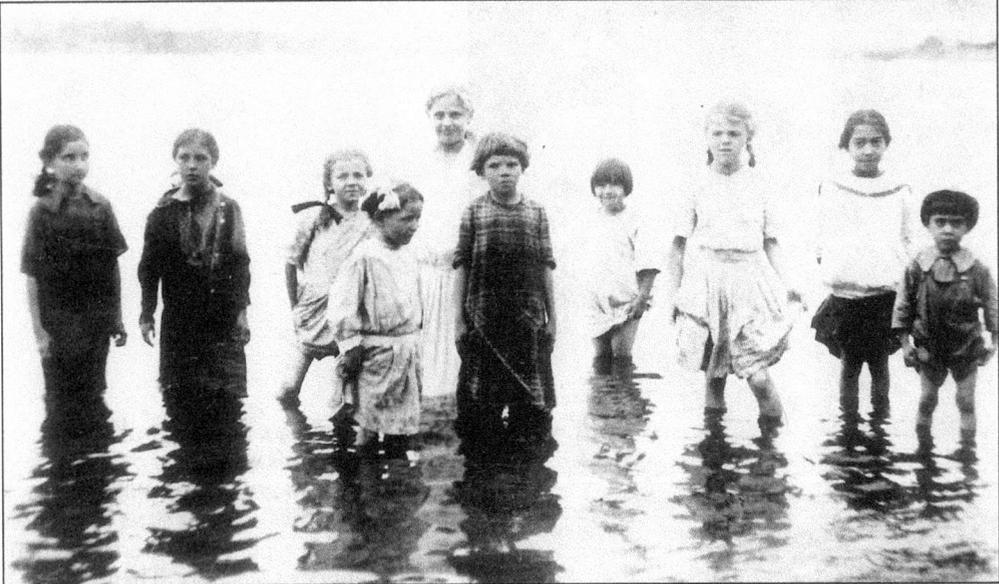

While Pres. Woodrow Wilson fought to keep America out of war, this bevy of Rock Island youngsters begged to "Let us get into the water!" On September 1, 1914, the public bathing beach opened on Ninth Street much to the delight of the nine girls and one boy pictured. The bathing attire appears extremely modest, leading one to wonder if the celebrants christened the new fun spot in whatever they were wearing.

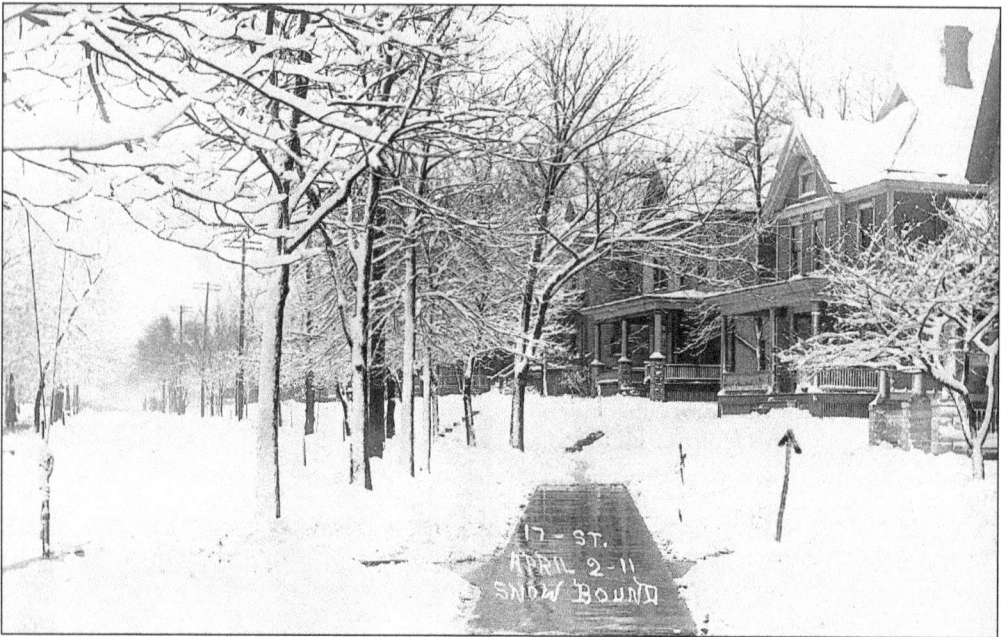

And you thought the snowfall of January 1999 was a real barnburner! In April 1911, everyone thought Old Man Winter was long gone. The month of March had already hinted of spring, and the snow shovels had been put away in garages and basements. This April 2, 1911 photo captures a scene of Seventeenth Street with the residents in hibernation.

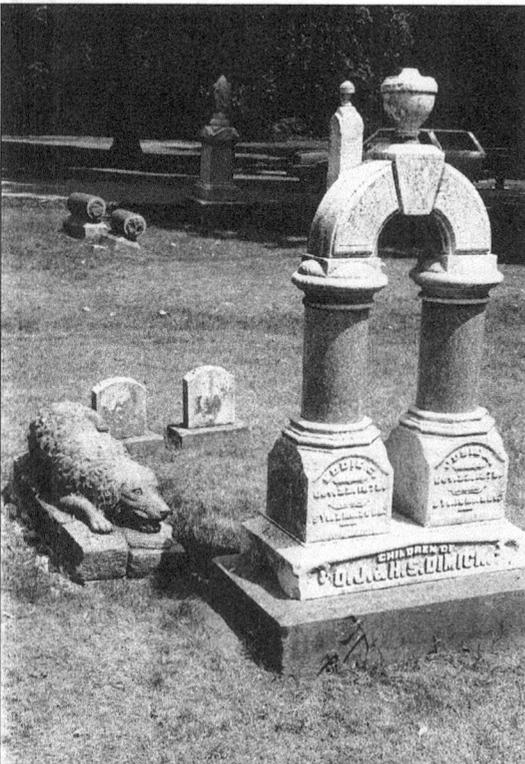

Generations ago, typhoid, influenza, and tuberculosis were killer diseases, especially among children. Eddie Dimick, age five, and his sister Josie, age three, died of typhoid and were buried in Chippiannock Cemetery. Their parents and family dog made daily visits to the gravesite. When the faithful dog passed away, it seemed only appropriate to place him close to the little friends he loved so well.

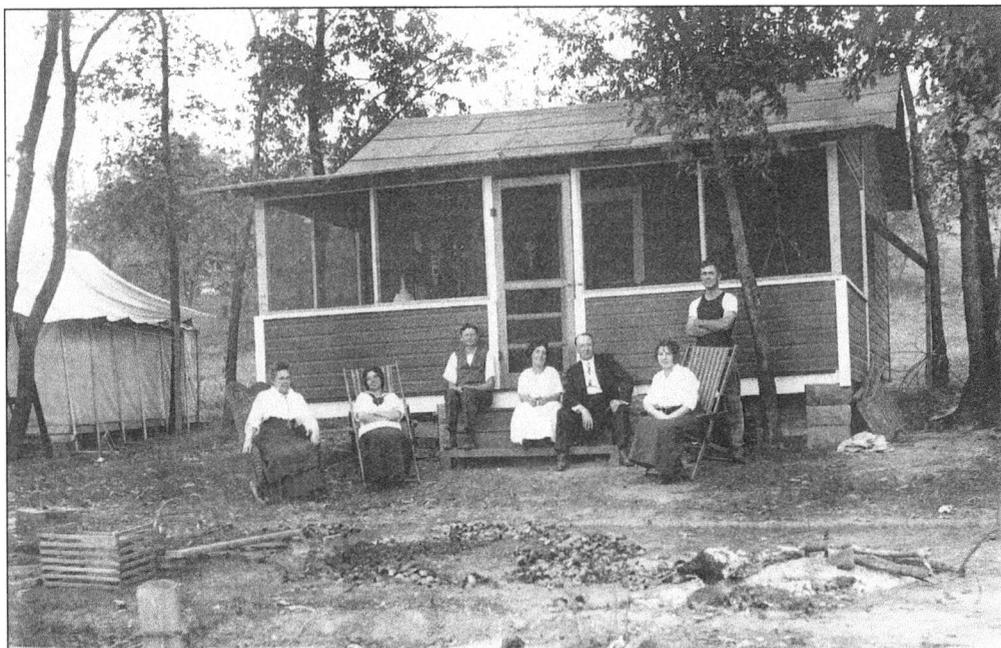

Remember the days when Sunday meant going to church in the morning and visiting the relatives in the afternoon? That weekend ritual passed from the days of the horse and buggy right into the age of "gas guzzlin" machines. This particular photo (possibly a Vize family gathering) comes from the John Vize Collection. The scene was photographed at the bottom of Rock Island's Seventeenth Street and Rock River.

" . . . and I hope you will also notice the unusual land formations on the hillside . . ." The leader of this expedition along 24th Street in Rock Island is Dr. Fritiof Fryxell, who brought much life and spirit to the Black Hawk Hiking Club. While at Augustana College, Fryxell developed one class of geology into a departmental major. "If one lives on soil," Fryxell would say, "one should understand its composition."

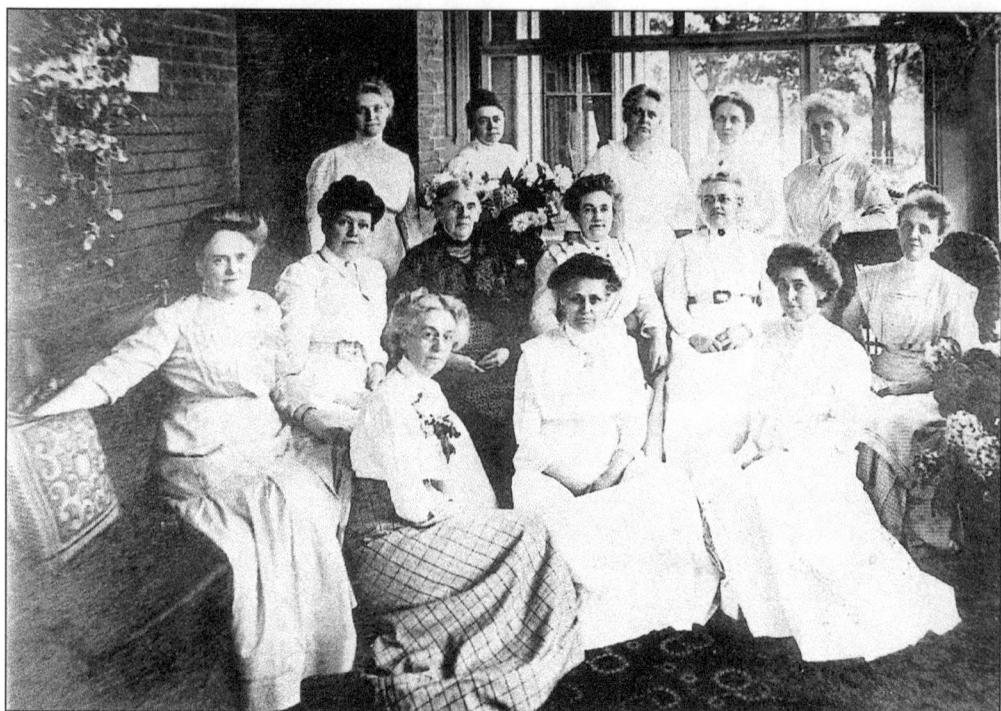

Many of the city's early "movers and shakers" belonged to the Rock Island Women's Club, which was formed in 1913. Members, shown here from left to right, included the following: (front row) Frances Cutter Boynton, Apollonia Denkmann Davis, and Mrs. Fred C. Denkmann; (middle row) Carrie Greff, Annette Guyer, Mrs. Kimball, Mrs. Mary Davis, Mrs. Charles Wells, and Sara Whitman; (back row) Apollonia Weyerhauser Davis, Susanne Denkmann, Mrs. W.H. Marshall, M. Davis, and Mary Bailey.

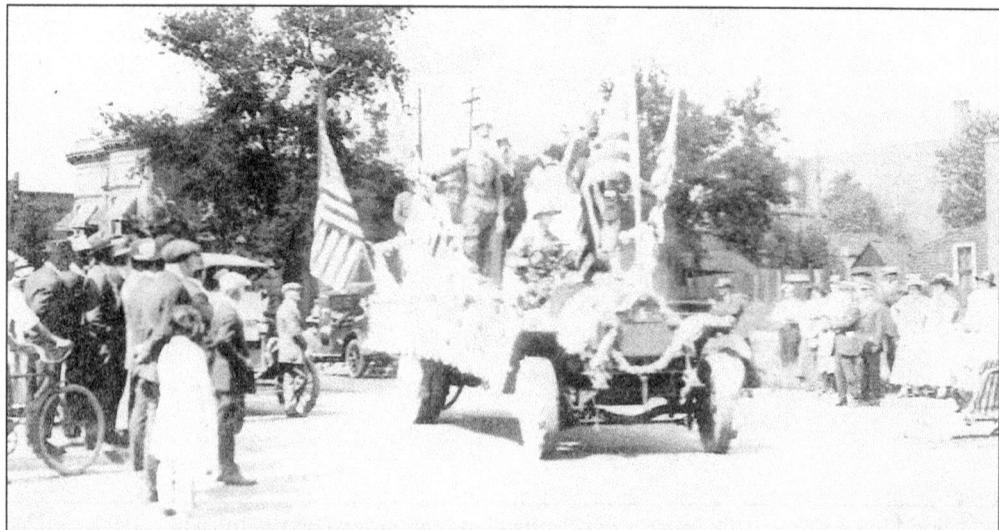

Far from the sounds of World War I fighting, thousands of Rock Islanders lined the streets downtown for a Fourth of July parade in 1917. There were flags everywhere, hanging from cars and poles and in the hands of men, women, and children. An armistice was signed the following year.

60

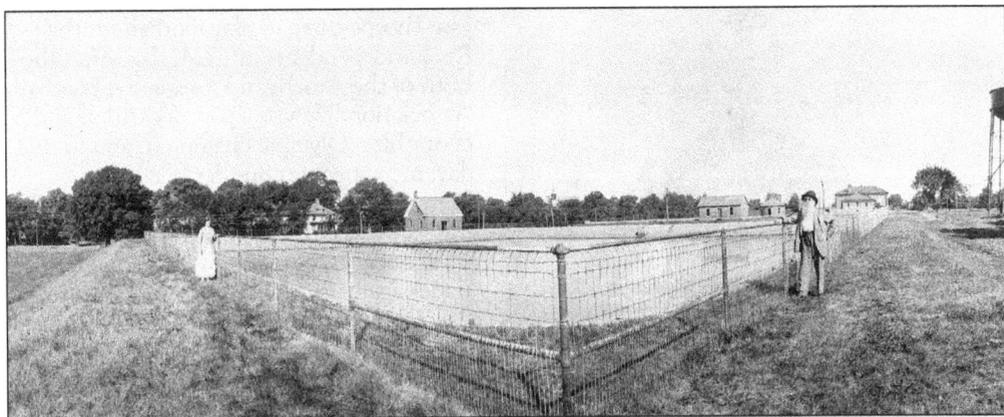

Is this a picture of a shy couple courting? Nope. This was the open reservoir of the Rock Island Waterworks looking northwest from 18th Avenue and east of 22nd Street in 1915. The low fence did little to keep out teenagers determined to enjoy midnight swimming. Thankfully, there were no skinny-dippers caught in those days!

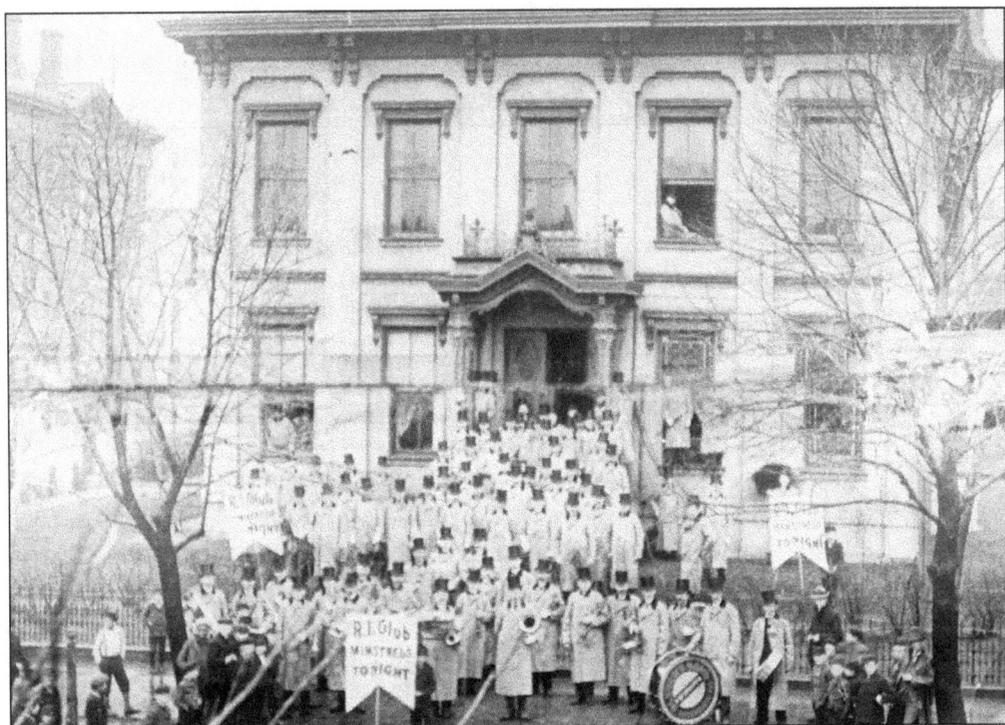

This building has served as the home of Judge Lynde, the meeting place for the Rock Island Club, and as the original Royal Neighbors of America Headquarters. It was razed in 1927, when the Royal Neighbors Supreme Office opened at 230 Sixteenth Street.

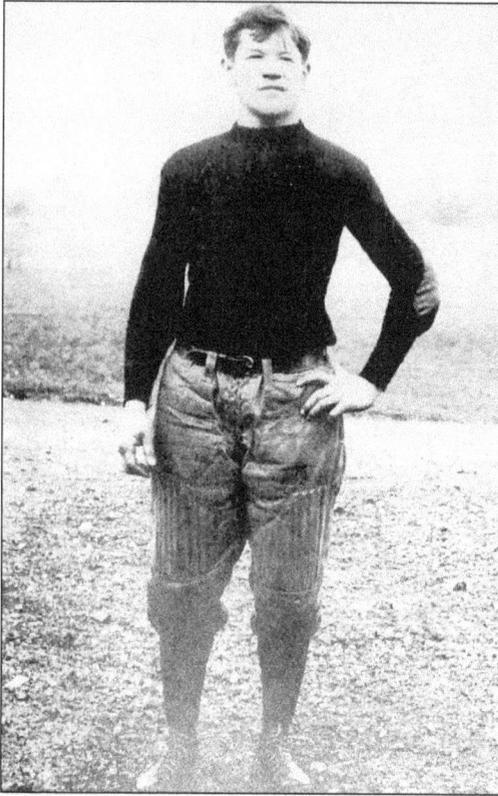

Jim Thorpe came to play football for the Rock Independents in 1924, soon after the birth of the American Professional Football Association. He was a past decathlon and pentathlon Olympic champion, and to this day, many people consider him to have been the world's greatest athlete. Thorpe was 40 years old when he played for the Independents, but he proved the team leader against such teams as the Chicago Bears and the Green Bay Packers.

Remember the old telephone poles that carried countless wires and the white, globed street lights? The downtown area was dotted with call-in fireboxes like this one on the corner. Shown here is the Rock Island Bank and McCabe's (with awnings). This was clearly a lazy day in downtown Rock Island.

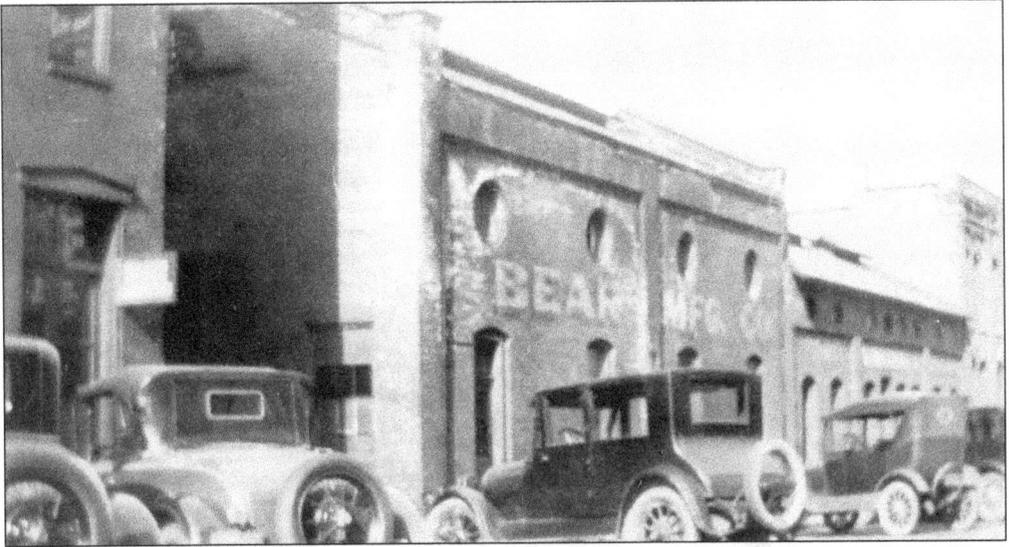

It was a quiet time in the nation with Pres. Woodrow Wilson in the White House and Americans settling into a post World War I routine in 1920. Machinery was rolling inside the walls of Bear Manufacturing Company, with former soldiers having been added to the employee lists. Notice the absence of parking meters.

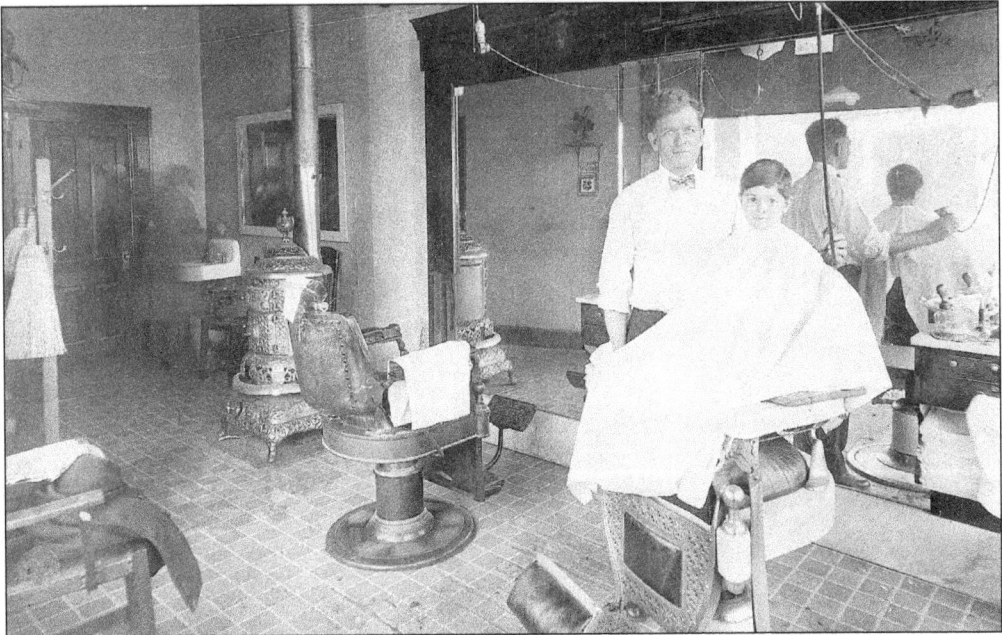

This early barbershop shows the reflection of the Central Oil building in the mirror. The barber was using electric clippers, but the heat still came from a coal stove that warmed many patrons on blustery winter days.

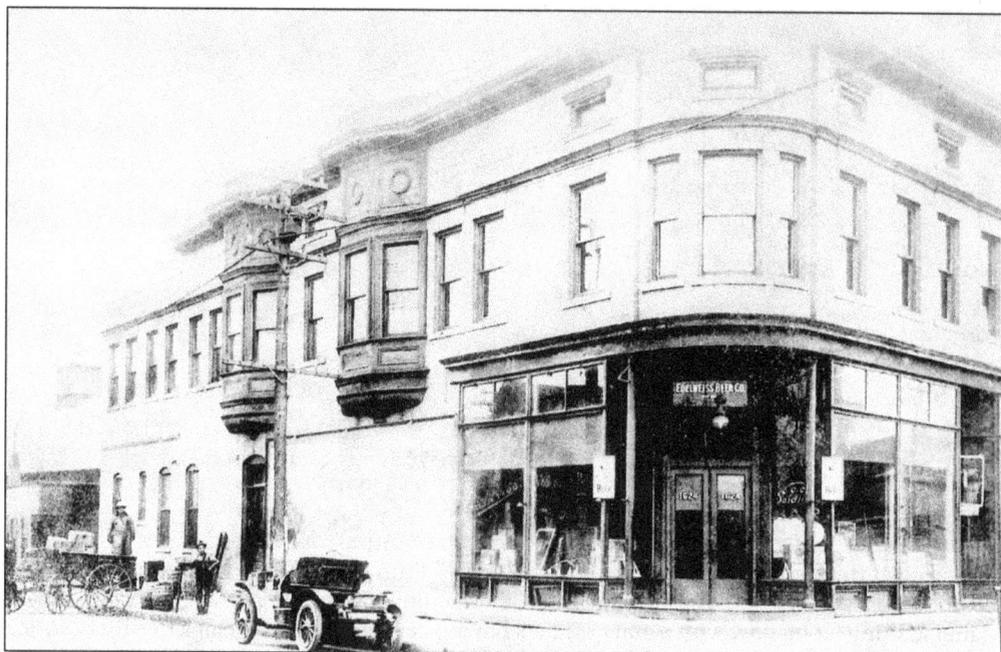

Atlantic Brewing Company, Huber's Brewing Company, the Rock Island Brewing Company, and here, the Edelweiss Beer Company, proved the foam in Rock Island was not entirely from the waves of the Mississippi. Well into the 20th century, this river city claimed its abundance of beer barons by producing a variety of brands. Lily Beer, a "near beer" named after the daughter of Rock Island brewery icon Ignatz Huber, proved a big seller during Prohibition.

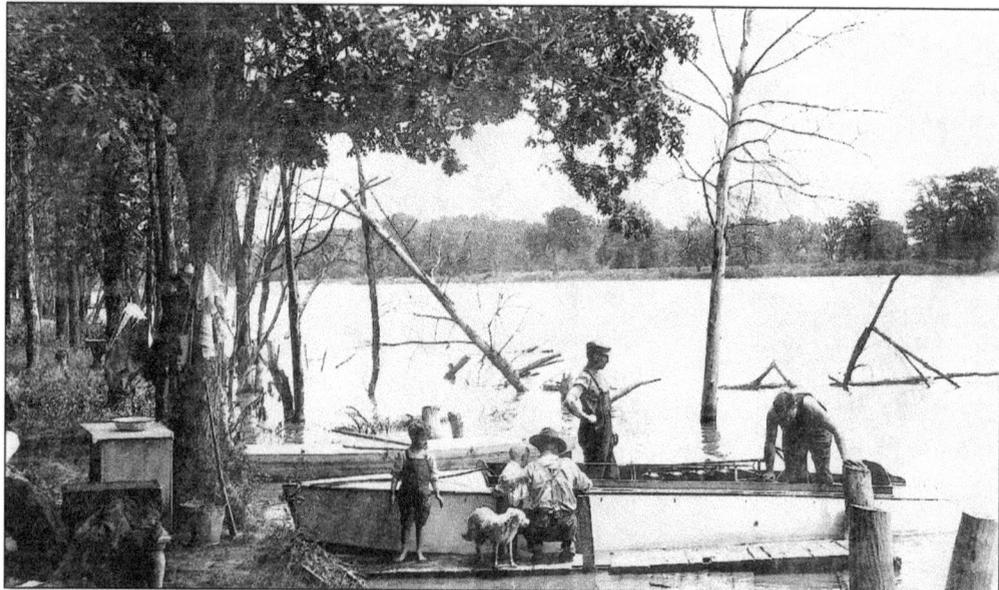

Whether the fishing and hunting is good or not, you have to keep your gear in top condition as the elders show their "young'ns." "Take care of the boat first and then we'll get some supper" is the order of things. Note the rifle leaning against the tree in this scene at the foot of Seventeenth Street on the Rock River. Fido seems to be making "doggone" sure the work gets done and his feet do not get wet.

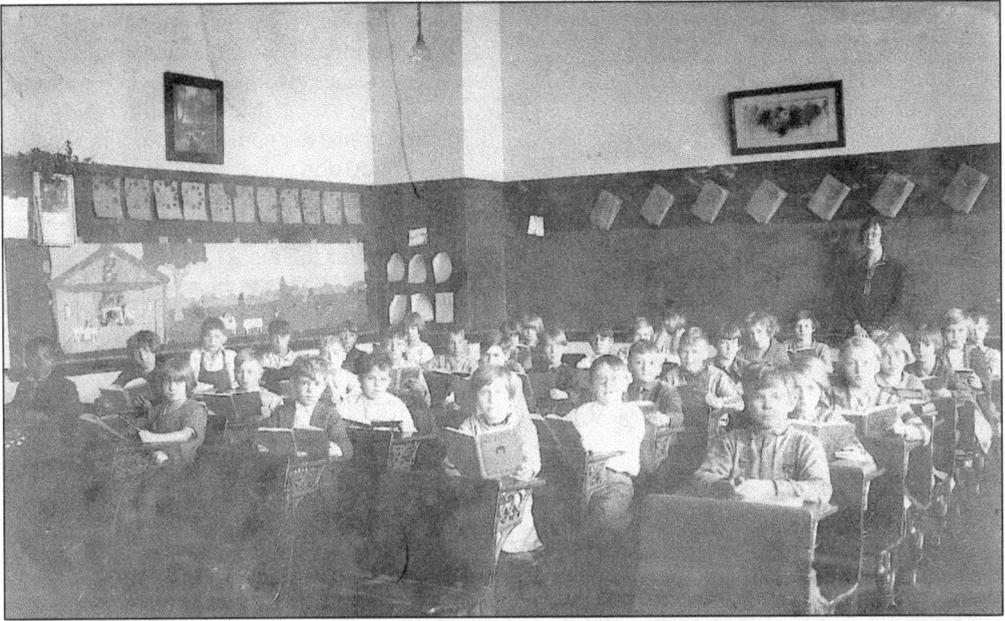

These fourth graders at Grant School in 1928 found little interest in posing for a photographer. After all, they were into a good story and did not want to be interrupted. Classroom sizes numbered between 30 and 35 in those days, with discipline left "to the teacher's discretion."

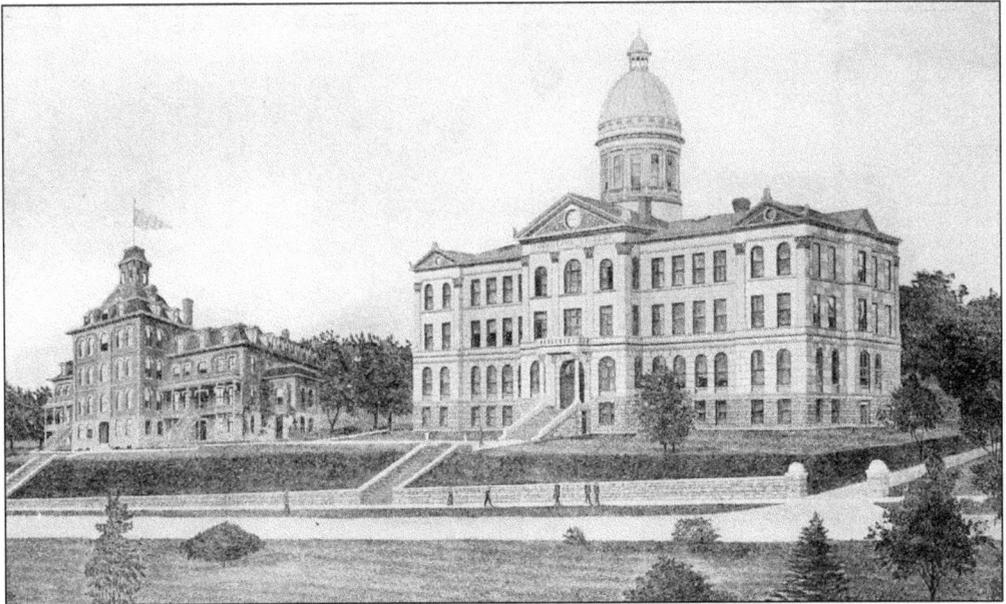

As the country suffered the pangs of an economic depression in the early 1930s, Augustana College struggled to maintain the reputation of being an outstanding liberal arts institution. This 1931 flyer provided an overview of the school's offerings in menu-like form, including a notation of "Inquirees Cheerfully Answered."

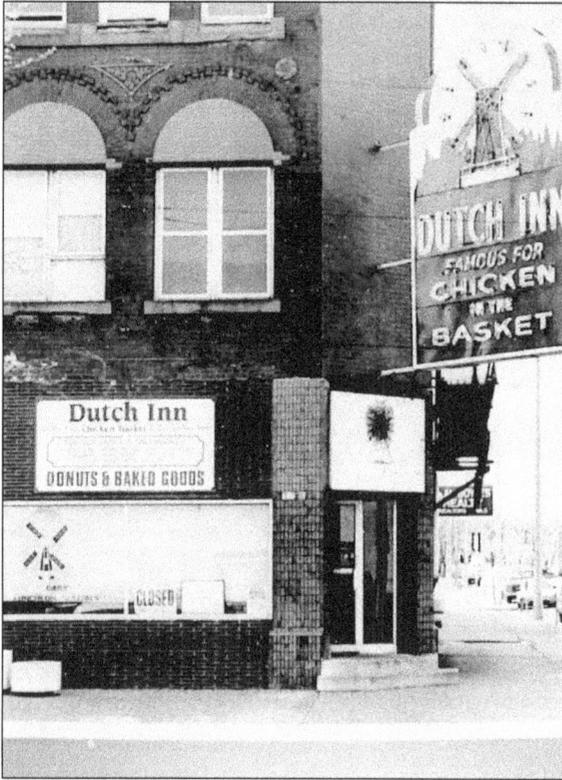

The Dutch Inn was one of many favorite hangouts downtown, whether one desired chicken-in-the-basket specialties or simply some stimulating conversation. The Toasty Shop down the street and around the corner offered some competition, especially since it stayed opened around the clock. Across the street was Todd's, a popular hangout for lawyers and business folks. Remember the Best Ever Cafe, with Jim Valley's personal opinions on people and events posted in the upstairs windows?

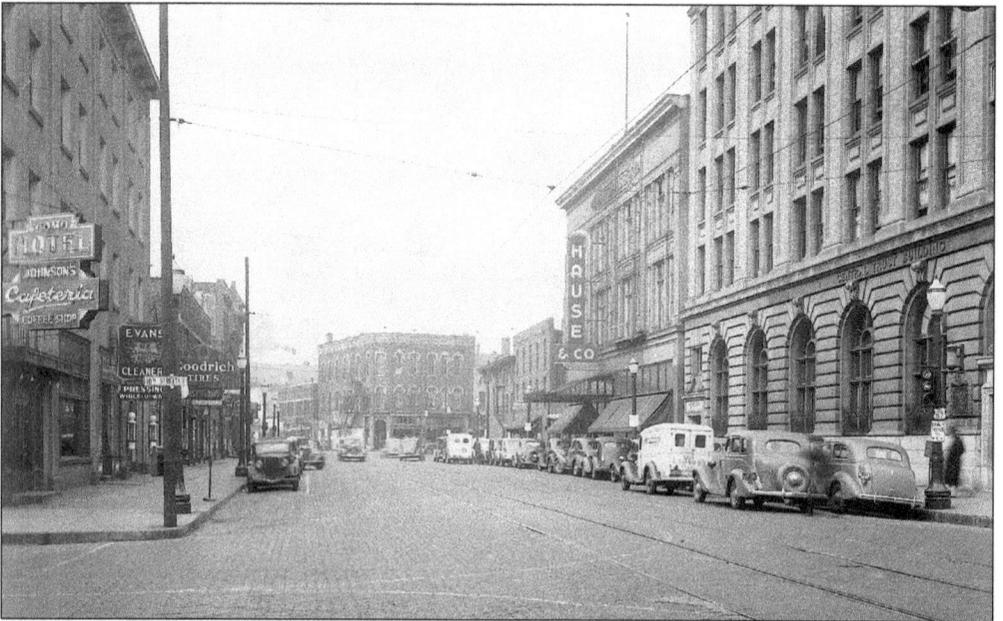

The year was 1936, and the people of Rock Island—like millions of other Americans—were climbing out of the throes of the Depression. The Como Hotel advertised "Rooms for Kings, Queens, and You!" while Evans Cleaners promised "Pressing While U Wait." It's amazing how uncluttered downtown areas can appear without parking meters and traffic lights.

Rock Islander Maurine Englin knew the Prince of Wales (not Charles but the one who gave up the British throne in 1936), Rudolph Valentino, Ronald Reagan (she claimed the former President named his oldest daughter after her), Bob Hope, and many other celebrities. A a trouper of the first order, she was a vaudevillian who introduced songs and told stories. In later life, she was a versatile commercial writer.

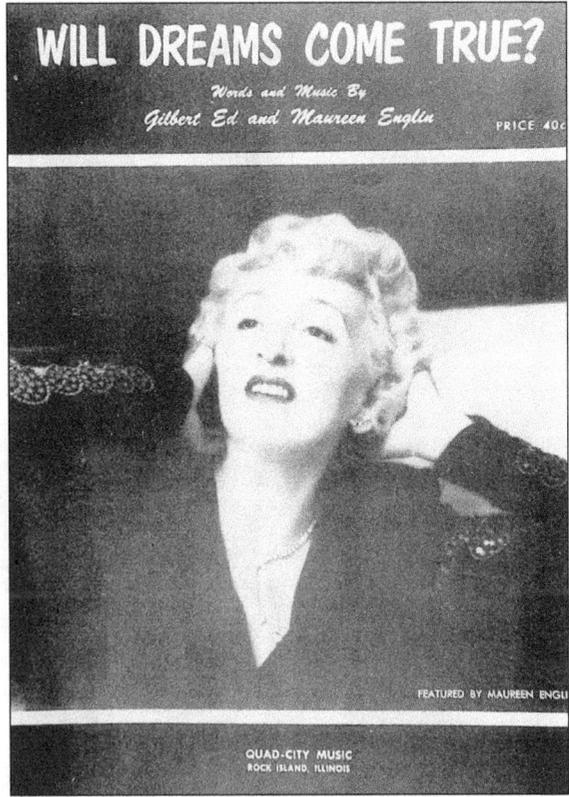

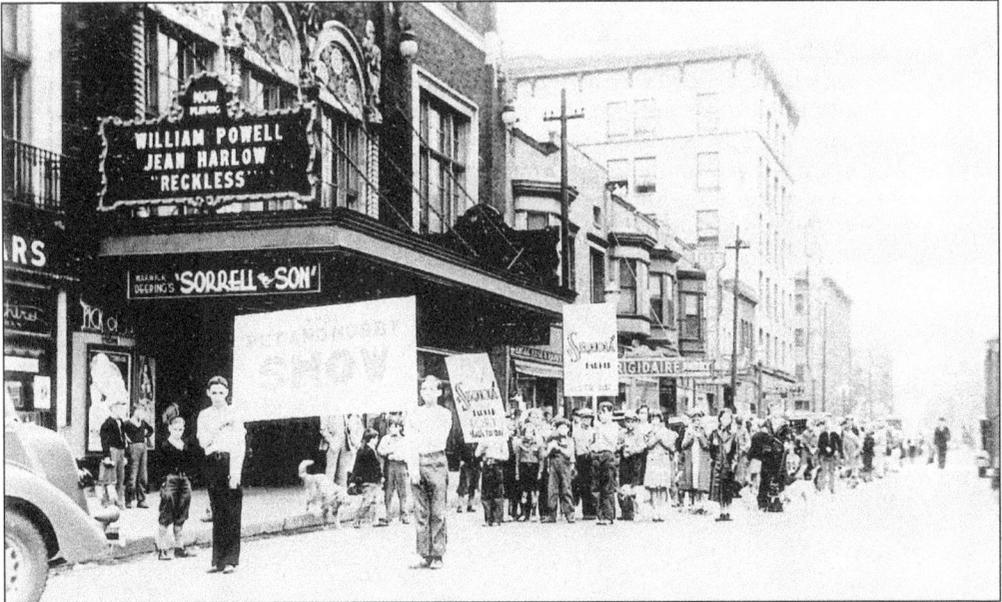

"Hurry up, Rover!" "Stay in step, Fido!" "No, not right in the public street, Spot!" Downtown Rock Island has been the scene of many parades in its history, this one being the YMCA Pet and Hobby Show Parade in the mid-1930s. The gathering is stopped at 3rd Avenue beside The Fort Theatre and Hickey Brothers Cigar Store.

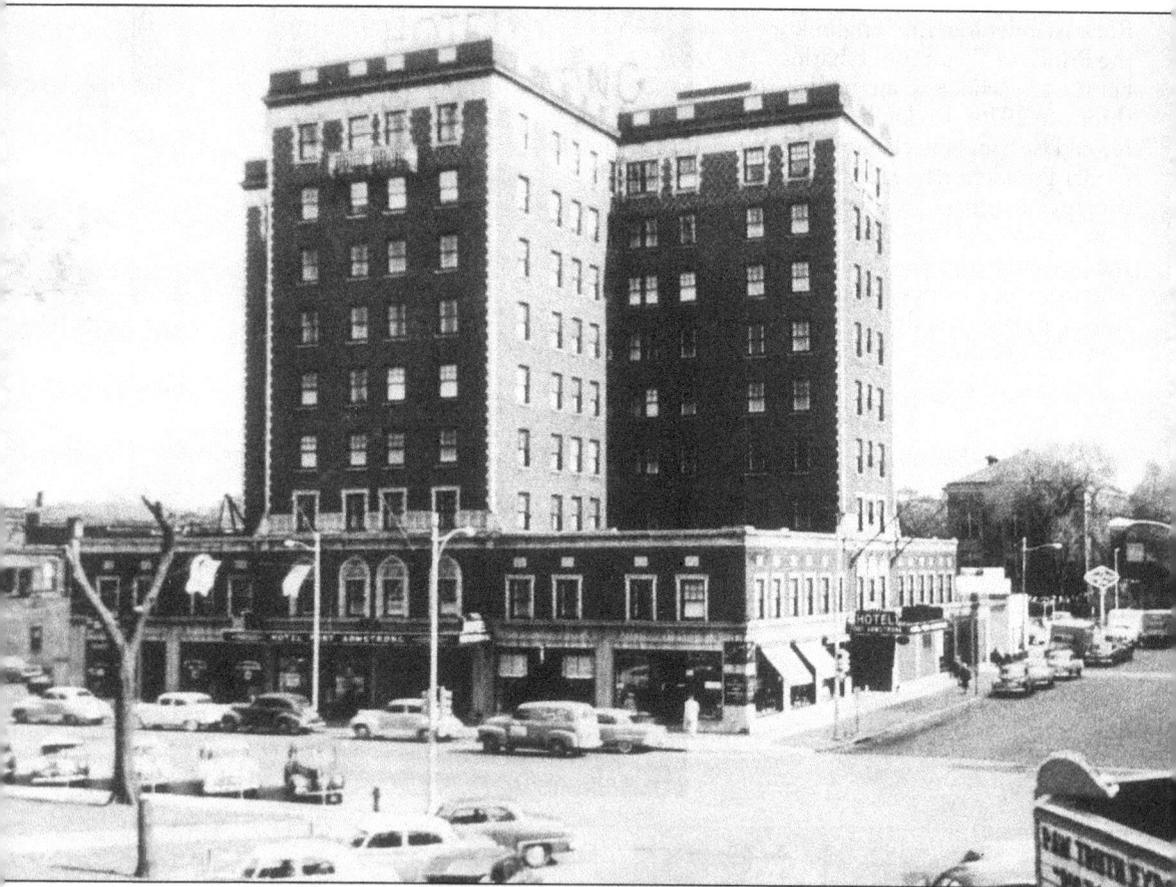

In the 1940s, Rock Island bustled with activity. Dollar Days attracted shoppers, and Bank Nights featured a chance to pick up surprise cash awards at area theatres. Bridge Line buses ran every half hour, carting "worldly" shoppers to Davenport. The Fort Armstrong and Como Hotels competed for overnight guests, the latter gaining extra notoriety when ex-gangland leader John Looney's son Conner was shot while leaving the building. About the same time, John Atanassoff, a professor from Iowa State University, sat in a bar thinking about the binary system and its application to computers. Atanassoff went on to develop the world's first digital computer.

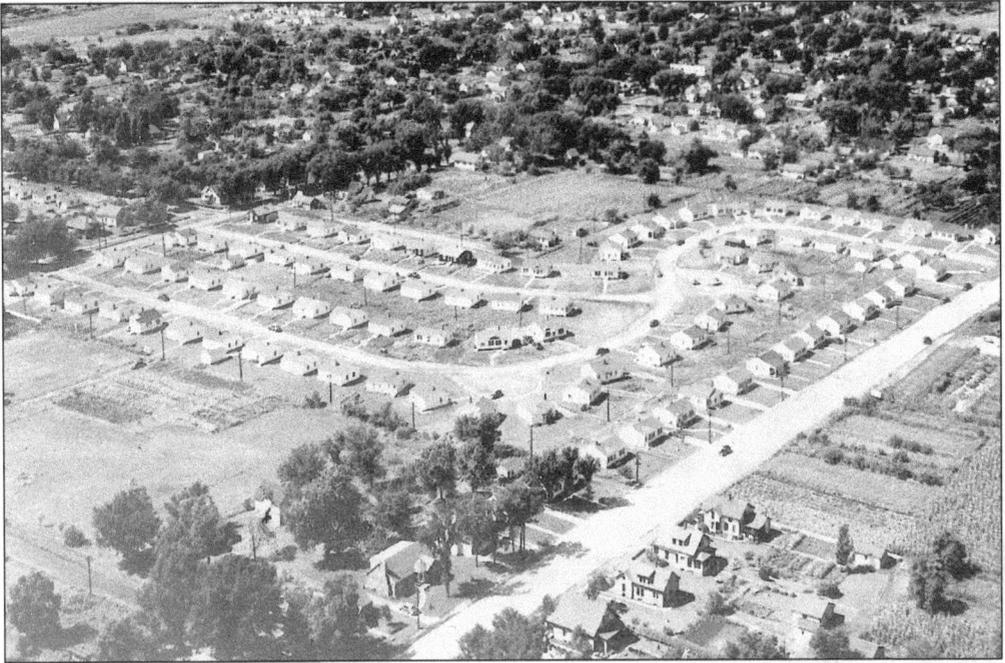

Before there was a Watch Tower Plaza or an Eleventh Street business area, this 1941 view looking Northwest along Eleventh Street shows how much the west end of Rock Island grew dramatically after World War II. Note how few of these new homes have garages or driveways. The day of the motor car had not yet arrived.

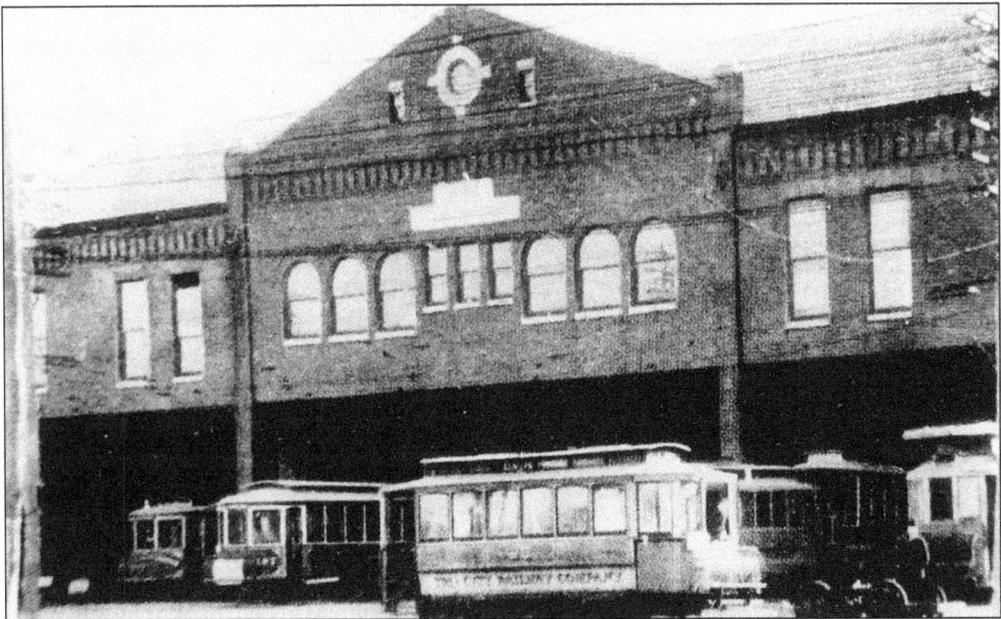

A barn in the city? Yup, that's exactly what it was called. Rock Island provided "room and board" to these handsome vehicles back in the Tri-Cities days, and the structure was known as the Tri-City Railway Company Car Barn. (No cows allowed!)

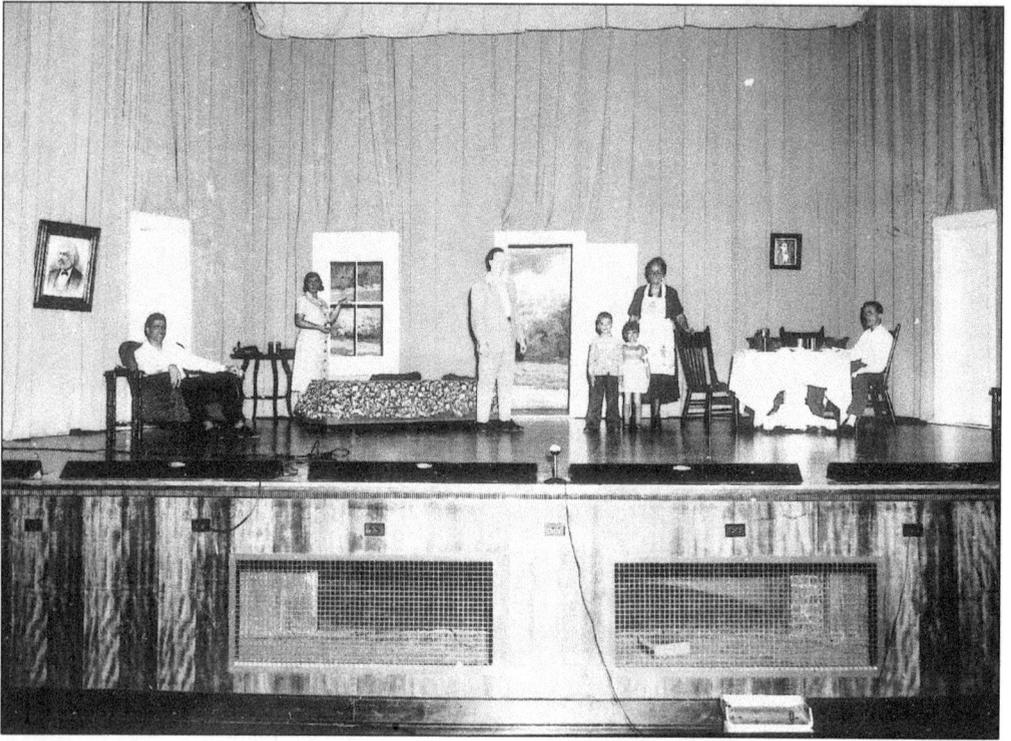

It might not be Broadway geographically, but during the 1940s and 1950s, the Rock Island High School auditorium provided area amateur thespians a chance to display their talents in front of grateful theatre-goers. Church and civic organizations brought one-act plays to the Marshall Dramatics Contest, culminating in the public announcement of winning groups on the final night of the competition.

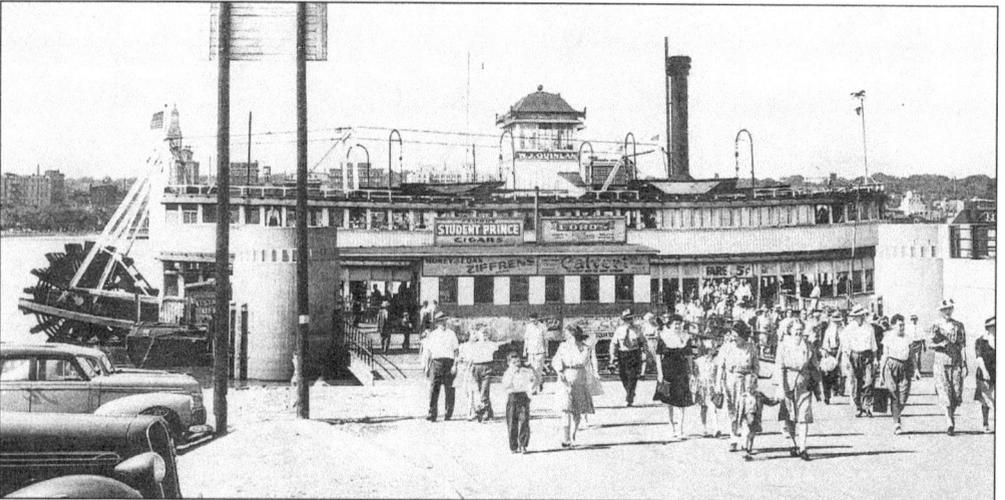

The year 1945 was one of rejoicing as World War II came to an end, bringing American servicemen and women home to Rock Island. There was a sadness about the year as well, with the *W.J. Quinlan* making her final cruises on the mighty Mississippi. "She was a grand old lady," noted Rock Islander Tom Johnson. "There's something about a boat like the *Quinlan*. When she stops sailing, it's like a death in the family."

To national radio and television audiences of the 1940s and 1950s, he was George "Kingfish" Stevens, but to those who knew him in Rock Island, he was Harry R. "Tim" Moore. As the conniving, blustering "Kingfish" on the *Amos and Andy Show*, he became a multimedia star. Another Rock Islander, Charlie Correll, portrayed "Andy." Correll was a former bricklayer in the city.

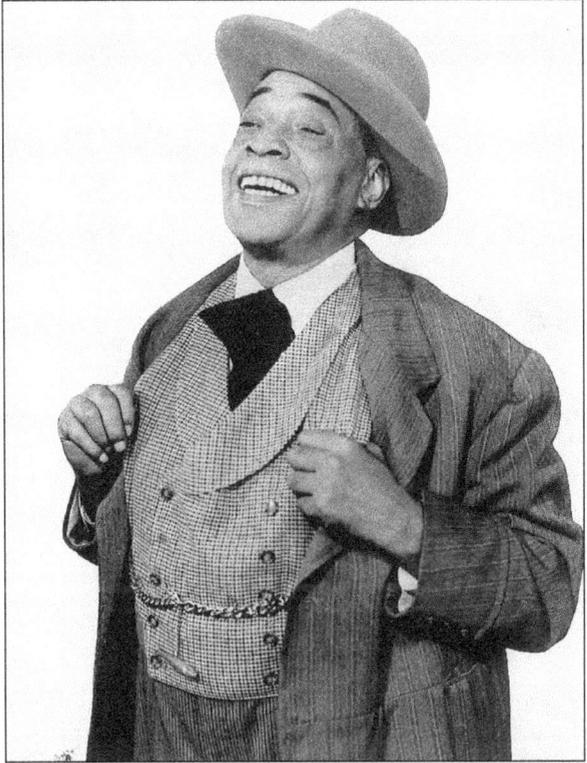

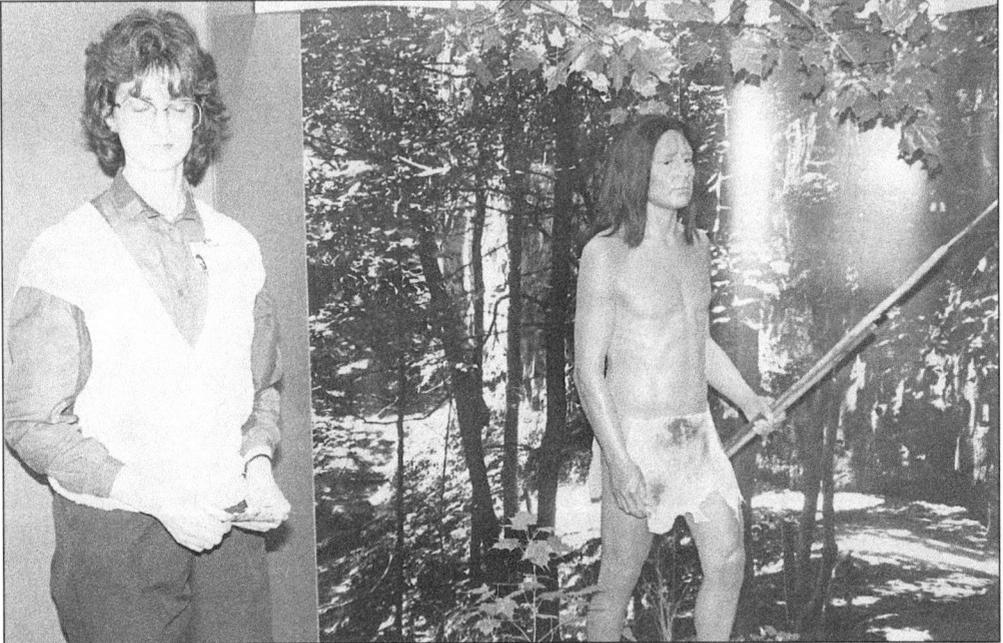

Few people in the Mississippi Valley community know more about area history than Beth Carvey-Stewart, who can usually be found at the John Hauberg Museum in Black Hawk State Park. The past comes alive in onsite displays like this Sawk/Fox brave roaming a rugged woodland trail.

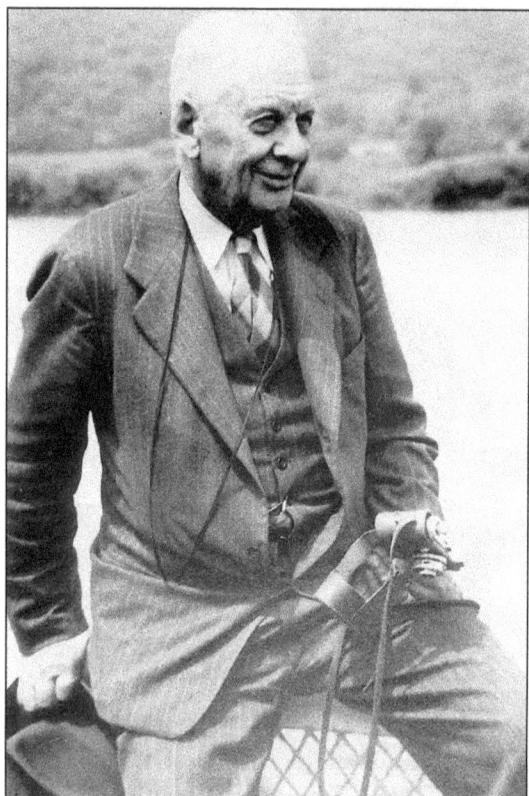

Historian, photographer, executive, writer, and humanitarian John Hauberg could rightly bear the title of "Mr. Rock Island." Born in 1869, Hauberg helped to build the city. A leader of numerous businesses, he constantly recorded local people and events in picture and in print. In 1943, his family helped build the present YWCA in memory of his wife, Susan. His home became a civic center after his death in 1955.

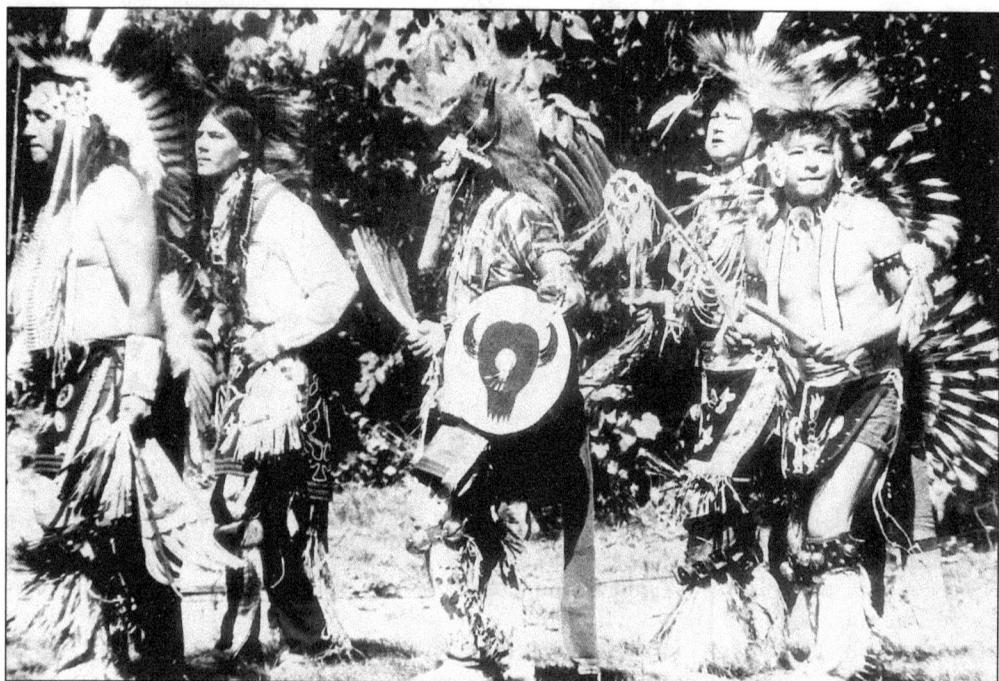

Mel McKay was his name, and many Rock Islanders thought the alliterative wording fit the man just fine. Whatever his name, Mel McKay was one of the most popular mayors ever elected. He poked fun at himself, encouraging visiting hometown girl and film star June Haver "to plant a lipsticked smooch on my bald head" when she visited in 1947. He was serious about city business, however, and sought improvements at every turn. Today, he has a swimming pool named for him as well as city awards and scholarships.

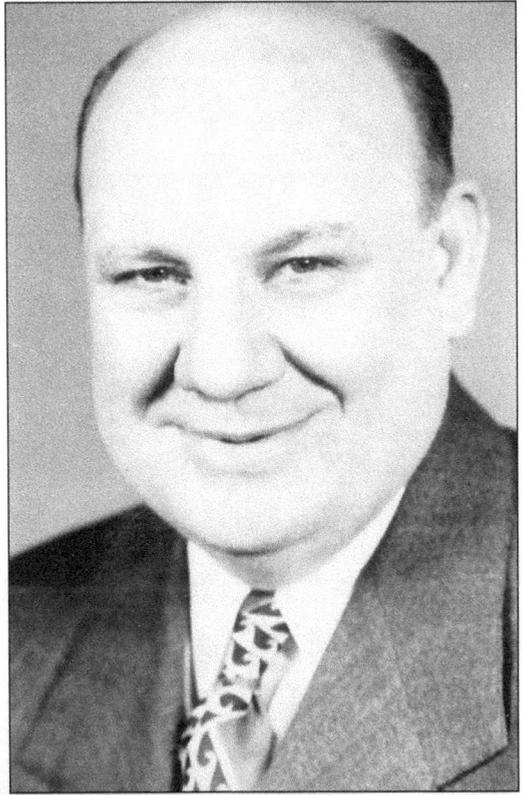

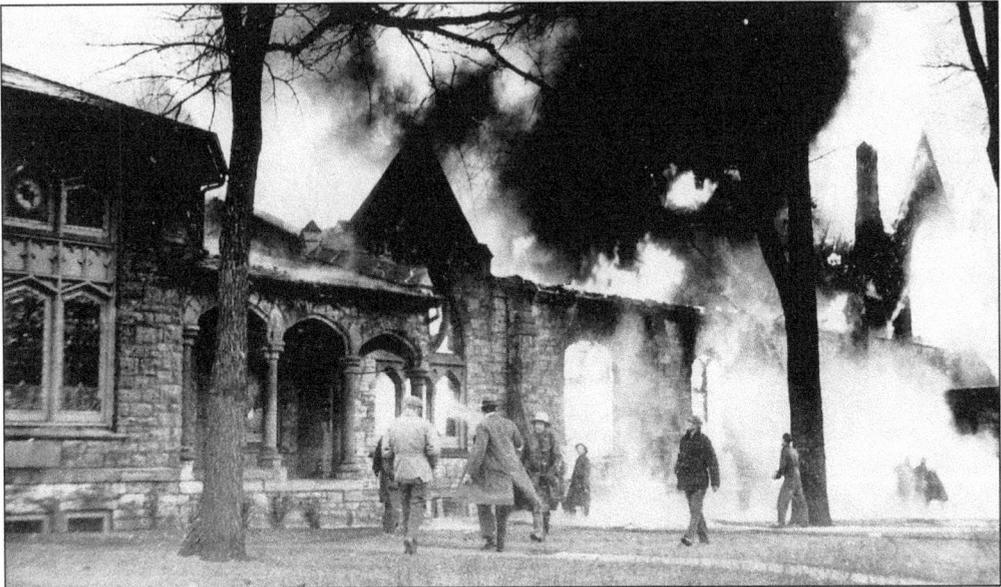

It was early morning in the late 1940s. Working people headed off to work and kids went to school. Suddenly, Broadway Presbyterian Church on Seventh Avenue and Twenty-third Street became a blazing inferno. Rock Island police and fire departments displayed first-class teamwork in keeping people safe while fighting the fire. Despite the valiant efforts of many, only a spiritual shell remained of what once was a beautiful place to worship.

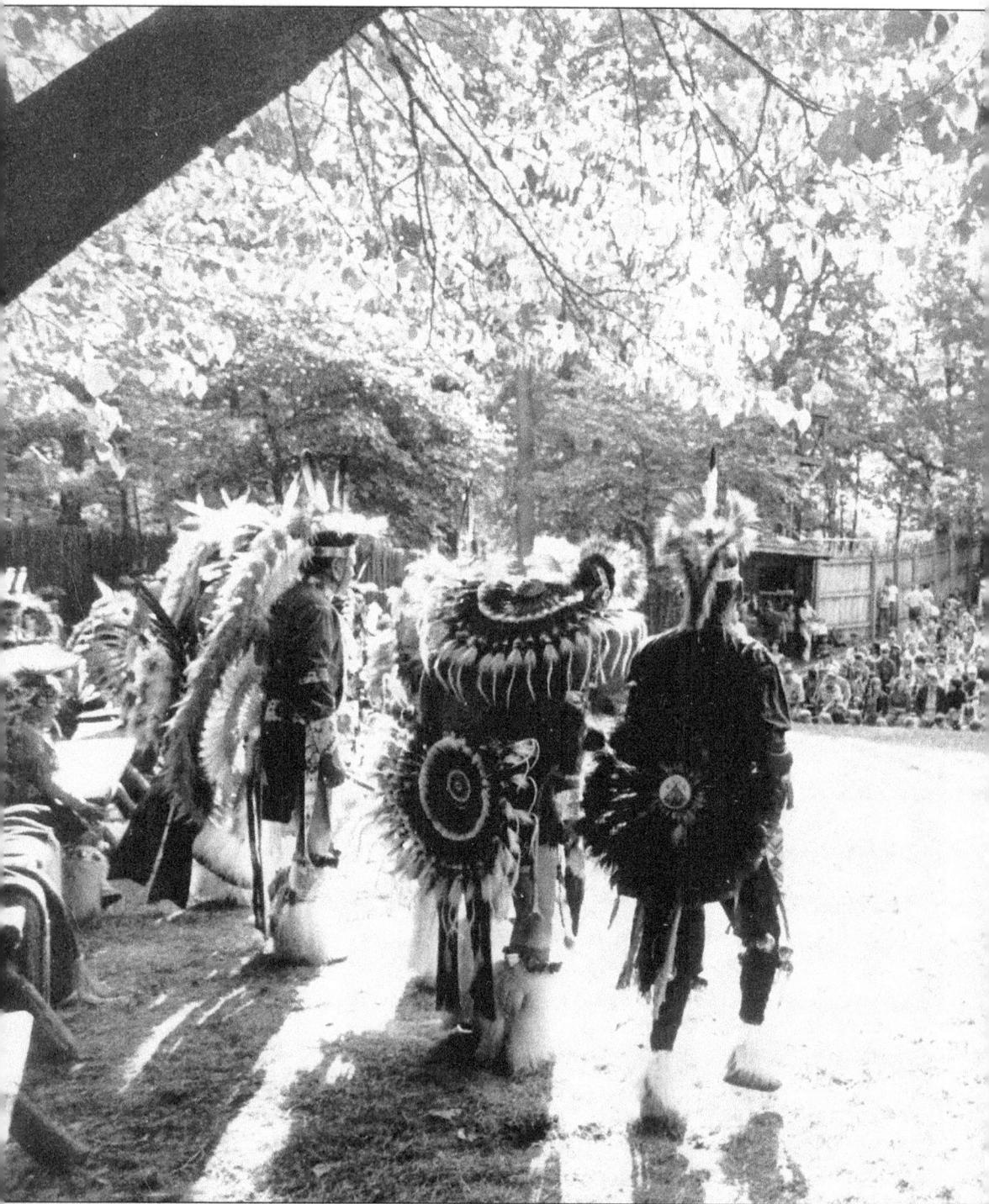

Some might think that the phrase "Indian summer" originated in Rock Island, for the end of the summer brought many American Indians to the grounds of Black Hawk State Park for the annual Pow Wow. It was a time of traditional dress and dancing and of celebration and reflection. Black Hawk's descendants were guests of honor; wide-eyed children soaked up culture

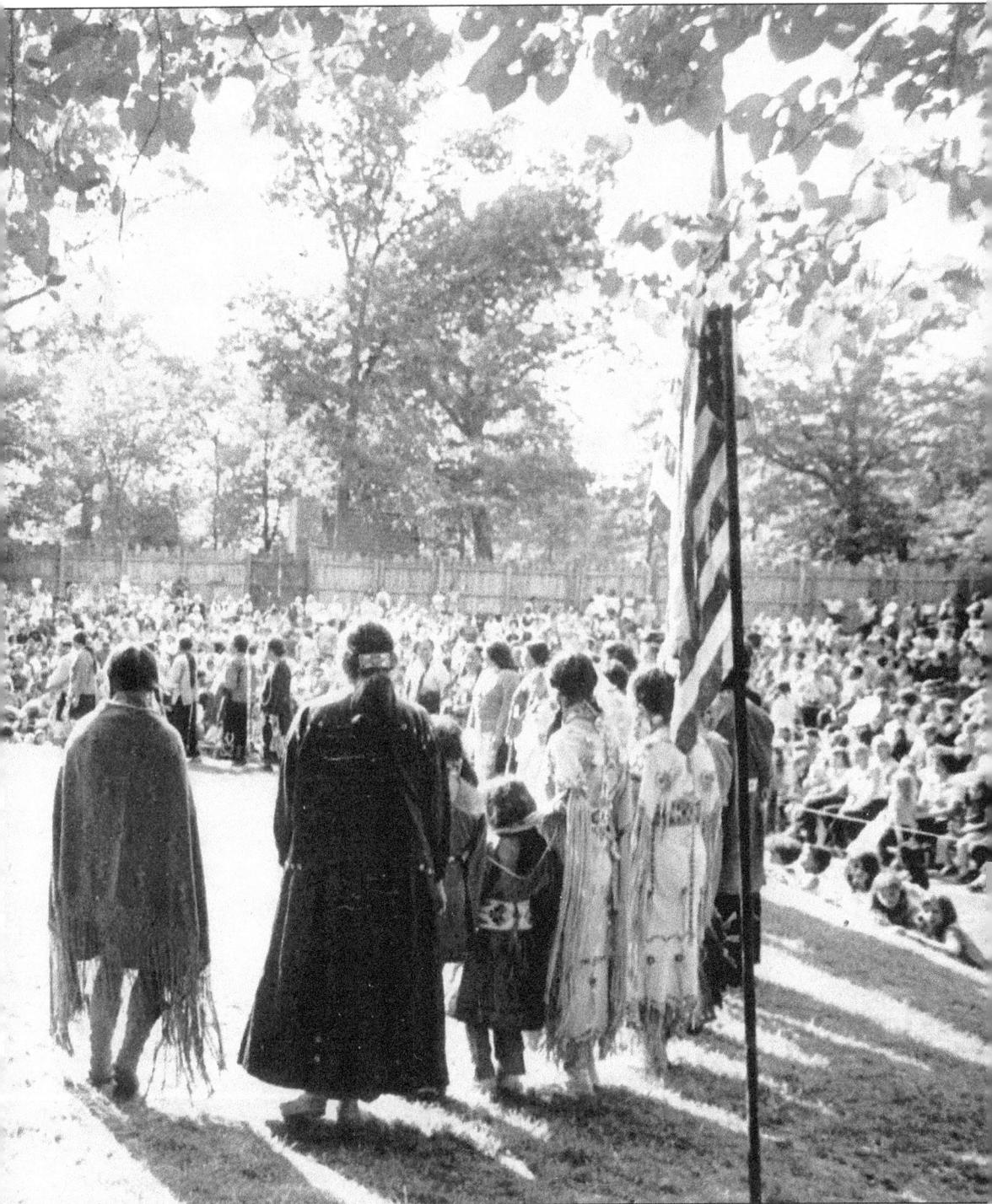

without even suspecting they were learning. In later years, fewer guests attended the event and parking problems caused the Pow Wow to end in the late 1970s. Parents and grandparents still share the spectacle in words with eager listeners who wish they could have been there.

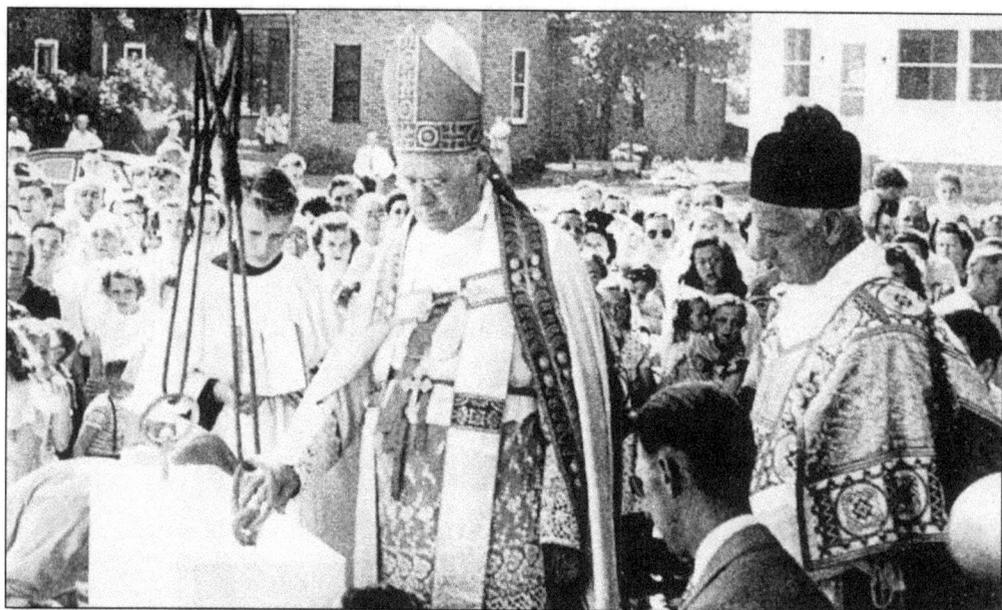

Over 7,000 people attended the dedication of Alleman High School on August 18, 1949. The Reverend Amleto Giovanni Cicognani, Apostolic Delegate to the United States, officiated at the ceremonies. The school was named in honor of Father John Alleman, a Catholic missionary who served the area in the mid-1800s. In this picture, Bishop Joseph Schlarman of Peoria blesses the school's cornerstone.

Author of eight young adult novels, four books of poetry, and three books about Illinois, Betty Chezum Mowery has left her personal literary imprint on the Rock Island cultural scene. She's also the longtime editor of *Oak/Grey Squirrel* and *Shepherd* adult publications and *The Acorn*, a magazine for student writers. In May of each year, she sponsors a Young Author Reading Night at Butterworth Center. It is an event spotlighting literary novices.

Four

REFLECTIONS

This place was once a vision
Of people long ago.....
We remember them with gratitude
For the seeds they chose to sow.
So many generations...
So many years gone by...
And still the mighty river flows
Beneath a Midwest sky
Rock Island is a special place
Upon the Mississippi shore...
It's a city with a friendly heart,
And who could ask for more?

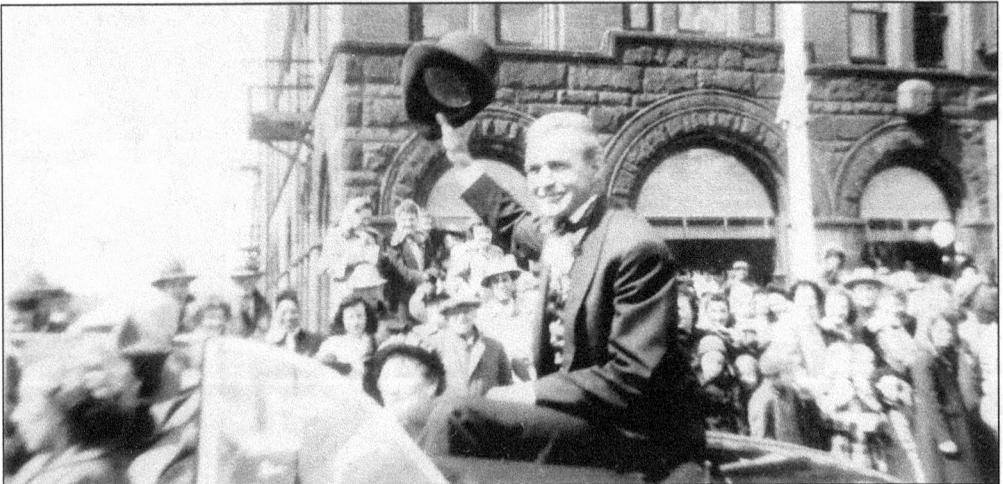

Republic Pictures' premiere showing of the *Rock Island Trail* brought a collection of Hollywood stars to the city in April 1950. John Wayne, Roy Rogers, Bruce Cabot, Chill Wills, and Adela Mara were among the illuminaries. Here, the movie's star, Forrest Tucker, waves to the crowd in front of The First National Bank building. Tucker went on to star in the television show *F-Troop*.

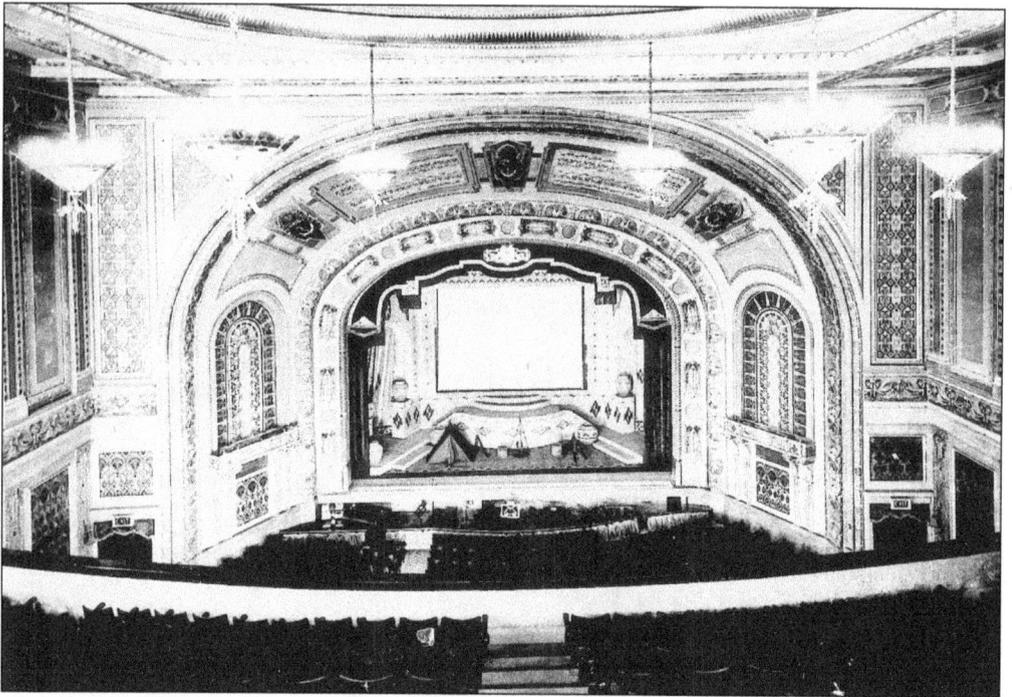

"In person and on the stage" proclaimed a 1940s ad for the Fort Theater's run of Paramount's *Pick-Up*, starring George Raft. The Hollywood star known best for his gangster roles must have looked a bit out of place with the Fort's Native American decor. It was the perfect venue for John Wayne and Forrest Tucker when they were here for the premiere of Republic Pictures' *Rock Island Trail*.

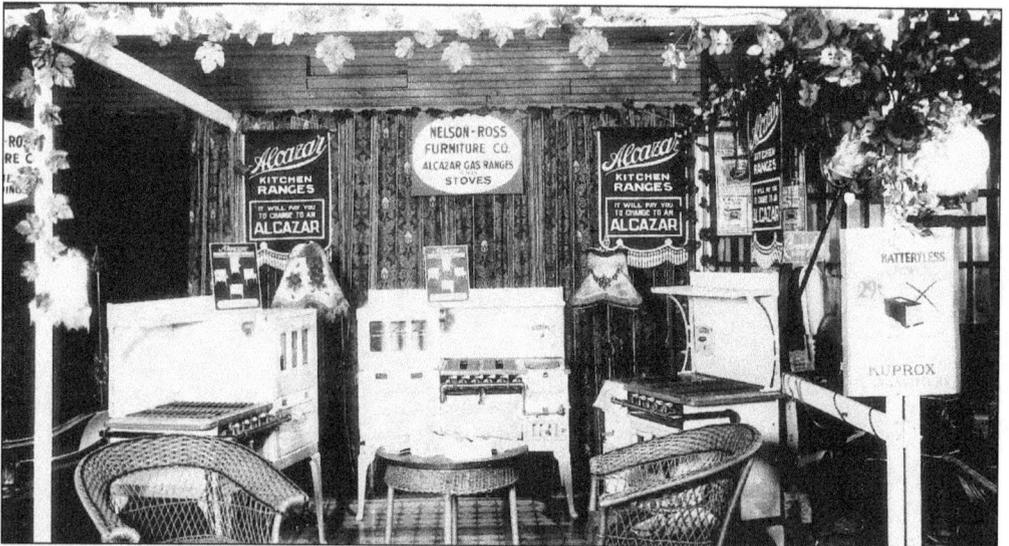

"If you want to be a cooking star, you better have an Alcazar" was the motto for Alcazar Gas Stoves and Ranges. You could take your choice as to the sizes and accessories you desired on your purchases. Nelson-Ross Furniture Company was the Alcazar dealer in Rock Island, and they sported displays like this one wherever and whenever they could. Ten dollars down was all you needed to snag a "hot" deal!

Upstairs, people enjoyed plush living accommodations, while in the coffee shop, there was good food and friendly waitresses. Among the favorite downtown spots was the ground floor of the Fort Armstrong Hotel. Whether it was ham and eggs for breakfast or a roast beef sandwich for lunch, the coffee pot was always perking and the service came with a smile.

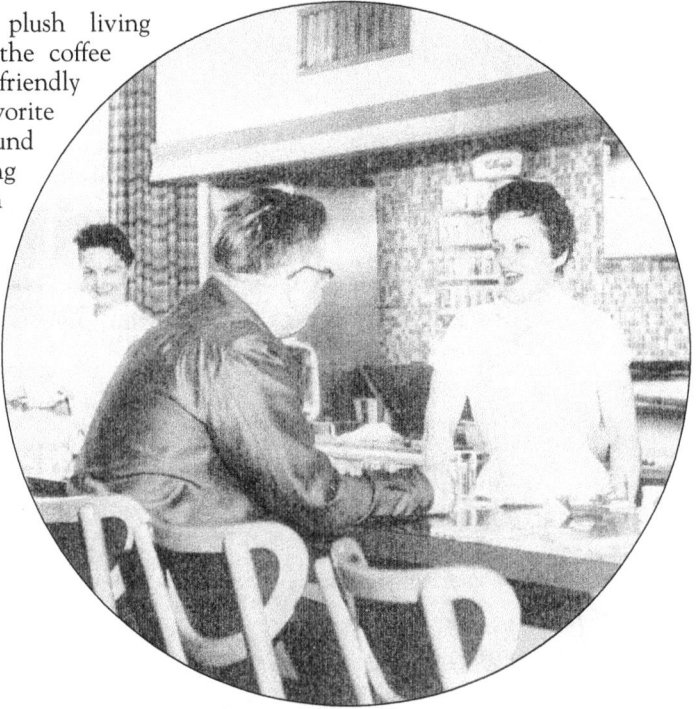

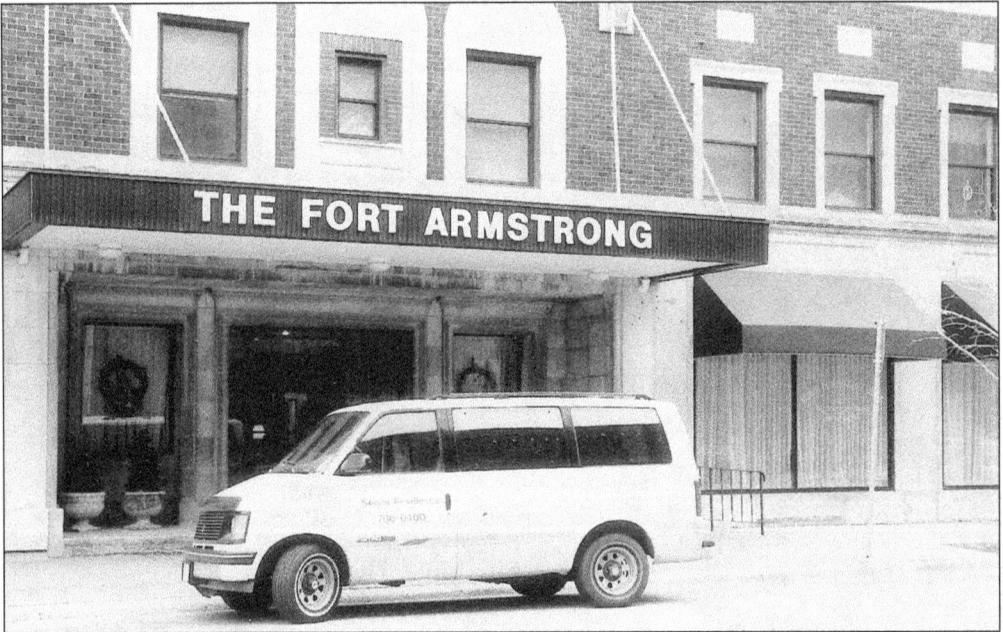

It's probably the most familiar site in downtown Rock Island and has had an exciting history. In the late 1920s, it housed the original WHBF radio studio on its mezzanine. "If you're going to Rock Island, stay in the Fort Armstrong Hotel," was the advice given to travelers. Presently, the building offers living facilities to senior citizens, who are often seen heading across the street to Circa 21 or a few blocks over to the President Casino.

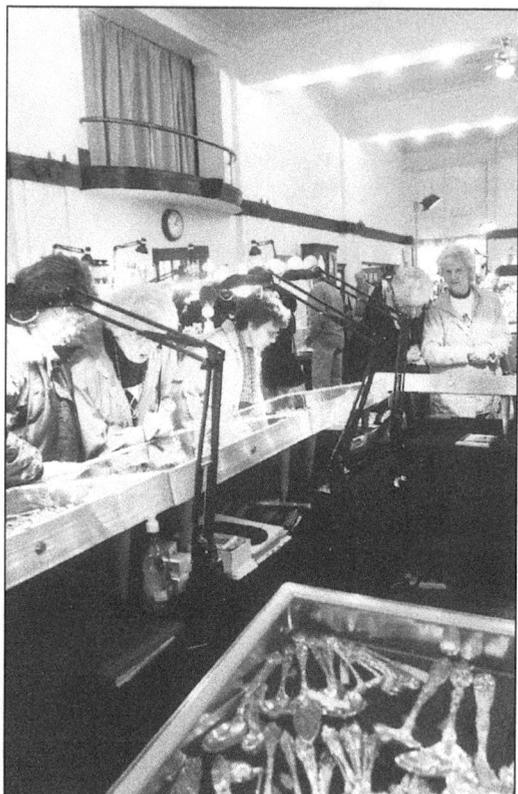

The year was 1957, and Russia's launching of the space satellite *Sputnik* began the "space war" with the United States. The Rock Island Women's Club launched their own project that year, a treasure-filled antique show, which is still growing strong as evidenced in this 1999 picture. The Masonic Temple lures exhibitors from across the country, who in turn bring in enthusiasts of the "once-upon-a-time" mindset.

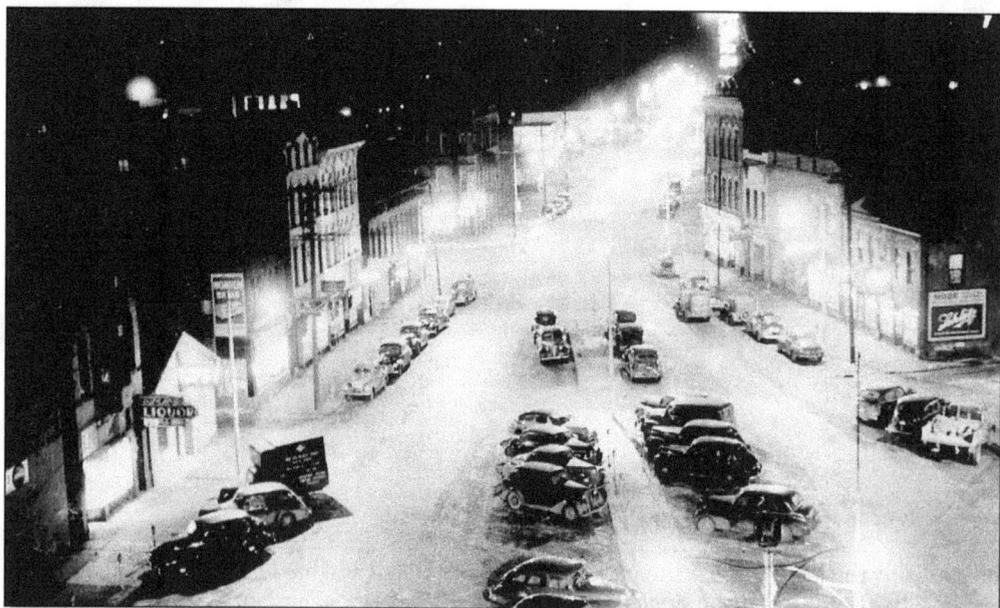

There doesn't seem to be a soul in sight, but the number of cars suggests the nightlife in the city is going strong. There have been many changes since this picture was taken. Note the signs for Wonder Bread and Schlitz Beer.

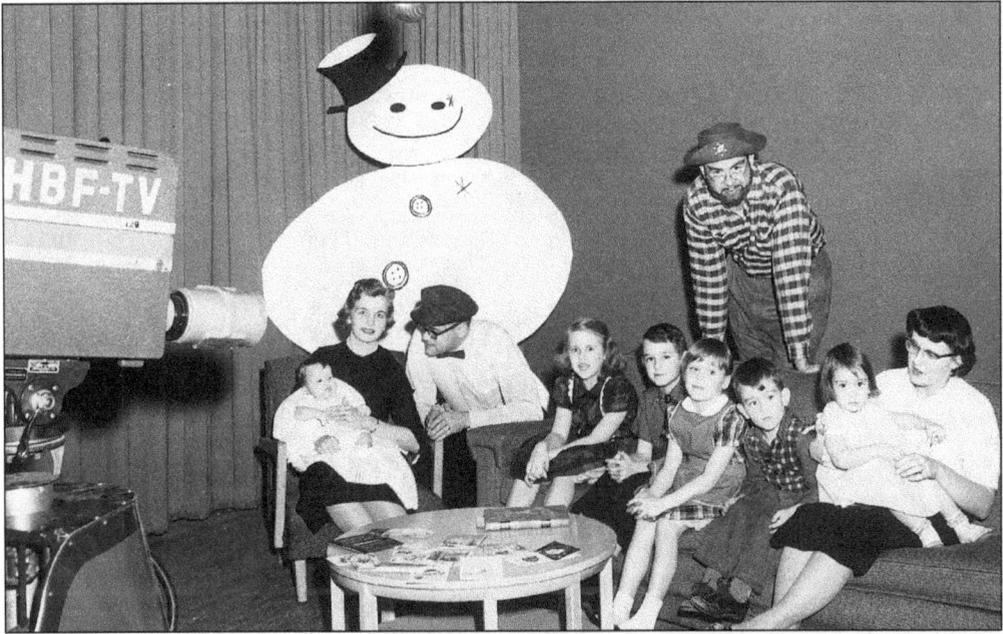

During the 1950s, one of the busiest spots in Rock Island was inside the Telco Building, where WHBF-TV cameras rolled throughout the day. One of the favorite featured performers was the ever-cheerful Grandpa Happy, played by Milt Boyd. With a never-ending collection of jokes, stories, and cartoons, Grandpa welcomed studio visitors of all ages, delighting home viewers throughout the community.

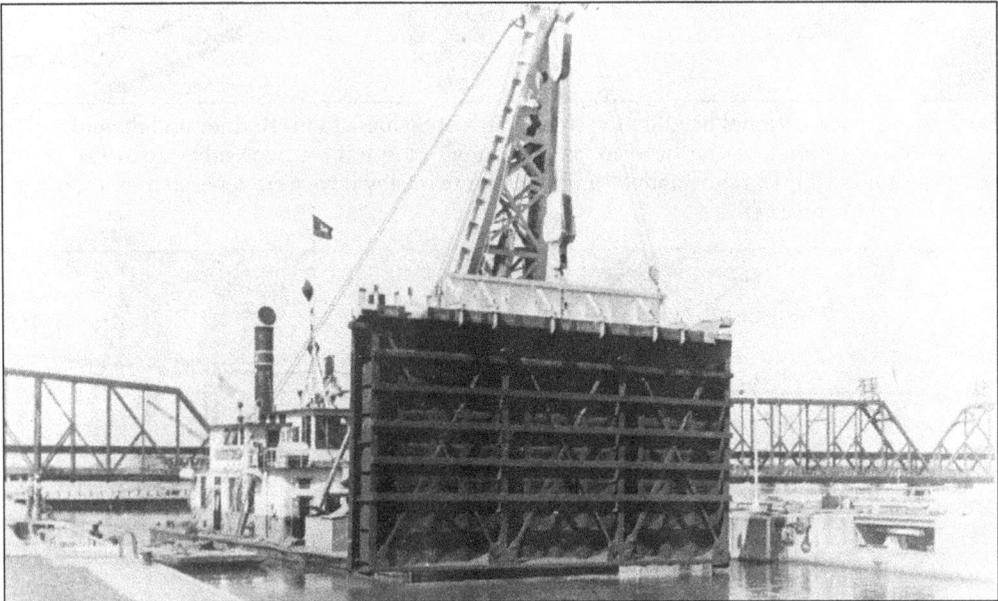

In the summer of 1941, the Derrick boat *Hercules* removed this gate from the auxiliary lock No. 15 for maintenance. Although there was tension in many parts of the world at the time, no one could have anticipated what the future months would bring. By the next summer, the locks along the Mississippi waters were in constant use by an unending stream of barges loaded with war materials.

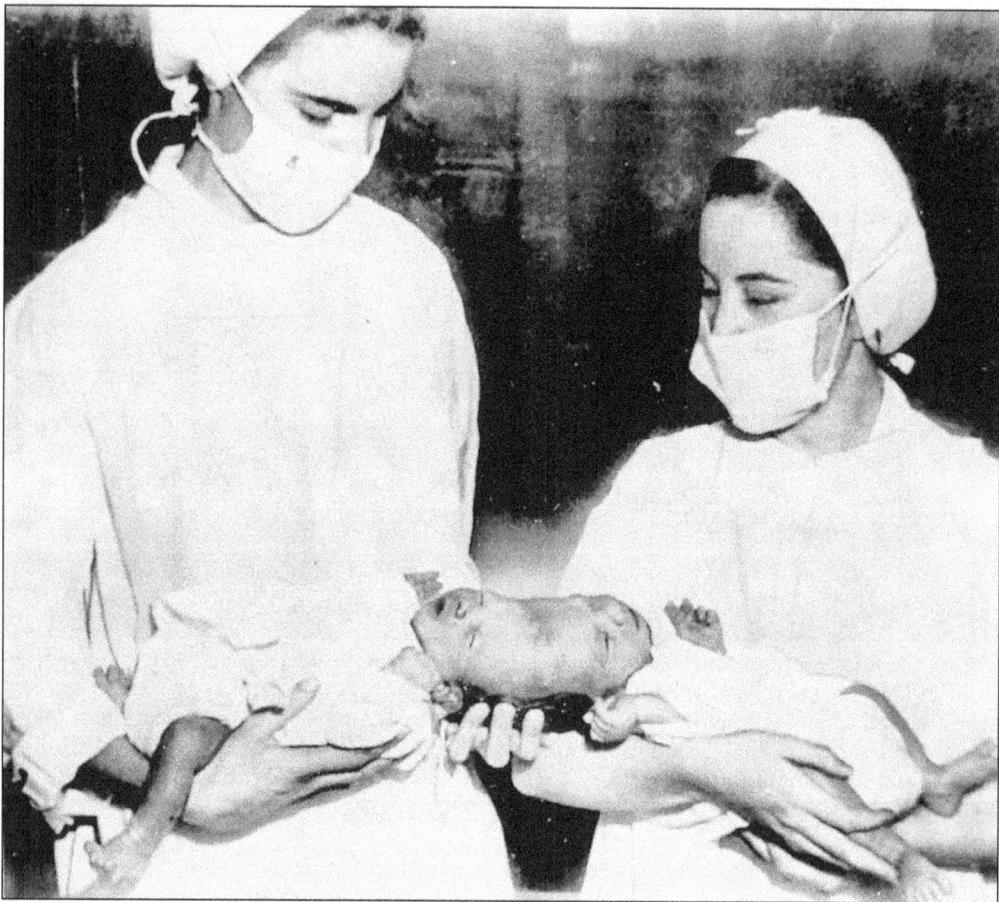

Rock Island made national headlines with the birth of Siamese twins Rodney and Roger Brodie, who were born joined at the head in St. Anthony's Hospital on September 16, 1951. After an operation lasting 12 hours and 40 minutes, the two baby boys were separated in a Chicago hospital on December 18.

"A quality curriculum, dedicated teachers, an attractive campus, a broad range of extra activities—that's what brought me to Augustana College, and that's what I got," remarked Dale Whiteside, a member of the Class of '56. This view of the campus shows the Wallenberg Hall of Science, the Swenson Swedish Immigration Research Center, and Old Main.

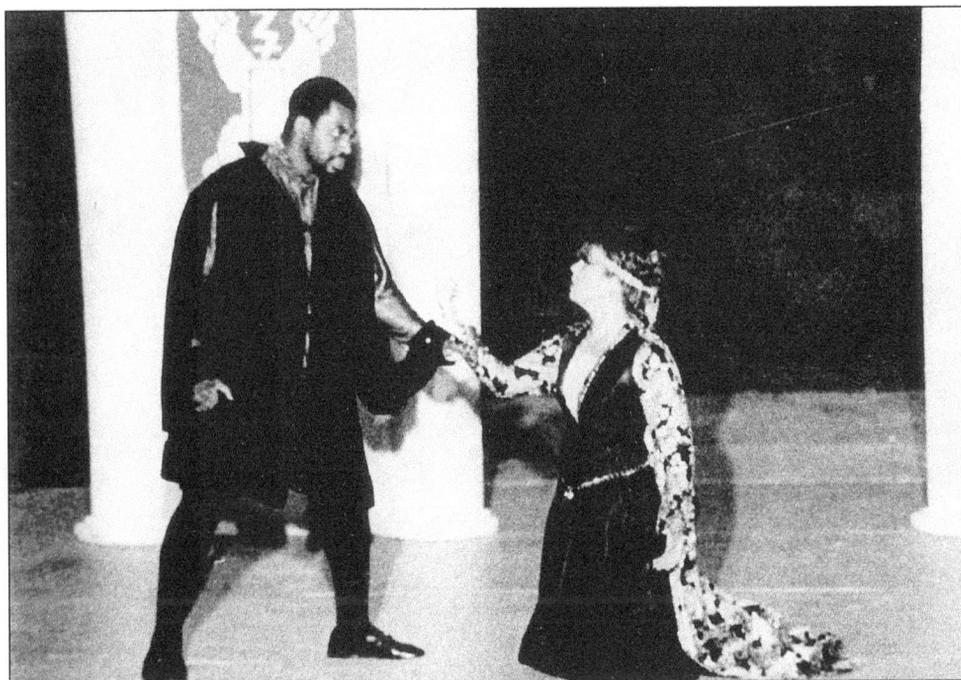

"Why wouldst thou lie to me?" an angry Othello demands of a distraught Dedemona while the mesmerized audience at Lincoln Park hinges on every word of the powerful onstage action. Since 1956, the open theatre has brought the best of classic Greek and Shakespearian productions every summer, thanks to the volunteer Genesius Guild performers and its founder, Don Wooten. The season even features an opera.

Don Wooten has worn many "hats" in this community, serving as an Alleman teacher, WHBF weatherman and "Bookman," Genesius Guild founder and director, state senator, and WVIK host and manager. Here, he discusses an upcoming Shakespearian play with the cast at Lincoln Park. Don's wife, Bernadette, not to be "upstaged," has a longtime record of public service and humanitarian interests.

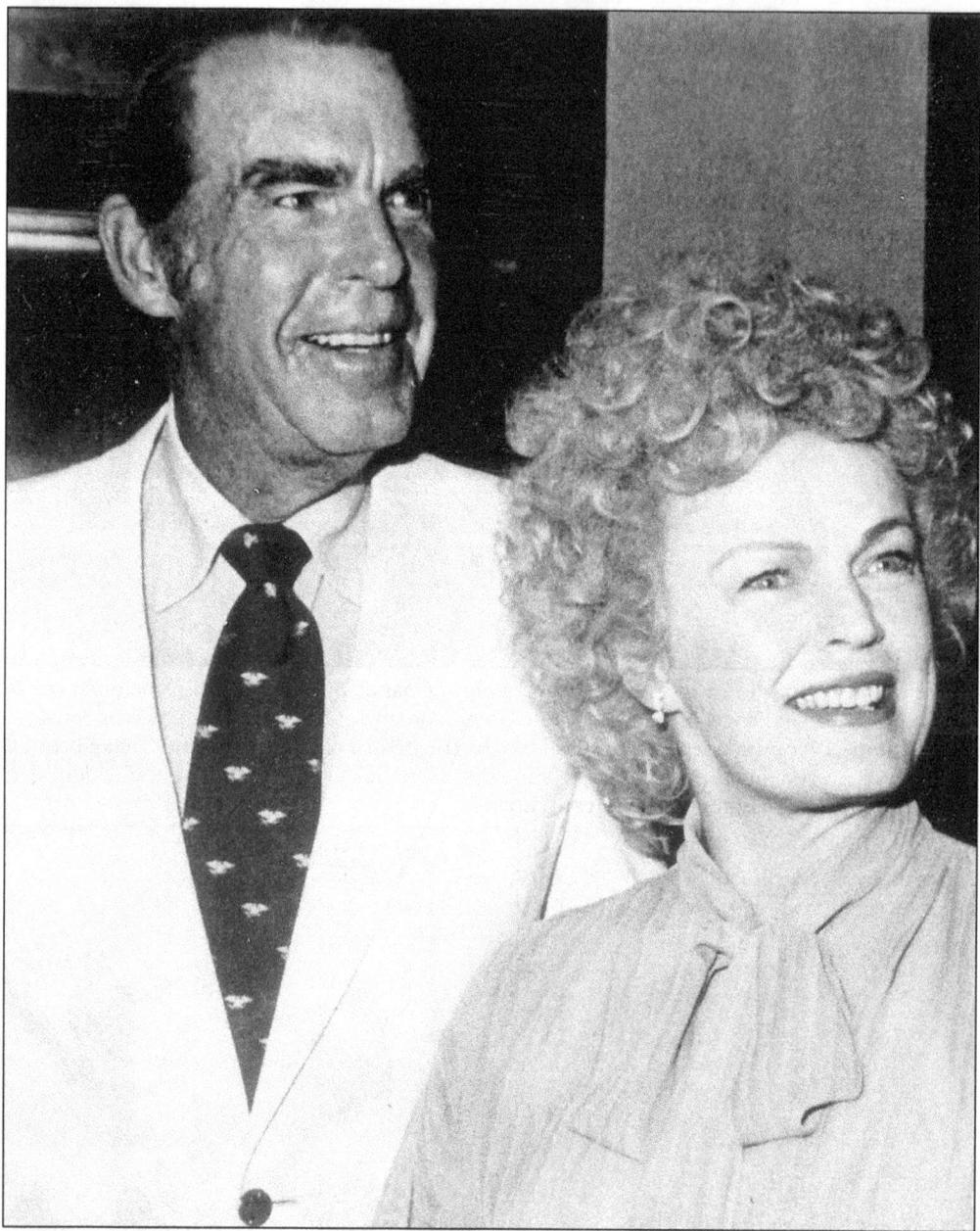

June Stovenour displayed star quality even as a Rock Island girl, singing and dancing on local excursion boat stages as well as delighting WHBF radio listeners with her sparkling voice. By the 1940s, she had become the movie star June Haver, captivating national audiences in lavish musicals like *Home in Indiana*, *Look for the Silver Lining*, and *Oh, You Beautiful Doll*. In 1954, June married film star Fred McMurray. While he continued acting duties both in movies (*The Caine Mutiny*, *Double Indemnity*) and television (*My Three Sons*), June concentrated on raising twin daughters Katie and Laurie. June always enjoyed coming home to Rock Island. In this photo she is bringing her husband Fred to the Ed McMahon Quad-Cities Open Pro-Am Golf Tournament in 1979. "I have wonderful memories of growing up in Rock Island," she recalls. "It was a special place with special people."

"Oh, the Rock Island Lines is a mighty fine road . . . the Rock Island Lines is the road to ride. . ." Remember that song from the 1950s? Dorothy Collins, Snooky Lanson, Giselle McKenzie, and Russell Arms all took their turns at singing the song on *Your Hit Parade* on Saturday nights. Between its railroads and river traffic, Rock Island was a true transportation center during the late 1800s. The Rock Island Lines made its final run in March 1980.

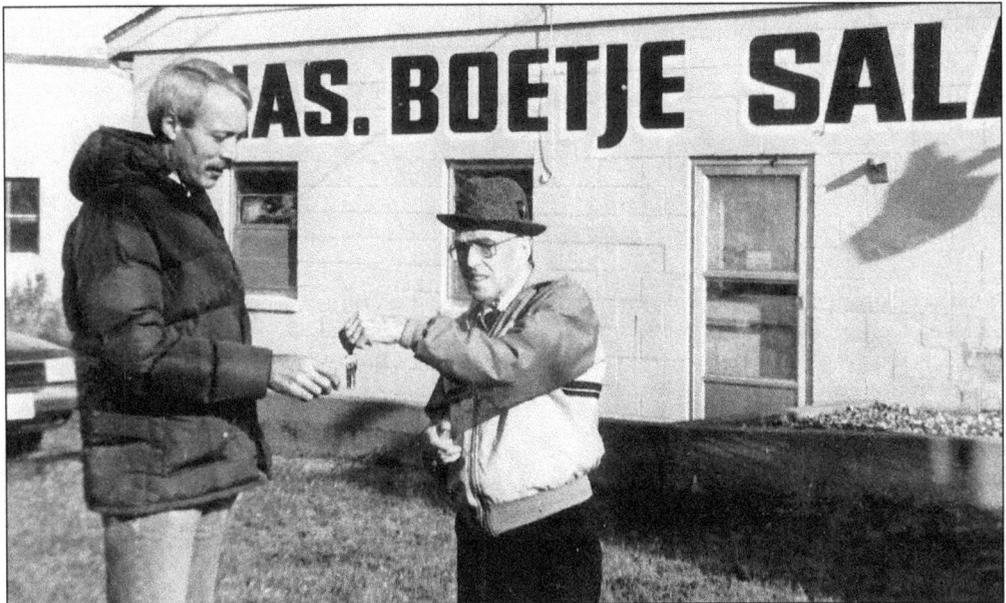

Say the name "Boetje" and many Rock Islanders lick their lips. Fred Boetje was the "mustard man" who mixed Canadian mustard seeds, sugar, vinegar, and water into a tasty spread. Brother Charles specialized in salad dressing and enjoyed a reputation among the finest chefs in the Midwest. "If it's not Boetje's salad dressing, your salad isn't dressed at all," observed one noted Chicago gourmet. In this picture, Charles turns over the keys to his business to Orion's John Swiger when Boetje retired in 1987.

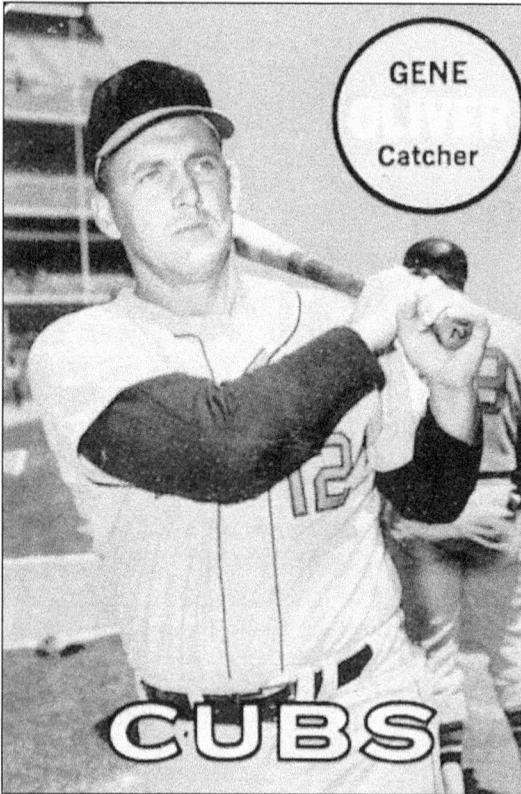

GENE OLIVER
Catcher

CUBS

A powerhouse football, basketball, and baseball star at Alleman, Gene Oliver carried his athletic prowess into the national spotlight, choosing baseball as his prime focus. A top catcher/outfielder for St. Louis, Atlanta, Chicago, and Milwaukee, Gene made headlines when he hit a home run at his first time at bat in the major leagues. He hit three home runs in one game against the San Francisco Giants in Atlanta and was one of six Milwaukee Braves to hit over 20 home runs in the 1965 season.

"Don't cook tonight, call Chicken Delite!" Rock Islanders took Al Tunick's advice in the 1950s and 1960s, allowing the entrepreneur to build up a home delivery restaurant business numbering 750 stores across the country. After selling his chicken cooker business, Al jumped into the Karmelkorn enterprise. Again, Al Tunick built a giant company. He died in 1987 as one of the city's most successful businessmen.

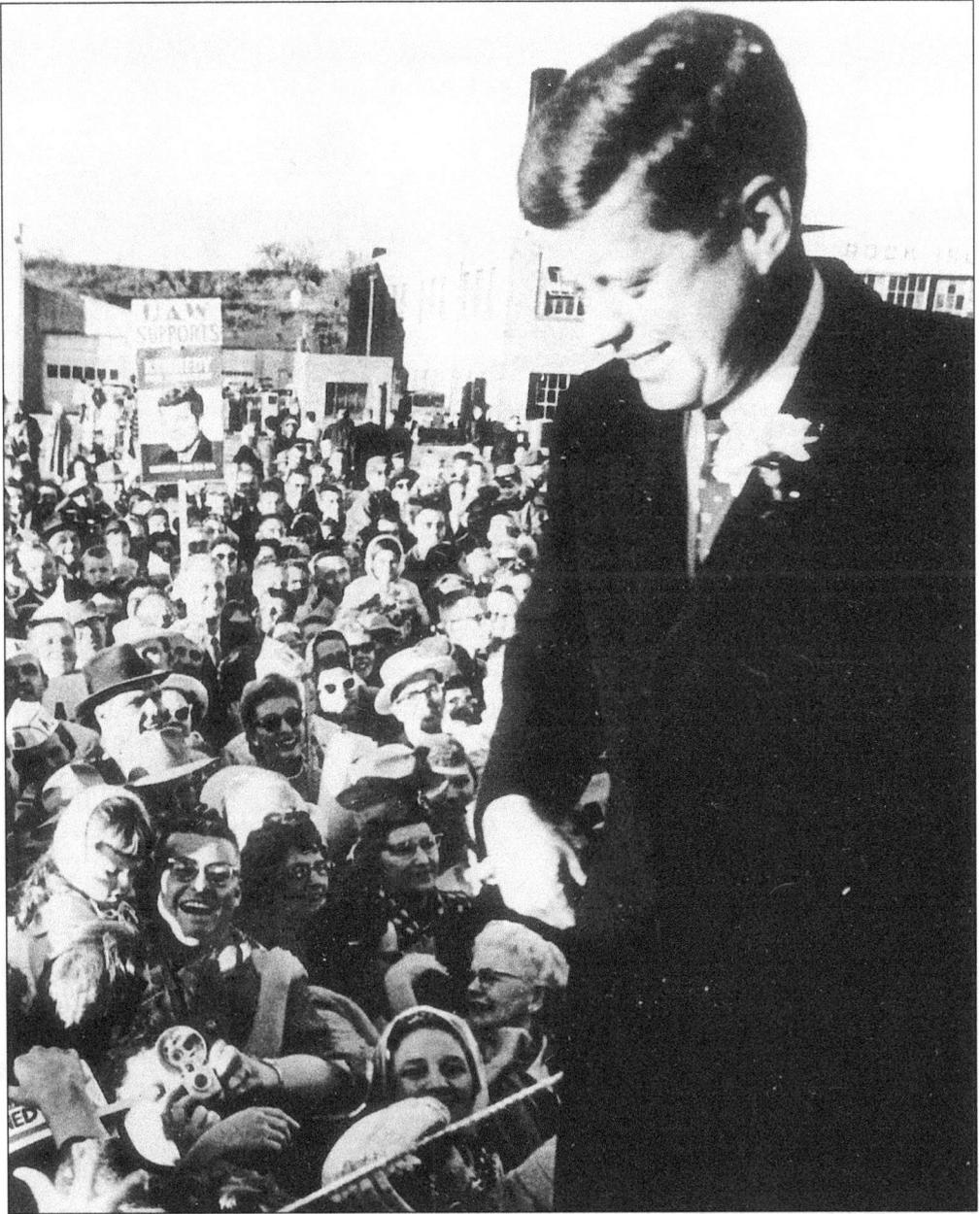

Thousands of area residents turned out in the fall of 1960 to welcome the handsome senator from Massachusetts. John F. Kennedy was running for president against Vice President Richard M. Nixon. Pollsters predicted a close race, and like everyone else, Rock Islanders wanted to see this Eastern fellow, hear what he had to say, and do everything necessary to size him up. Kennedy spoke at the Rock Island High School Fieldhouse to a standing-room-only crowd. It was a typical pre-election speech, content wise, yet the audience seemed to enjoy every phrase and every clipped-accented syllable. "He might be young," remarked Walter Teuscher, a longtime Rock Island resident, "but he sounds like he knows what he's talking about." Others must have agreed, for Kennedy went on to win the election and become the country's 35th President. Many still remember seeing and hearing John F. Kennedy on this day in 1960.

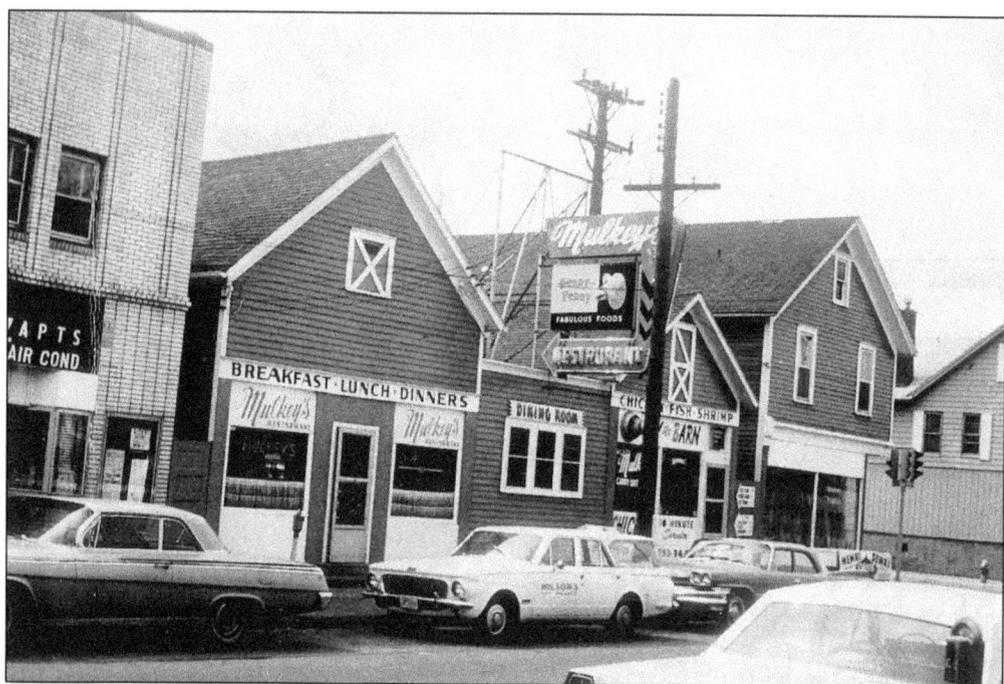

Bender's was sold in 1959 to the father of the present owner, Chuck Mulkey. It soon became *the* place in Rock Island's east end for real home cooking. Carryout service began in 1960. By 1969, demand for their famous chicken grew and they built the new brick building. The old frame restaurant was torn down later that year.

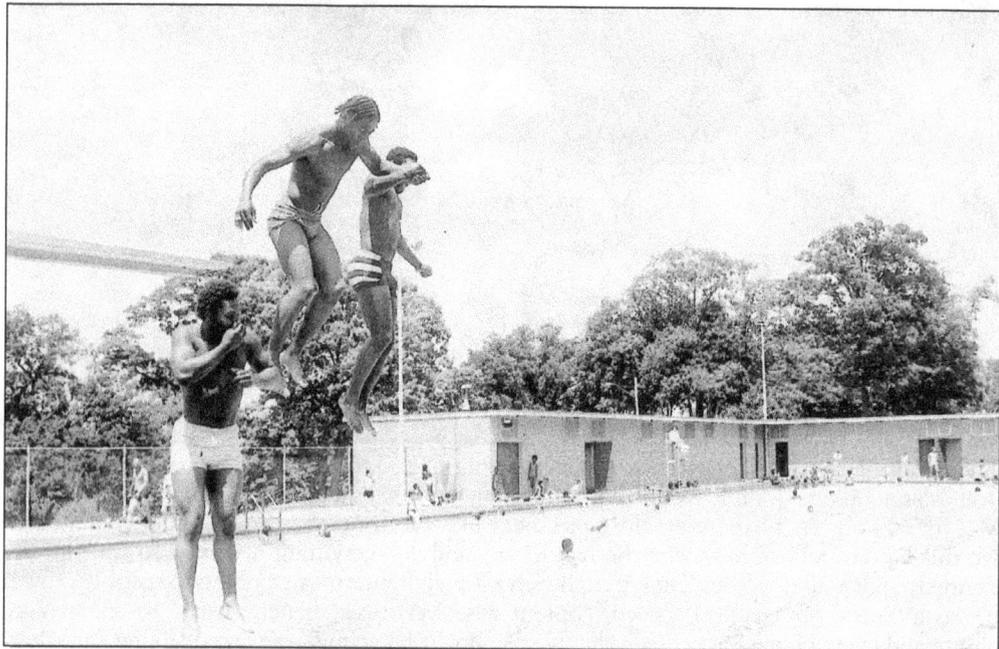

With the final clanging of schoolbells or buzzers, the charge of the mite brigade beelines for the the ole swimming hole. Not exactly a "hole" for young Rock Islanders, the Long View Park pool, later renamed the Mel McKay Pool in honor of a past mayor, has cooled thousands.

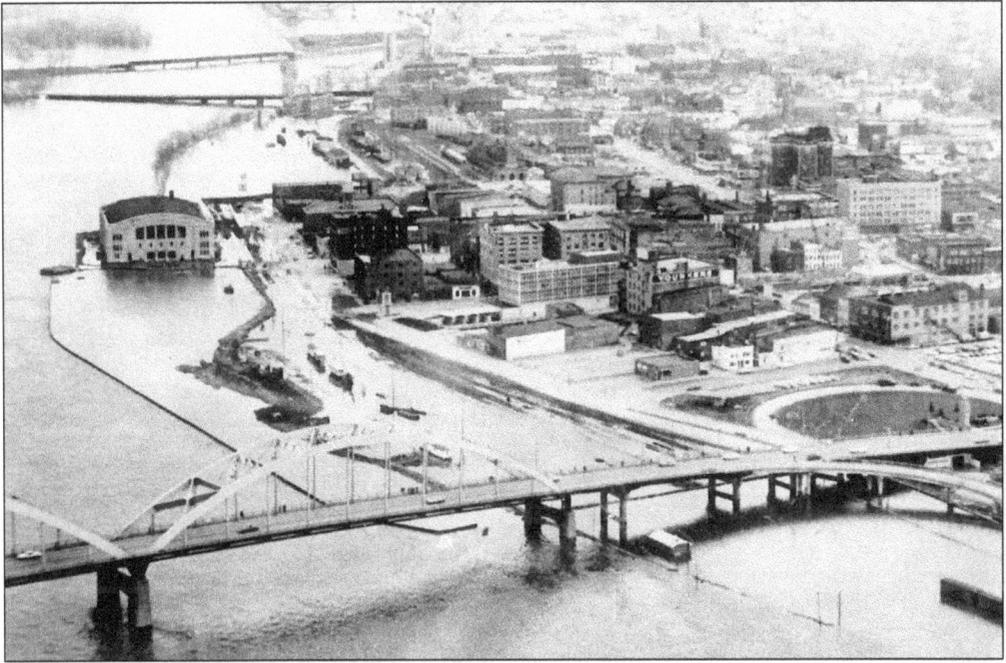

In April 1965 the waters of the Mississippi spilled into the city, causing many downtown merchants major financial losses. The dreaded flood, however, encouraged the city leaders to erect a protective wall to prevent future reoccurrences.

It sits like a diamond atop the Rock Island hillside, attractive to behold on the outside, and boasting beautiful views from within. Construction began on the Steepmeadows apartments on September 1, 1960. The condominium complex is located at Twenty-first Avenue and Fourteenth Street. "It's almost like a castle," observes Rock Islander Carolyn Stevenson.

"Shorty" may have been Harold V. Almquist's nickname, but he was a giant on a football field. As a player at the University of Minnesota, he racked up All-American honors in the late 1920s. Fortunately, he came to Rock Island High School, where he built a gridiron dynasty based on character building, game fundamentals, and determination. "Coach always made it clear what your job was on the field," noted Joe Robb, a defensive end on the 1957 squad. In 1990, shortly before Shorty's death, the Rocky playing area was officially named Almquist Field. Unofficially, the place had been that for decades.

Rock Island sports rivalries go beyond inter-city clashes. Here, longtime Washington Junior High coach Ray Collins greets his son Richard, who has brought his Wilson Wildcats from Moline to Saukie Field in 1968. Age and experience won out, with the Warriors winning. The elder Collins became assistant principal at Washington and died of a heart attack at his desk in 1971. The younger Collins ended his coaching career at Washington, capturing the Tri-City Championship in November 1991. He died the following January.

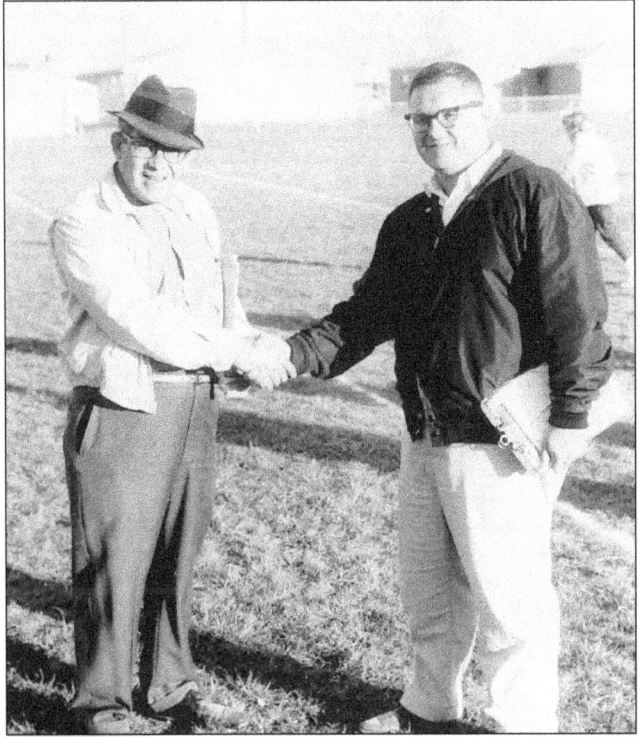

Making All State in any sport is a major achievement. Making All State in two sports is amazing. Joel Collier managed to do it at Rocky in both football and basketball. He headed to Northwestern, where he won All Big Ten honors on the gridiron. In the newly organized AFL, Joel coached for the Buffalo Bills before going on to spend two decades coaching the Denver Broncos.

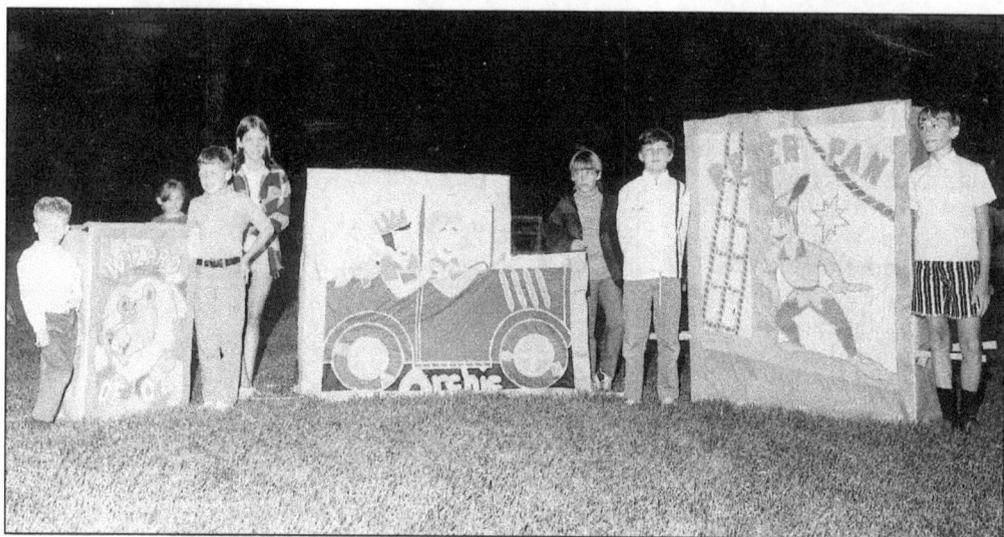

"Amazing, unbelievable, and incredible" were among the exclamations of spectators at the 1971 Rock Island Lantern Parade. The "ooos" and "ahhs" were too innumerable to count. The annual event tested the artistry and craftsmanship of the city's junior Michaelangelos and DaVincis as they designed, assembled, then carried their unique creations around Rock Island High School Field.

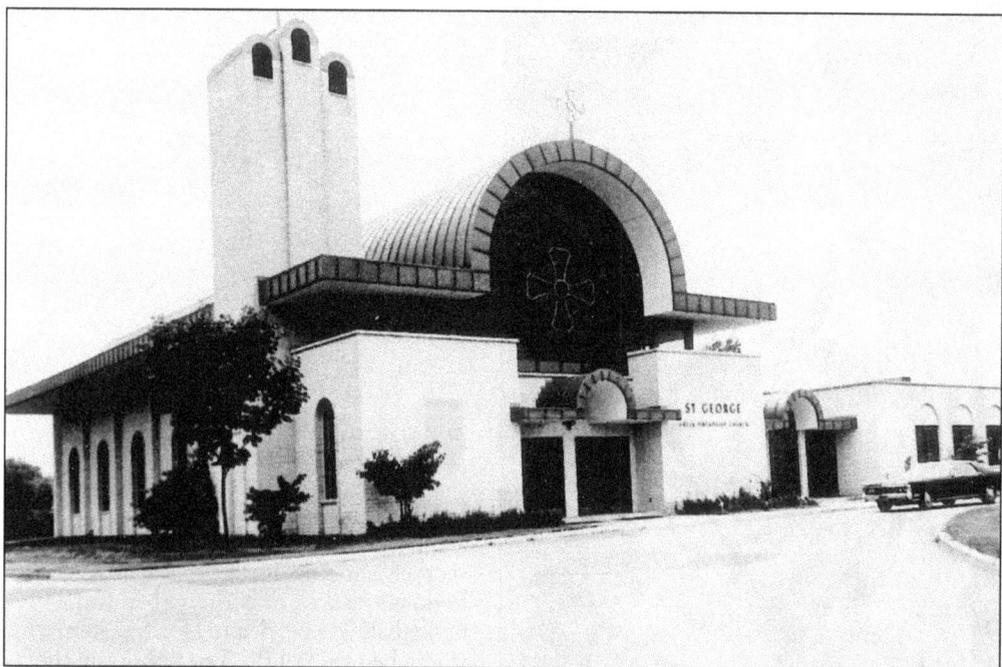

One cannot drive by the corner of Thirtieth Street and Thirty-first Avenue without noticing the imposing St. George's Greek Orthodox Church. Its unique design and attractive landscaping offers a warm welcome to those of any faith. "It seems to fit there so naturally," offers Rock Island resident Mary Foster. "It's a lovely corner in the city."

Michael Jordan was certainly not the first major athlete to endorse products. Ken Anderson, once a valiant Viking on the Augustana gridiron, went on to play for the Cincinnati Bengals. Naturally, one thing led to another, and before you know it, there's a smiling Ken raving about those delicious sandwiches that gave him the mind and muscle to dazzle spectators as he tore up the field.

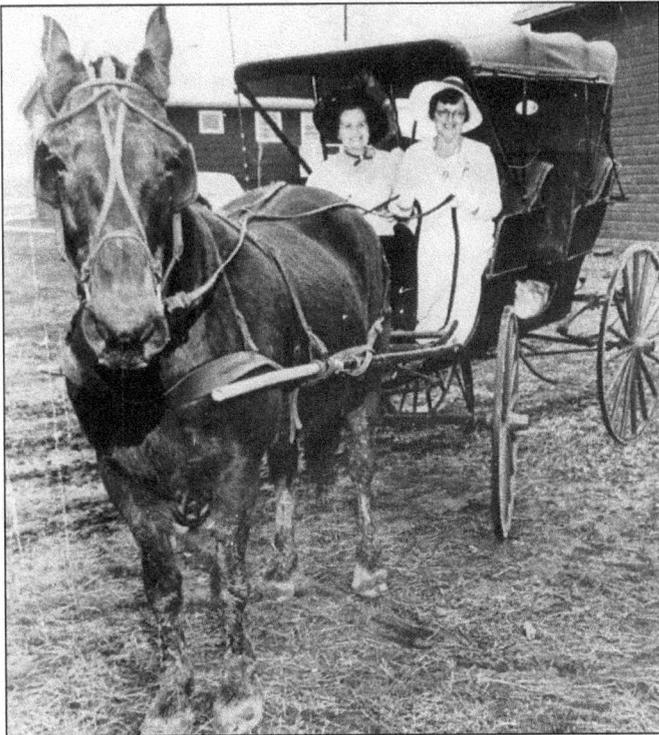

Harriet Shetter and Nonie Leithner are all ready to go in this turn-of-the-century buggy as they prepare for the Annual Woman's Club Antique Show at the Rock Island Masonic Temple. Exhibitors fill the booths with antiques and collectibles that intrigue the novice and expert alike. Where else can you find a genuine moustache curler?

93

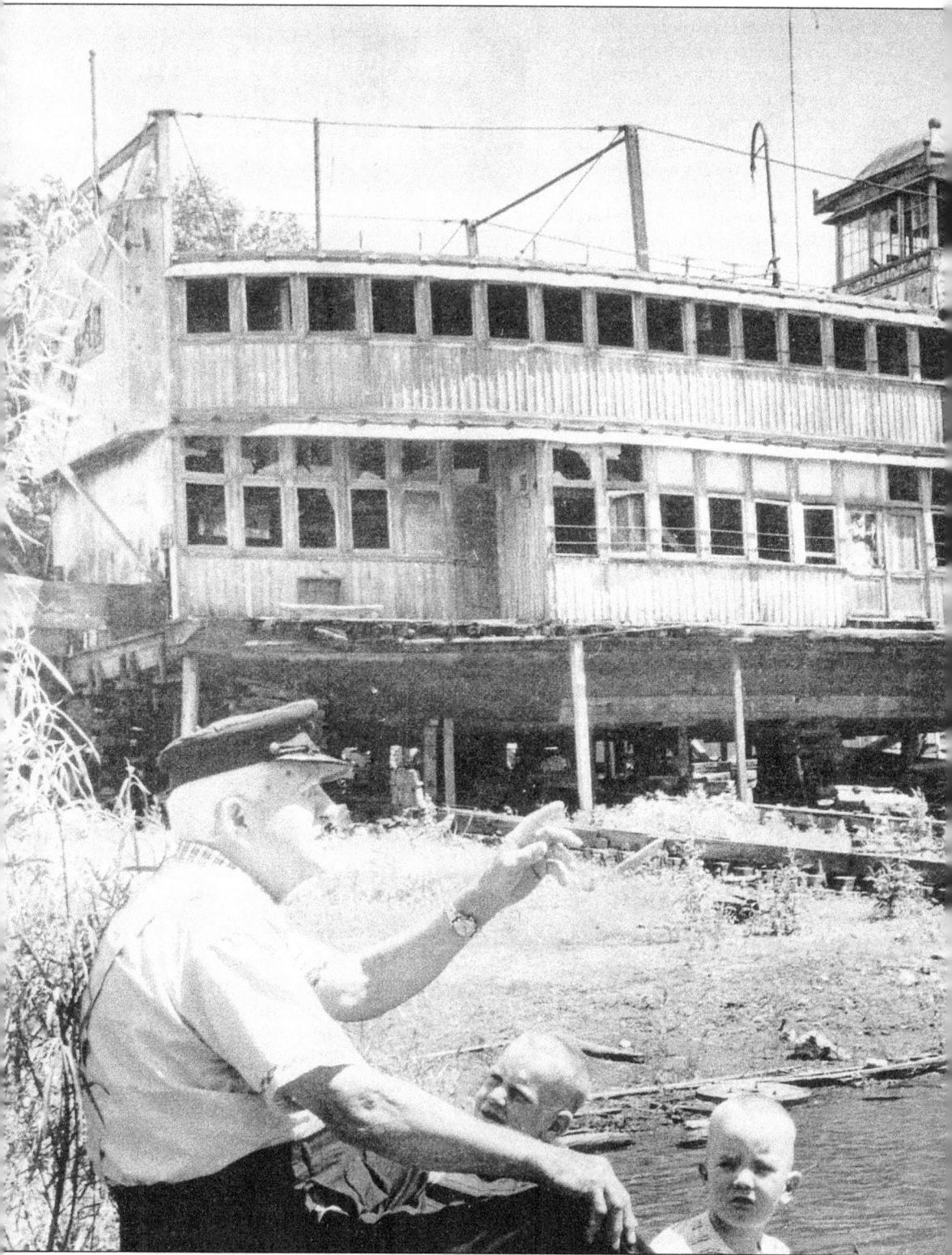

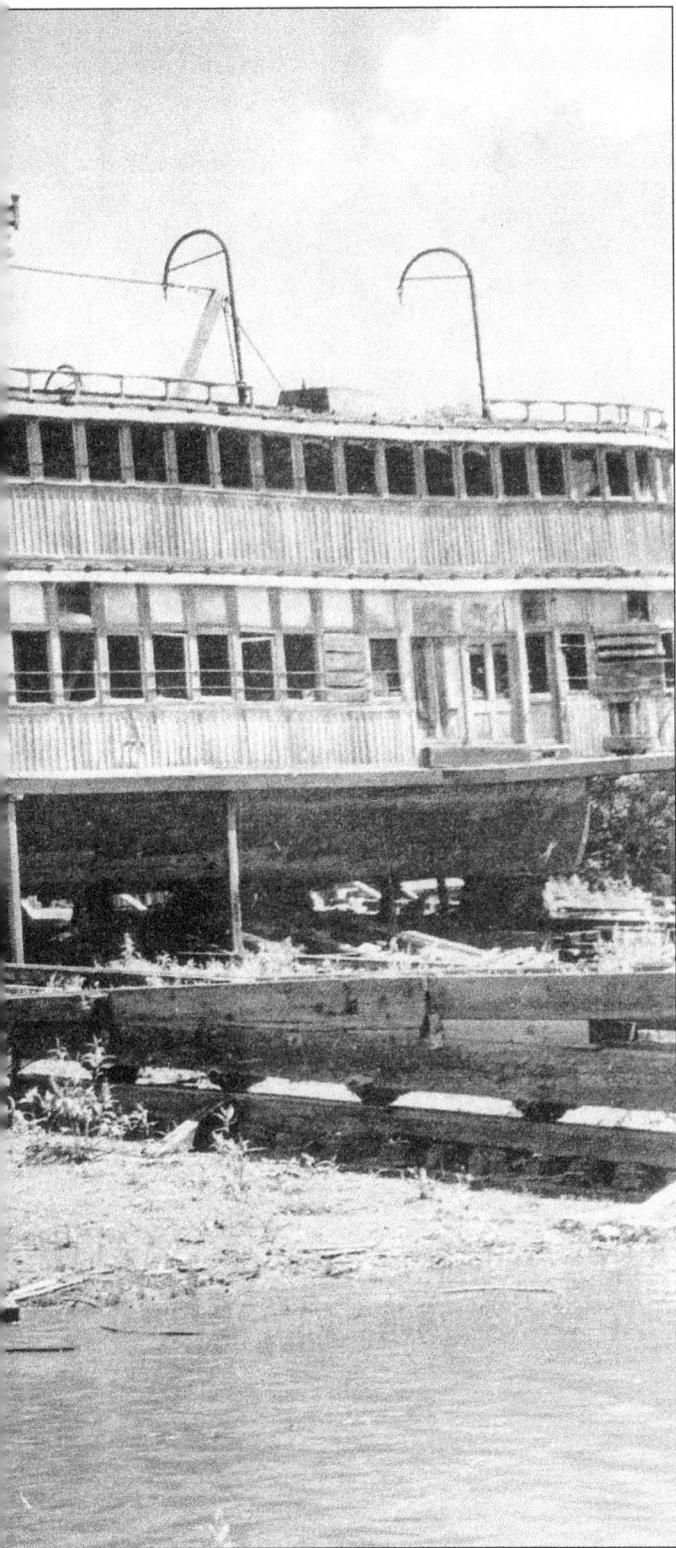

Years are swept aside as two young boys listen to their grandfather relive happy times when steamboats traveled in glory on the Mississippi. The *W.J. Quinlan*, shown here in drydock at the Kahlke boatyards, was called "the jewel of the river." The proud steamer was destroyed by fire in 1967.

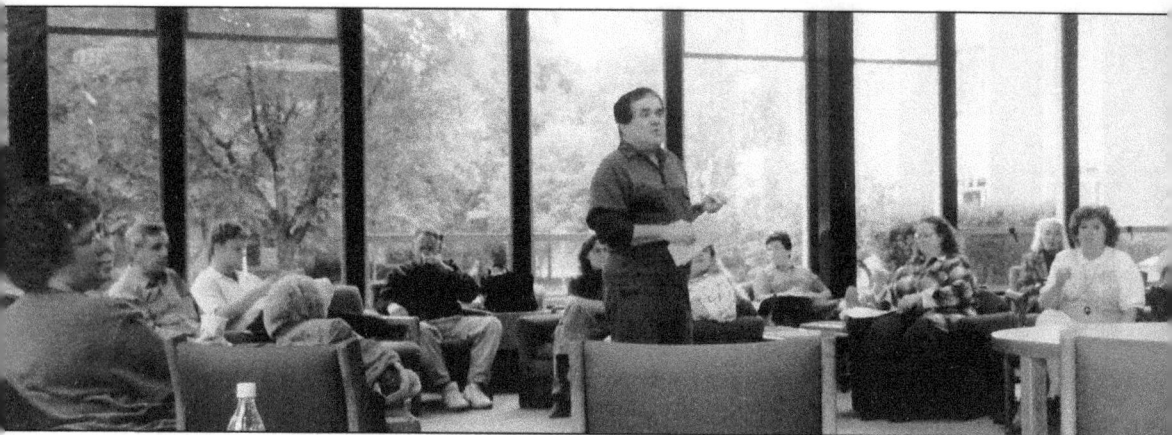

Since 1973, Rock Island's Augustana College has welcomed beginning writers and polished professionals to the week-long Mississippi Valley Writers Conference held in June. Not content to rely on the past local literary heritage of historian John Hauberg, mystery novelist Charlotte Murray Russell, or Newberry Award winner Cornelia Meigs, Rock Islanders Linda Hender Wallerich, Kimberly Caitlin, Betty Mowery, Susan Coppula, Roald Tweet, and others have carved their own niche as nationally known wordsmiths. Here, conference founder-director David R. Collins, an award-winning children's author, discusses elements of biography at the 1998 gathering of writers.

As a young basketball player, the boy showed little promise. Was it Michael Jordan? They did have many similarities. Both Jordan and Rocky's Don Nelson developed super skills in high school, with Nelson under varsity coach Bob Riley. In 1958, "Nellie" was named Illinois All-State Center. He carried his talent to the University of Iowa, then on to the Boston Celtics. The player became a coach, and Nelson airlifted the Milwaukee Bucks. He is presently the head coach of the Dallas Mavericks. Michael Jordan and Don Nelson are two guys who never gave up.

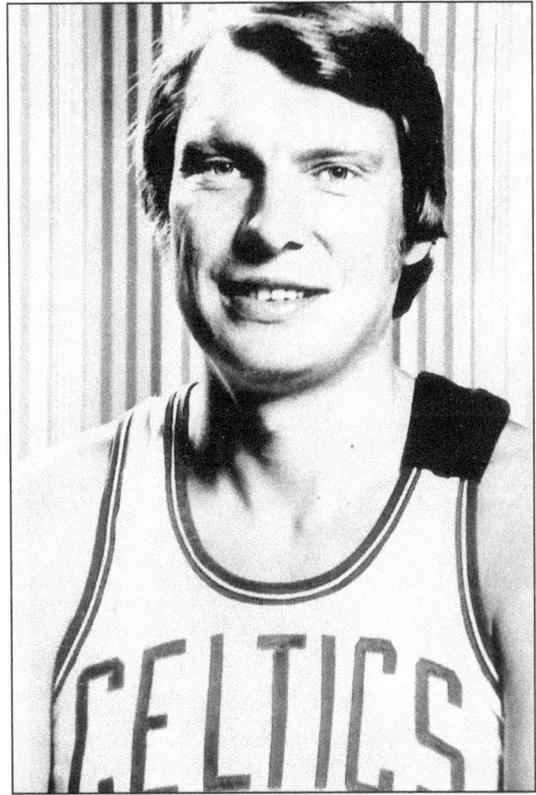

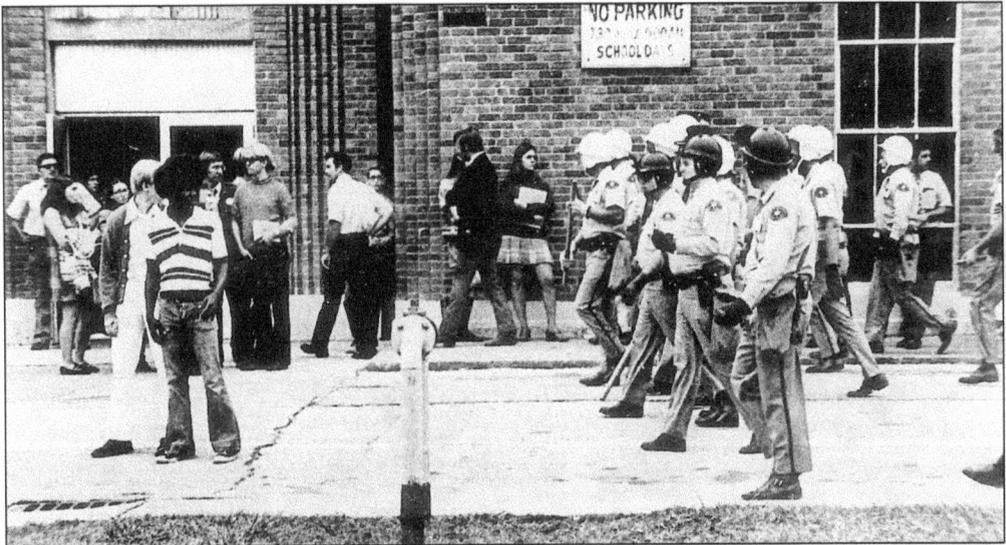

As usual, Rocky High students were winning National Merit scholarships, athletic encounters, and delighting theatre audiences with grand productions. But in October 1972, racial tensions erupted into violence, forcing heavy security measures to be imposed and the school to be closed for a week. When Rocky reopened, the atmosphere was more relaxed, but those who were there said "it would never be quite the same."

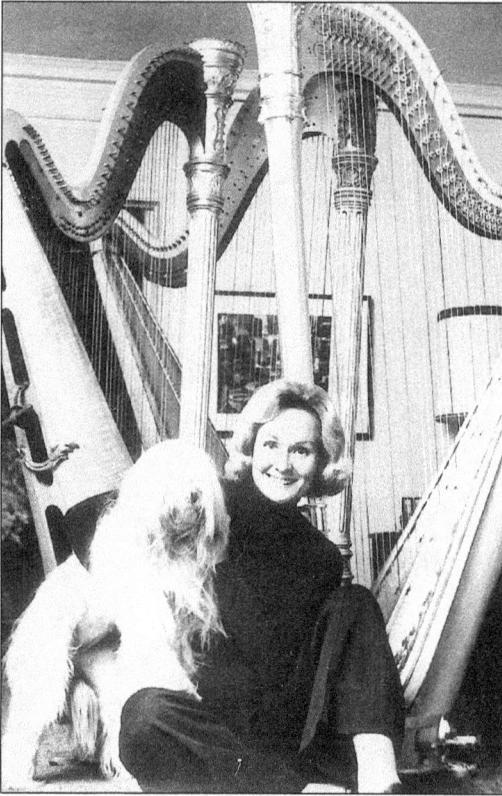

"A musical love affair takes place whenever Susann McDonald's fingers caress the strings of a harp," wrote one national music critic after hearing the Rock Islander perform on stage in 1973. From 1975 to 1985, Susann served as head of the harp department at the famed Julliard School of Music. She presently serves as Artistic Director of the World Harp Congress.

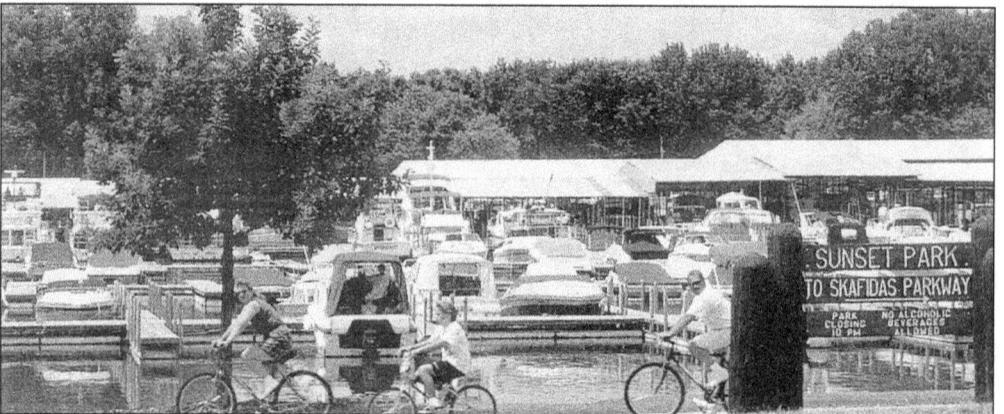

"Happy Birthday, America!" The year 1976 was a bicentennial year across the country. Rock Island joined other cities and counties in celebrating the 200th birthday of the nation. Area boaters welcomed the opening of the Sunset Marina as part of the bicentennial observances.

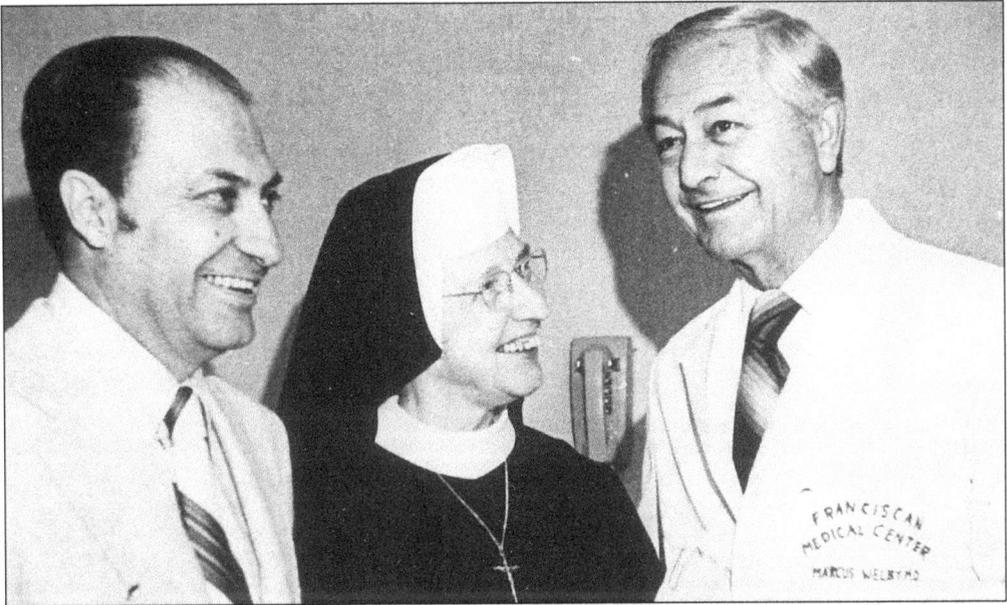

"Is there a doctor in the house?" Indeed, there is. Two are featured in this picture, framing Franciscan Medical Center's president Mother Anthony. Real M.D. Eduardo Ricaurte welcomes longtime friend Robert Young, who portrayed television's M.D. Marcus Welby. Young, who died in 1998, offered both moral and financial support to Franciscan. The Robert Young Mental Health Unit is named in his honor.

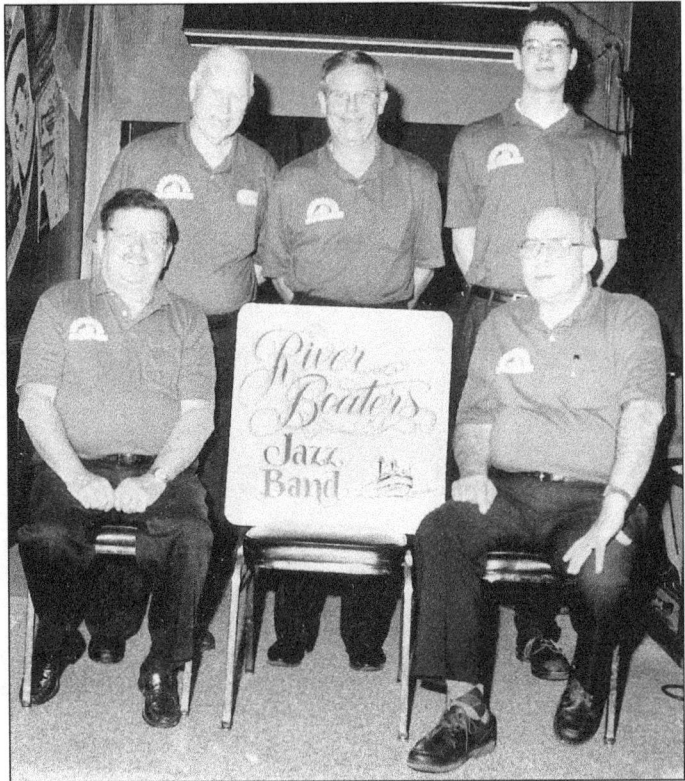

Now in their 22nd year as the Hunters Club house band, the River Boaters continue to play their own style of dixieland jazz. Originated in 1965, the band played at various venues around town including a Midwest tour, before beginning their gig at Hunters. Owner Bill Hunter, also a very fine jazz pianist, hired the band that then included piano jazz virtuoso Warren Parrish. Current members in this photo are from left to right as follows: (seated) Gus Tripilas and Bob Cook; (standing) Rich Johnson, Jim Valentine, and Ben Chappell.

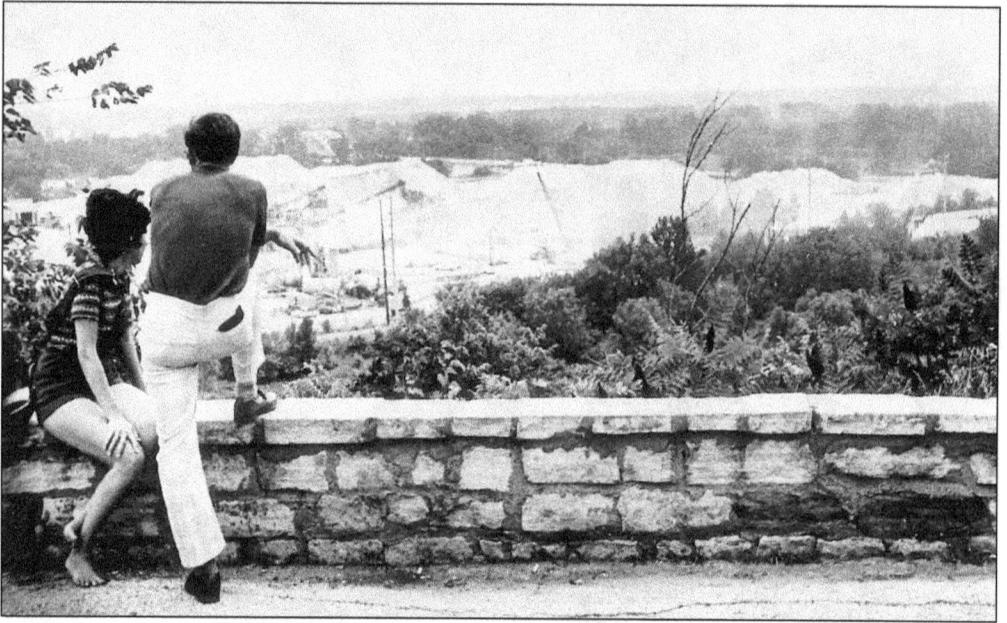

On a clear day you could see forever—or at least to the stone quarries beneath the bluffs of Black Hawk State Park and to the dense forests of Big Island. Squint a bit and you might see the Rock Island bridge leading towards Milan. Perhaps the couple is enjoying the view—or maybe just each other.

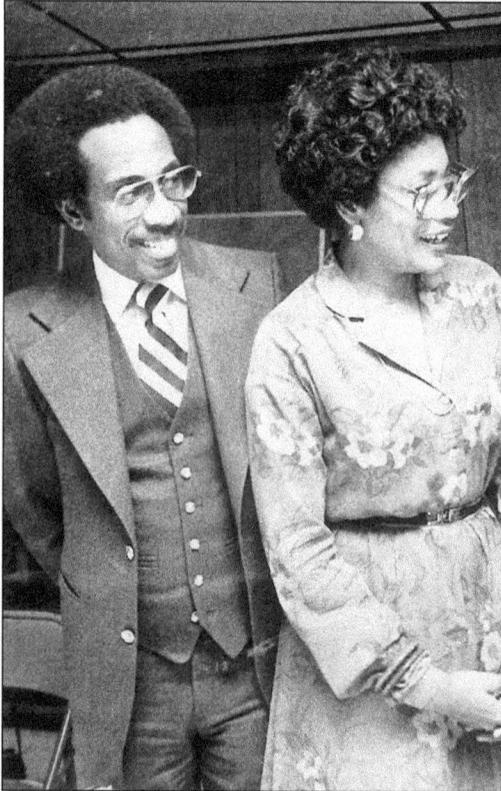

"There are no racial boundaries to this office, nor geographical ones either," declared Jim Davis, the first black man elected as mayor of Rock Island in April 1979. Davis juggled his duties as mayor while also serving as an elementary school principal. Davis and his wife, Louise (also a school principal), moved to Texas in 1998.

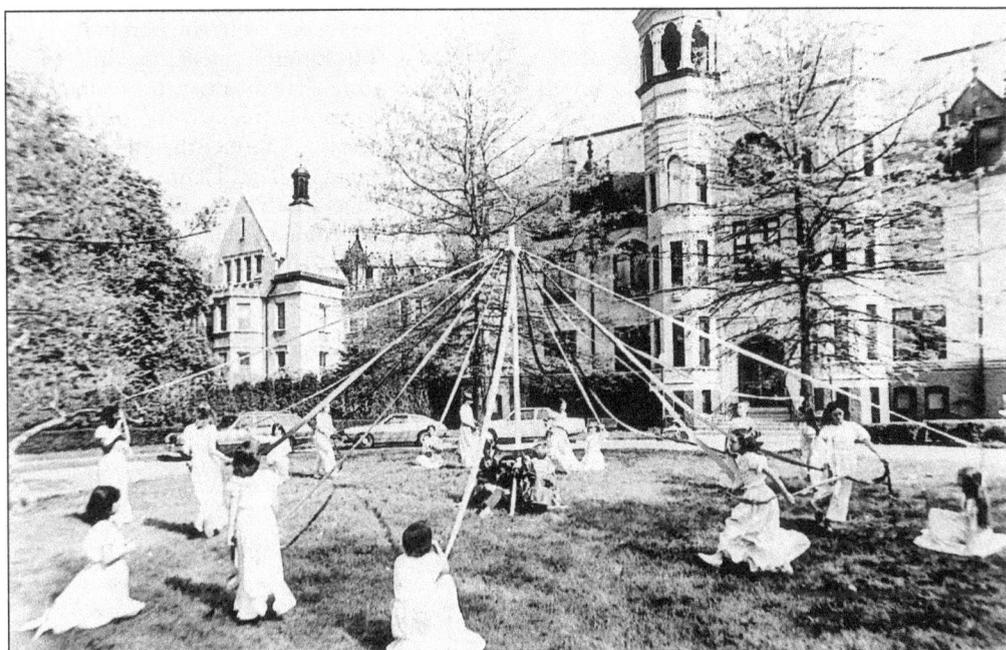

There was something different about this traditional May Day celebration at the Villa de Chantel. For decades, girls at the Catholic boarding school had twirled cheerfully around the center pole, singing and humming. But on this May Day in 1978, the mood was overcast. The school was closing, and this was the last May Day observance.

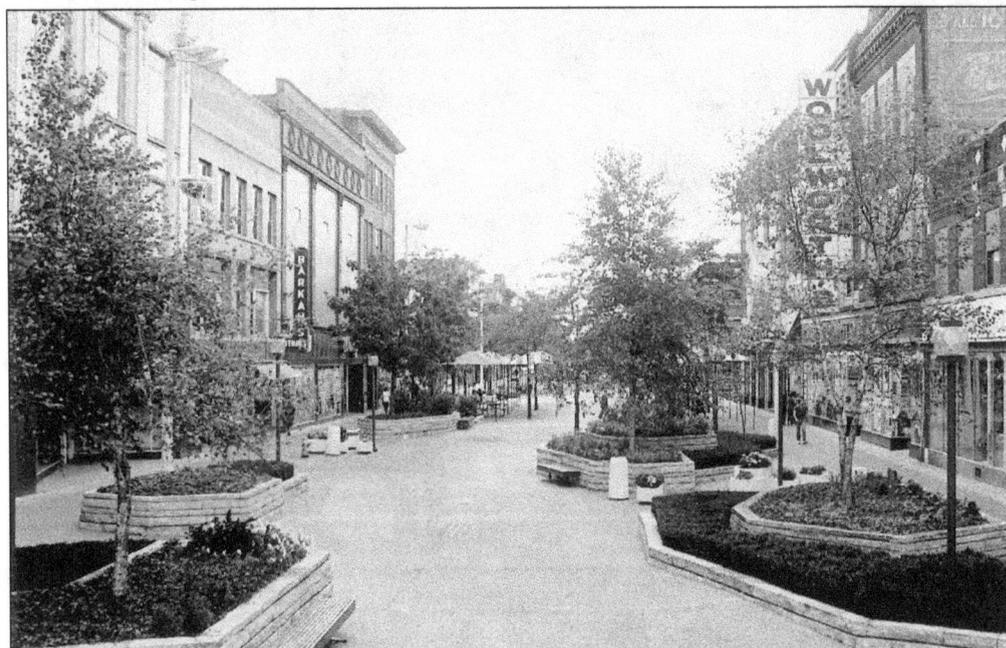

You could stop by Mosenfelder's, Barkan's and Lefstein's to find Dad his Father's Day gift or swing by Woolworth's and Newberry's Five and Dime just for fun, then grab a bite at Walgreen's and catch the first show at the Rocket Theatre. Those were the days long before this peaceful park-like setting existed along Second Avenue in downtown Rock Island.

Denny Hitchcock owns the honorary title of "Mr. Entertainment," having turned a one-time dream into a reality by allowing area theatre-goers top-quality entertainment. A former theatre teacher at Augustana College, Denny offers Circa 21 customers a rich menu of musicals and drama, comedy, and children's productions. "The food is good too!" observes Moliner Jason Moskowitz.

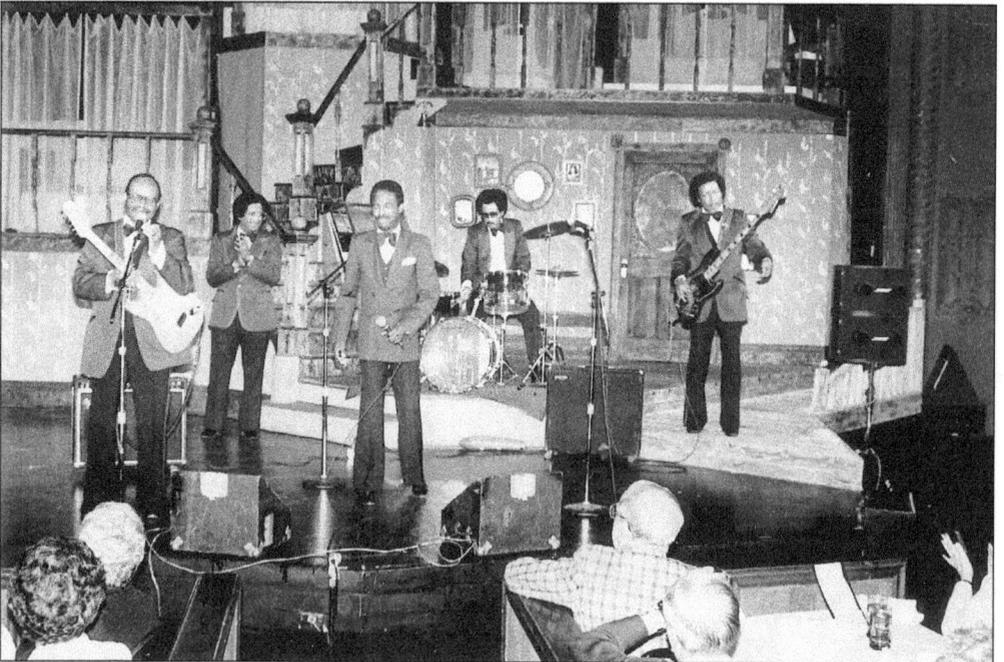

Since Circa 21 opened in June of 1977, top flight entertainment like the Inkspots (shown here performing live on stage) has basked under the lights of the remodeled Fort Theatre. For a theatre matinee or for a "night on the town," Circa 21 has brought in such notables as Phyllis Diller, Tony Bennett, Dave Brubeck, and Woody Herman.

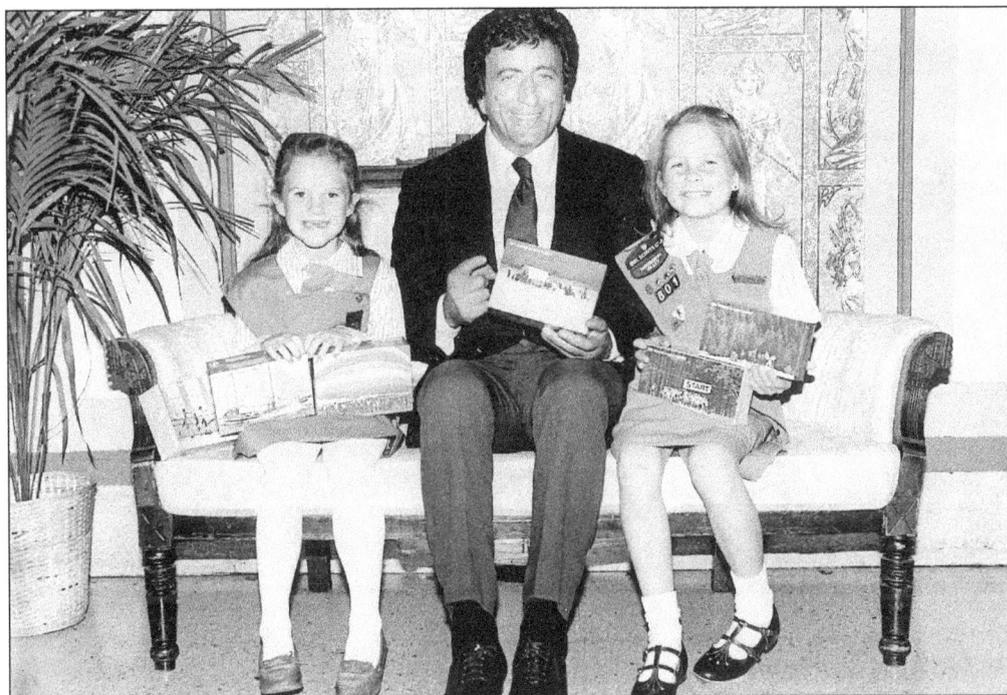

Ever wonder why singer Tony Bennett left his heart in San Francisco? Now you know the answer. The smiles were contagious as these two giggling Rock Island Girl Scouts and their famous friend prepare to satisfy their sweet tooth with some delicious refreshments during their annual cookie sale.

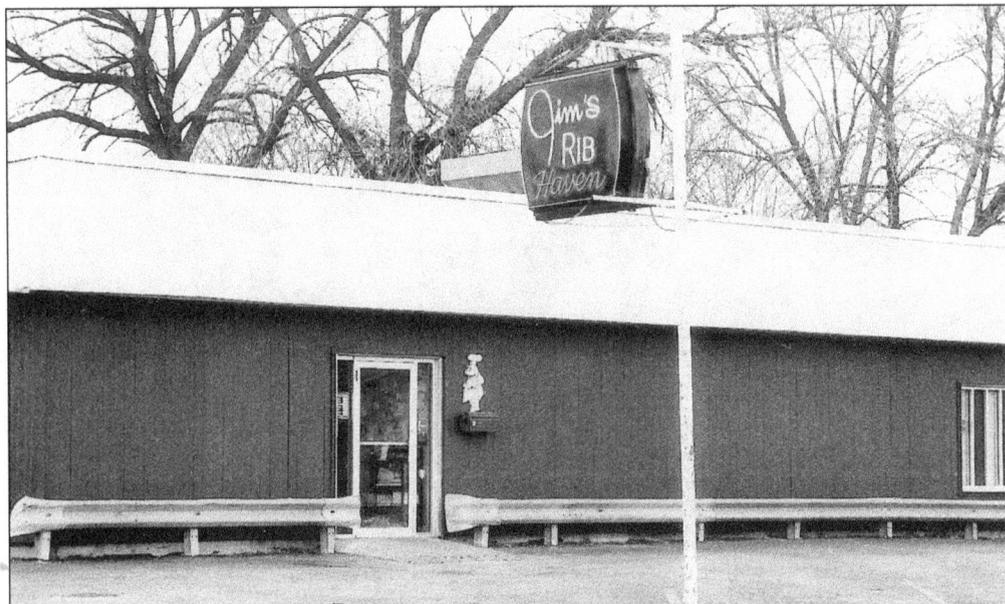

"Ummmmmm . . . what smells so good? Surely all that tantalizing aroma could not be coming out of that red shoebox on 5th Avenue and 24th Street, could it?" It sure could! Jim's Ribs have been identified as one of Rock Island's tastiest treats for decades. "I'll have to admit it's worth the drive," says Moline resident Joey Schauenberg.

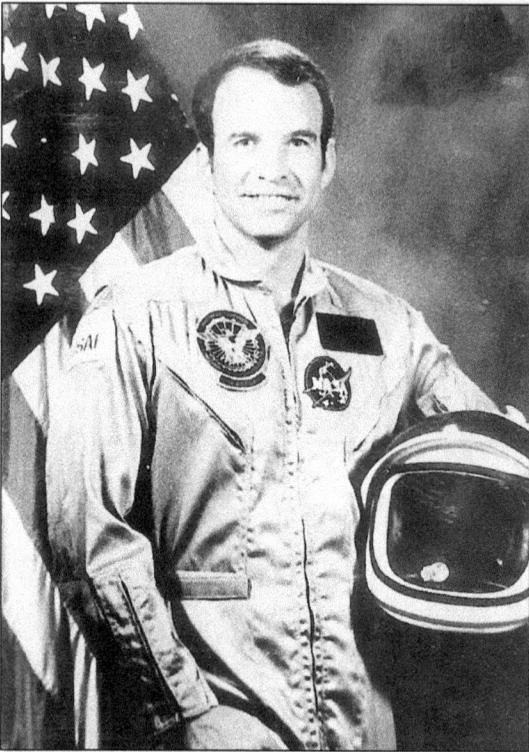

Americans have grown up with the countdown leading to a blastoff in space. Yet few American cities can claim a genuine, honest-to-goodness astronaut. Rock Island can: Gary Payton was born here. Payton was part of the *Discovery* Space Shuttle Mission that took place on January 24–27, 1985.

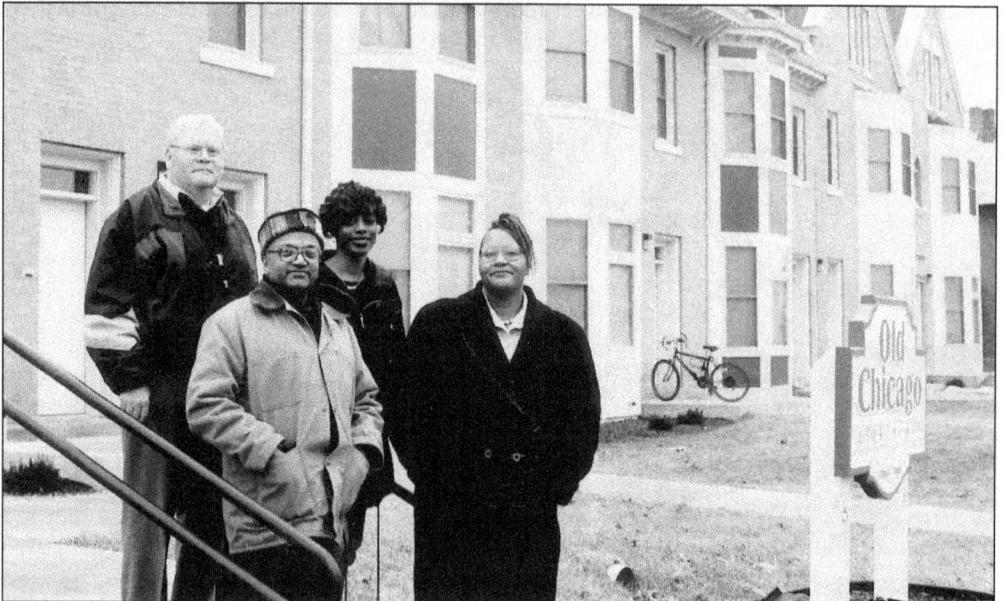

Project NOW executive director Vince Thomas came to Rock Island as an exchange student from Bombay, India. He worked as a newspaper reporter and became a leading voice in the Quad Cities civil rights movement, working with Father Jack Real, Simon Roberts, Jim Collins, and Peter Lardner to found the community outreach programs. Thomas is pictured here with Project NOW board member Jessie Lisle (front), Old Chicago apartments resident Denise Gardner, and board president Fabian Ortiz.

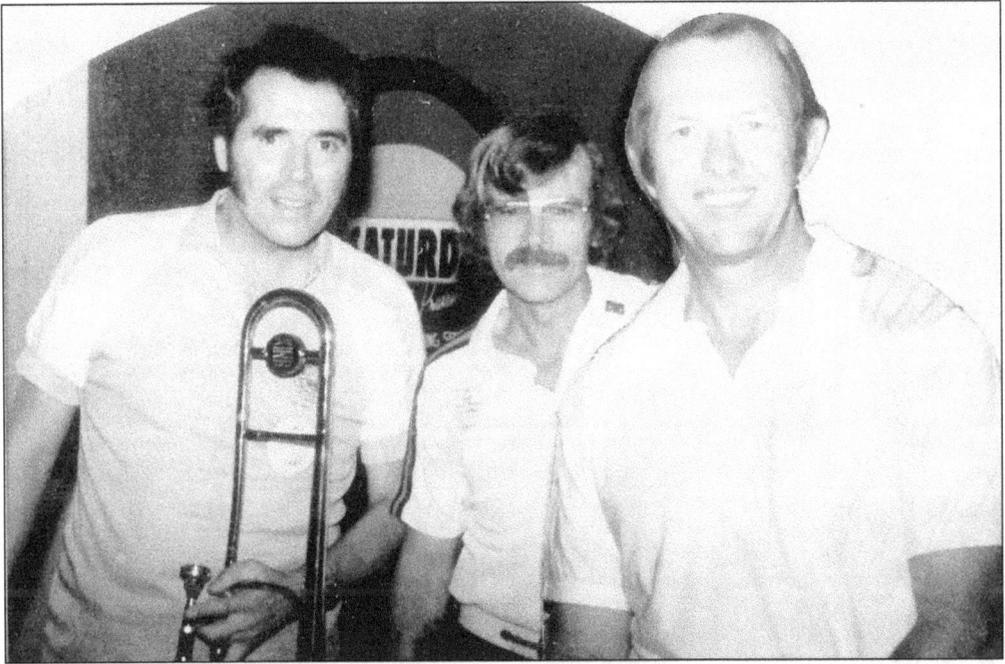

They played together at Rocky High and later became staff musicians at musical-prestigious Walt Disney World in Florida. Today, Jim Maihack, Boyd Bergeson, and Bill Allred rank at the top of their profession, playing their own style of jazz, individually and collectively, at renowned festivals around the world.

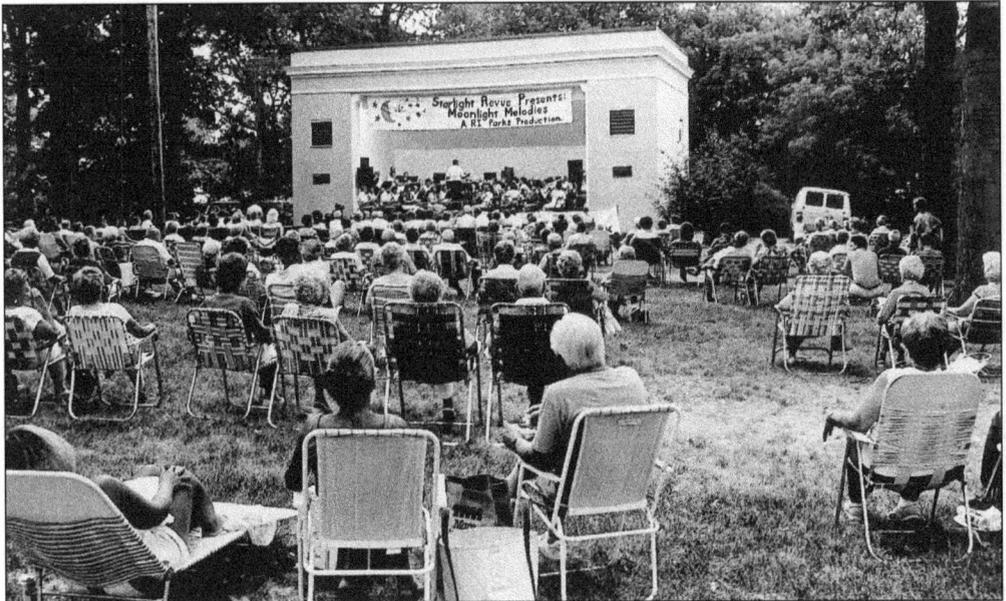

Thousands of Rock Islanders head to Lincoln Park each summer to enjoy the bands playing in the Starlight Revue presentations. They are part of the RI parks productions, free and open to all. There is nothing like a lawn chair and good music on a warm summer night!

Fresh from J.D. Darnall High School in Geneseo, where he helped to establish a gridiron power known as "The Green Machine," Coach Bob Reid molded a similar football dynasty at Augustana College in Rock Island. Not only did the Vikings win under "Gentleman Bob," his teams built a reputation for quality, spirit, and character, a tradition maintained by Augie students on and off the field.

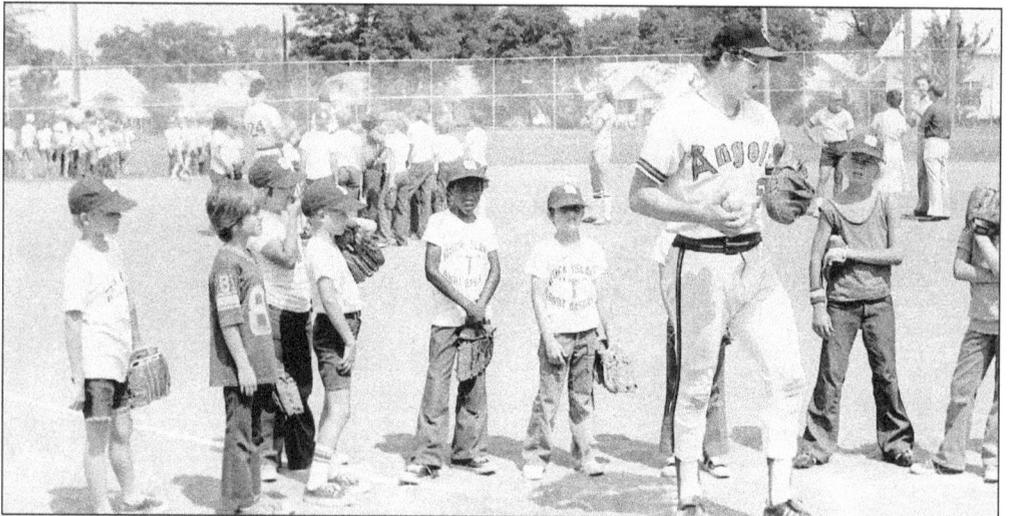

Is there a Mark McGwire in this group, or maybe a Sammy Sosa? Actually, both superstars of the 1998 baseball season were unknowns back in 1975 when this clinic took place. The Quad City Angels shared their tips and talents with the Rock Island T-Shirt League. The Angels later became the Quad City Bandits, and with former Des Moines resident Kevin Krause taking charge, new plans for both the team and John O'Donnell Stadium are planned for the millennium.

106

Augustana . . . Bergendoff . . . a school and a man. Yet, in so many ways, they seemed like synonyms. Both represented intellect, caring, and kindness. Wrapped in a spiritual cloak of faith, not a dominating, demanding albatross, the school was a presence that allowed one to understand, to grow, and to discover. The man, sage philosopher and educational shepherd, led the school during war and peace, during times of turmoil and triumph. Finally, after more than a century of living, Conrad Bergendoff was gone. Yet, in another sense, he still lives—in the spirit that is Augustana.

Shown here is a press conference to announce the formation of Project NOW (Neighborhood Outreach Work) in 1968. Father Jack Real, Si Roberts, Peter Lardner, and Jim Collins led the way in grassroots efforts to overcome poverty in the Quad-Cities and to develop politics and better relationships among people of all races.

Taking time out from the chaos of the issues of war and Watergate, Bj Wilson finds a moment for contemplation outside Augie's graffiti room in East Hall during the turbulent 1970s. "It wasn't easy paying attention in Professor Tweet's popular literature class," she recalled. "All those pithy writings on the wall made Herman Melville dull reading." East Hall fell victim to the wrecking ball in 1978 to make way for a new student center on the corner of Thirty-eighth Street and Seventh Avenue.

Remember the political drama and intrigue of *All the President's Men*, when the camera zoomed down and then up on Dustin Hoffman and Robert Redford in the Library of Congress? The tenseness is the same in the Rock Island County Courthouse as political candidates and their supporters eagerly tally voting results as shown in this photo.

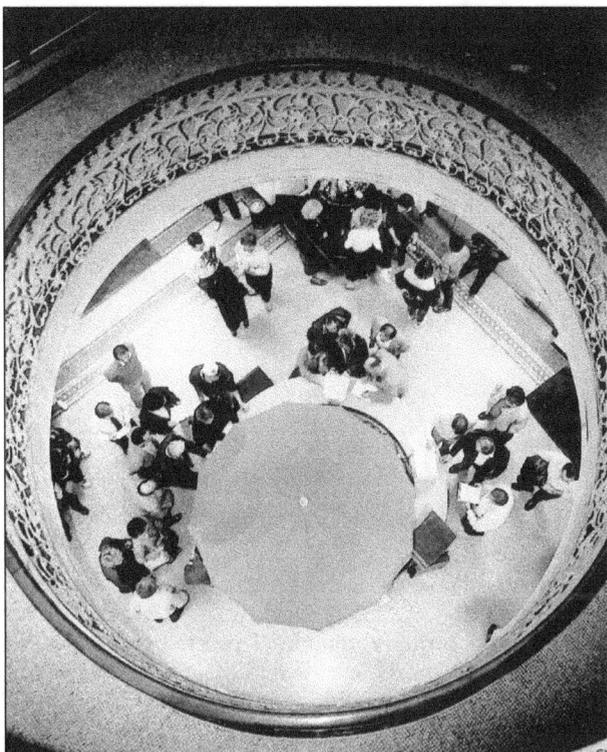

"Trick or treat, trick or treat—we hope you'll give us something sweet! Actually, we would settle for candy and a dog biscuit!" It's time for the annual Halloween haunting, when Rock Island guys and girls prowl their neighborhoods, hoping to fill their sacks and then their tummies. Cori and Chris Bright are ready to go! If you're not generous, Brandi, the fellow in the middle, just might have a bone to pick with you.

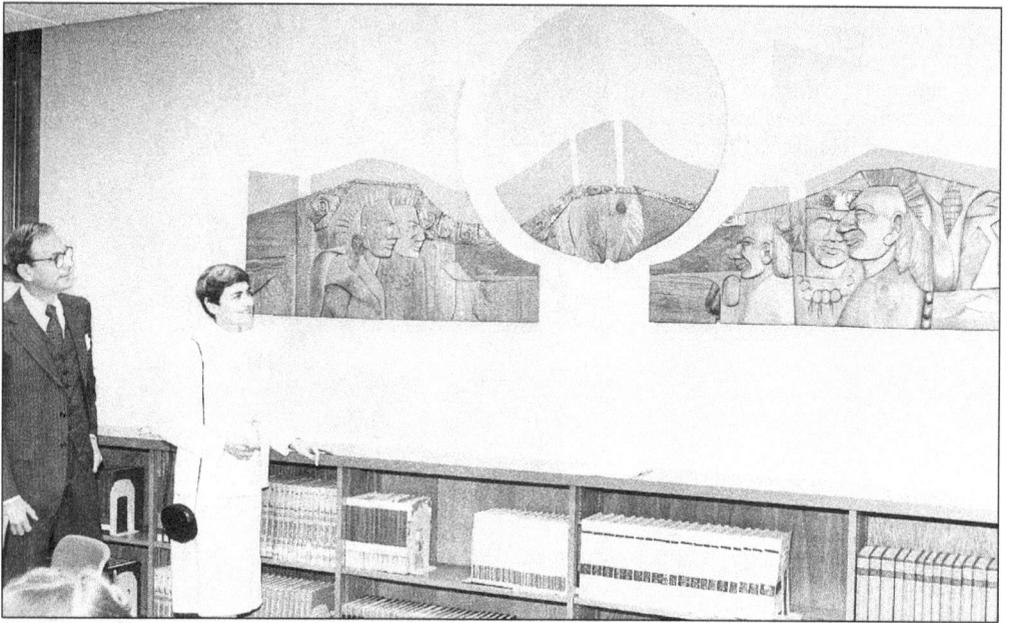

Artist Phyllis Stringer combined painted canvas, pewter, and wood to come up with this delightful wall mural entitled "Legacy" for the Rock Island Public Library's Children's Department. The eye-catching artwork was donated by benefactors Zeifel and Shirley Harris during the 1986 restoration. "Any age can appreciate this quality of artistry and craftsmanship," says art instructor Michael Payne, a native Rock Islander. "And the entire piece reflects the legacy of our area."

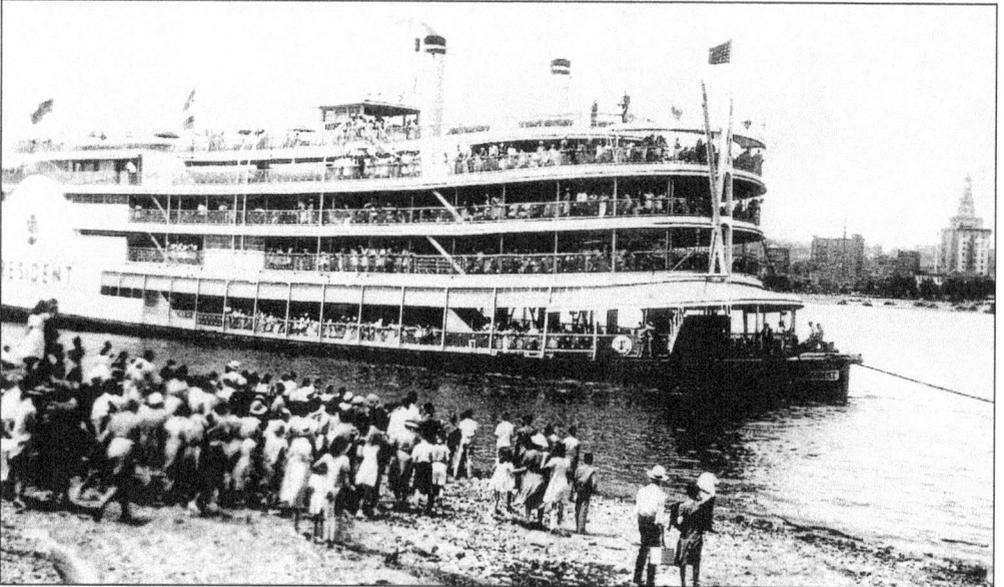

Hey, something is strange about this picture! Everyone knows *The President* is docked on the Davenport side of the Mississippi, but isn't that Davenport across the river? Long before *The President* was filled with the sounds of slot machines and people trying their luck at gambling, the mighty boat served as an excursion steamer. It is shown here, docked on the Rock Island shore.

The Quint City Roughriders face their physical challenges head on with determination and dedication. Here, with Farmall in the background, the batter is poised, the pitch is thrown, and the hearts pound with anticipation.

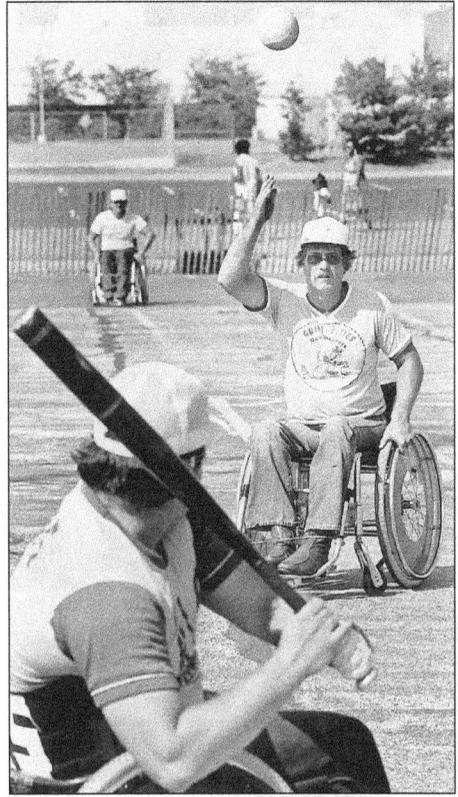

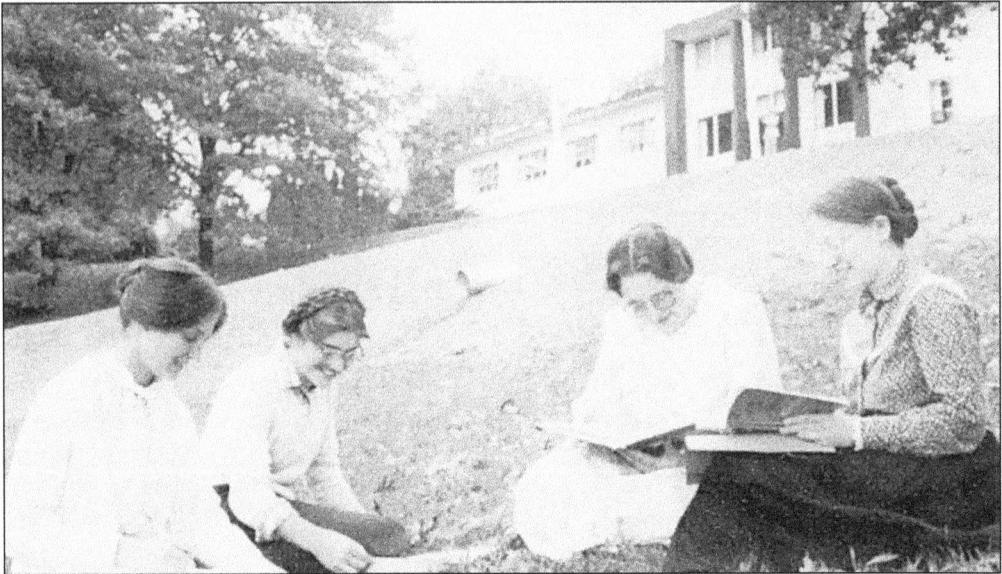

Taking their studies seriously and still finding time for girl talk, Judie Stracener Lewis, Darla Dawson, Doneda Lance, and Emily Massengill were classmates at the Bible Missionary Institute when this photo was taken in 1986. The school opened in 1958 at the Methodist Campgrounds 10 miles south of Rock Island. The following year, it was moved to its scenic campus overlooking the Rock River.

It was a special historic moment for Herbert Hull Sr. and Herbert Hull Jr. when the last Farmall tractor rolled off the line on May 14, 1985. The younger Hull helped assemble that final farm machine, and his father came to witness the occasion since he had helped put the first Farmall tractor together in 1927.

Whether sausage-anchovy-mushroom or just old-fashioned cheese, if it's Harris Pizza from the famed Fourteenth Avenue stores in Rock Island, it's bound to melt in your mouth. For 40 years, Harris Pizza locations have furnished area residents with handmade dough and fresh ingredients. "I love coming home for Harris pizza," says Roger Schneff, a broker in Milwaukee. "Now if I could only get them on Dow Jones . . ."

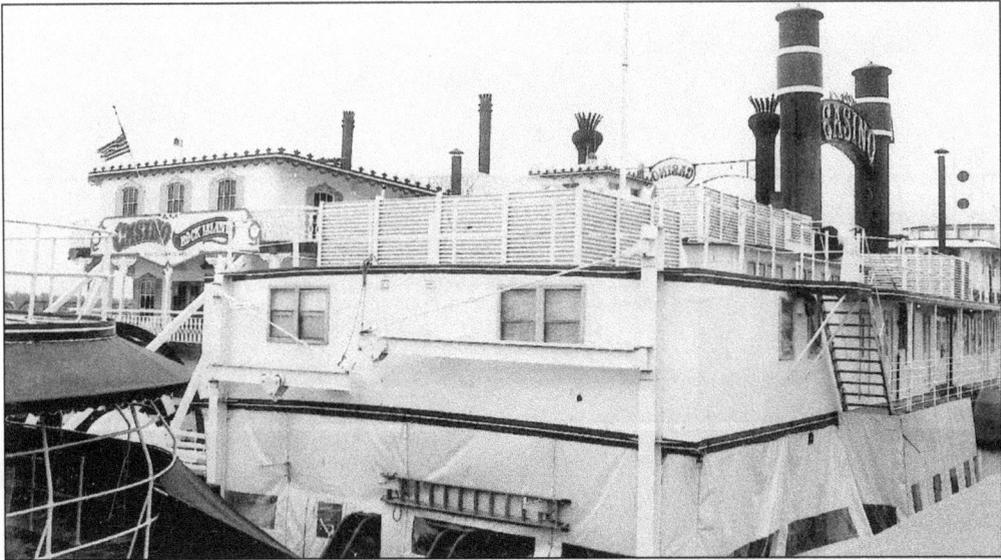

Feeling lucky? Got a rabbit's foot in your pocket and a four-leaf clover in your purse or billfold? If so, you're ready to board the Casino Rock Island and become the world's next millionaire. Well, it's not all that simple, but there is no doubt that the riverboat has become a featured attraction for Rock Islanders and visitors.

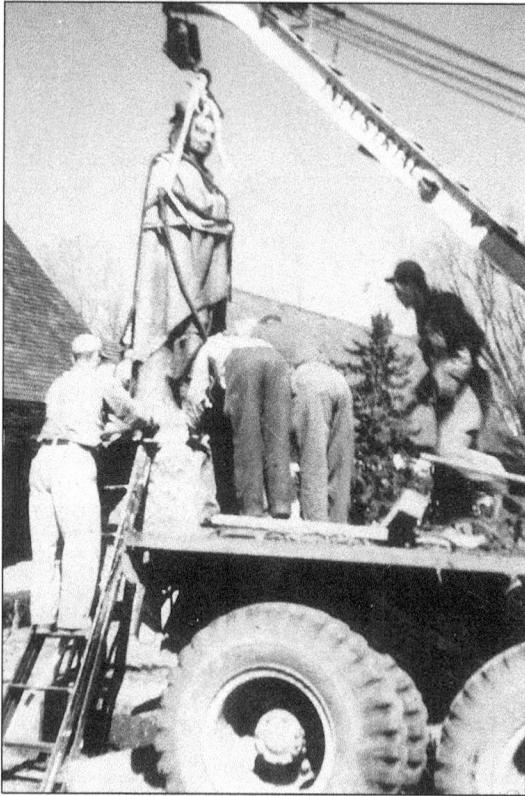

It's moving day! Lifting the grand old Black Hawk statue from years of enjoying the Spencer Square scenery posed a challenge of the first order. Replanting the impressive memorial on the grounds of the watch tower in the state park named in his honor also proved a backbreaking chore, but each step of the task was handled with great care.

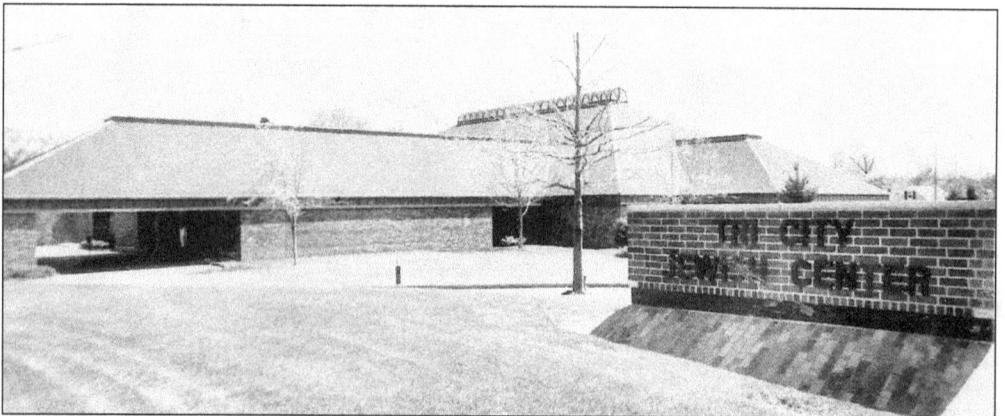

Nestled off of the busy Thirtieth Street thoroughfare at Twenty-seventh Street is the present Tri-City Jewish Center, a modern-style structure housing a spiritual home base for the Jewish community. The facility was opened on November 19, 1981.

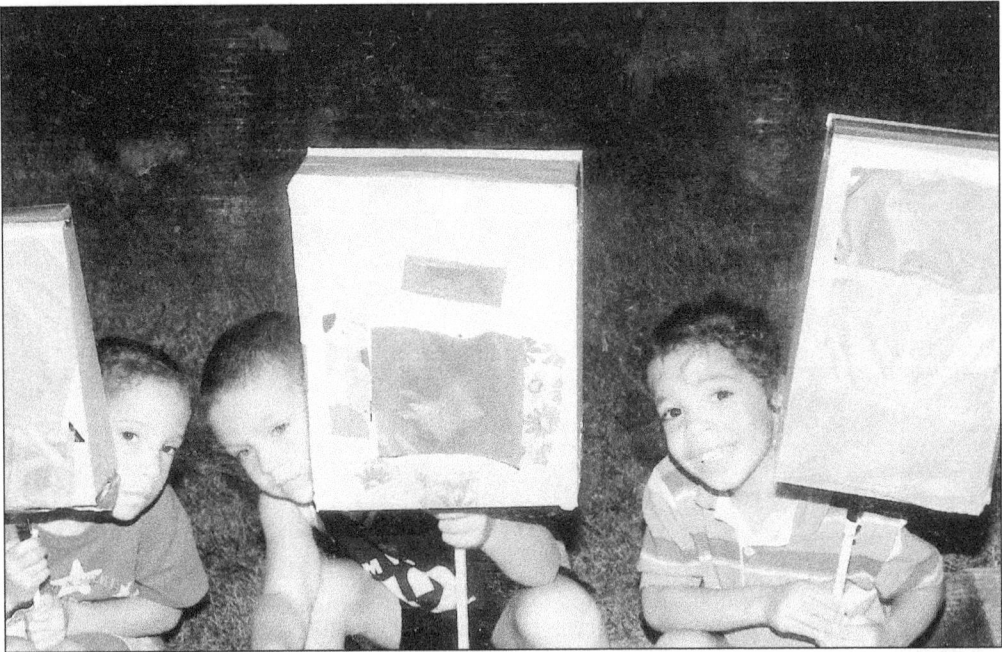

Nicole, Damon, and Breanna Watts are hoisting their colorful lanterns for spectator approval as part of the Rock Island Lantern Parade ceremonies. The trio might also be sparkling because their grandmother, Bonnie Watts, is looking on proudly. You can bet she would give each one of them a first-place ribbon!

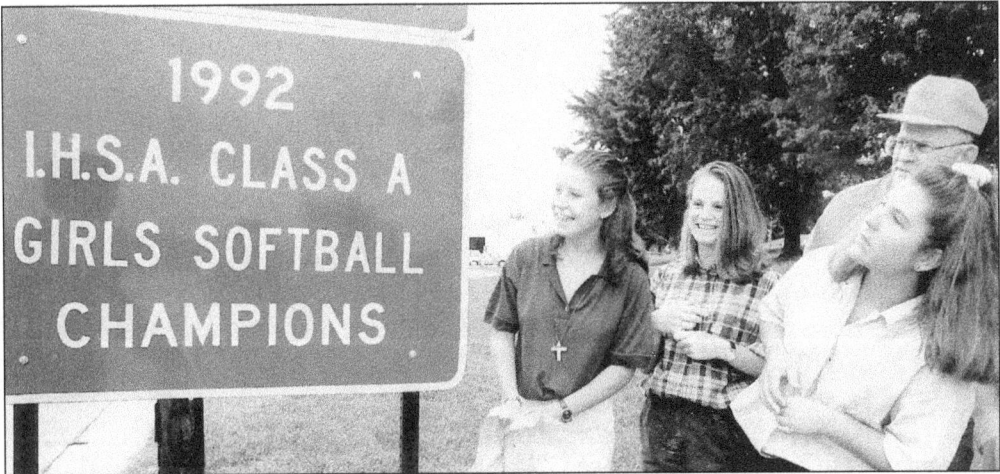

Alleman's girls' softball team captured the 1992 Class A Championship, and the Illinois Department of Transportation found a special way of saluting the team. Enjoying the new sign at Twelfth Street and U.S. 67 in Rock Island are players Heather Lackley, Korrie Klier, and Heather Blancke. Three additional signs were put up in the city.

Sporting a rainbow of ribbons, John Scally jokes with fellow marchers before the 1995 Saint Patrick's Day Parade. The tuxedoed group includes Dan Rierdon, Bonnie Burke, Pat Burke, Silia Smiley, Terry Cunardi, John Scally, Larry Rafferty, Mike Grothusen, Merton Whitted, and Steve Graham. Play those pipes, Merton!

You don't need to be an O'Connell or an O'Brien to enjoy the fun of a grand ole Saint Patrick's Day! All you lads and lassies need is to be in Rock Island for the annual March celebration. The parade between Illinois and Iowa over the Centennial is touted as the only two-state march in the country, not to mention the music, the food, and the recognition of an Irish Mom of the Year. Erin go brau to all!

116

It is story time in Melva Hearn's classroom at Rainbow Skip-A-Long II. She's working with the children of the children she taught back in the 1970s, when Rainbow opened with funding through the Model Cities Act. Rock Island was one of 150 American cities on the front lines of Pres. Lyndon Johnson's War on Poverty. The parents chose Rainbow as the name of their preschool because they envisioned it as a place where children of all colors would play together.

Let's see the New York City Rockettes try this! Members of the Backwater Gamblers water-ski team slip and slide along the Rock River waters, thrilling the crowds at their seasonal practices at the foot of Forty-fourth Street. The shows are free to the public and give team members a chance to try out new routines and perfect their championship performances. They currently rank third in the nation among water-ski teams.

On your mark, get set, go! Rock Island's calendar of events is crowded throughout the year, and many are manned by volunteer workers, willing to offer their time and talents on behalf of others. Here, an anxious group of relay workers in the annual Special Olympics competition cheer on their team members at events held at Augustana College.

The steps are precise, the music is lively, and the marchers are eager to share their talents as they head to the annual Night Out at Long View Park. The Metro Youth Marching Band has become a popular musical group throughout the Quad Cities, delighting listeners of all ages. "I like them," says six-year-old Josh Cooper. "They play good and loud."

Sunlight through the stained glass brings back memories of Robb Dussliere, who died before seeing the completion of the DeLaCerda House, a home for those with HIV/AIDS. Opened in May 1996, the house was renovated by friends and community members in honor of the late Jim DeLaCerda, who returned to Rock Island after a decade of working with AIDS patients in San Francisco and Chicago.

Television has its Tim "The Tool Man" Taylor on the show *Home Improvement*. Rock Island has its very own "House Doctor" Bob Yapp on his nationally syndicated PBS program, *About Your House*. Since moving from Des Moines in 1989, Bob has fueled local interest in restoring vintage homes and has uncovered many "jewels" among the deteriorating and abandoned houses in Rock Island's older neighborhoods.

Whoever heard of pedaling a cardboard craft in a marina? Robert Gooch of Rock Island has! On Saturday, August 21, 1993, the Rock Island Park and Recreation Department sponsored a Cardboard Boat Regatta as part of their Family Day Celebration at the Sunset Marina. The nautilus looks like a handsome hunk of boat, and the skipper appears to be in total control.

Computer savvy kids like Libby will probably read all the books they want someday at the click of a button. For now, however, she chooses to enjoy a quiet game of solitaire among the stacks at Rock Island's Southwest branch of the library.

120

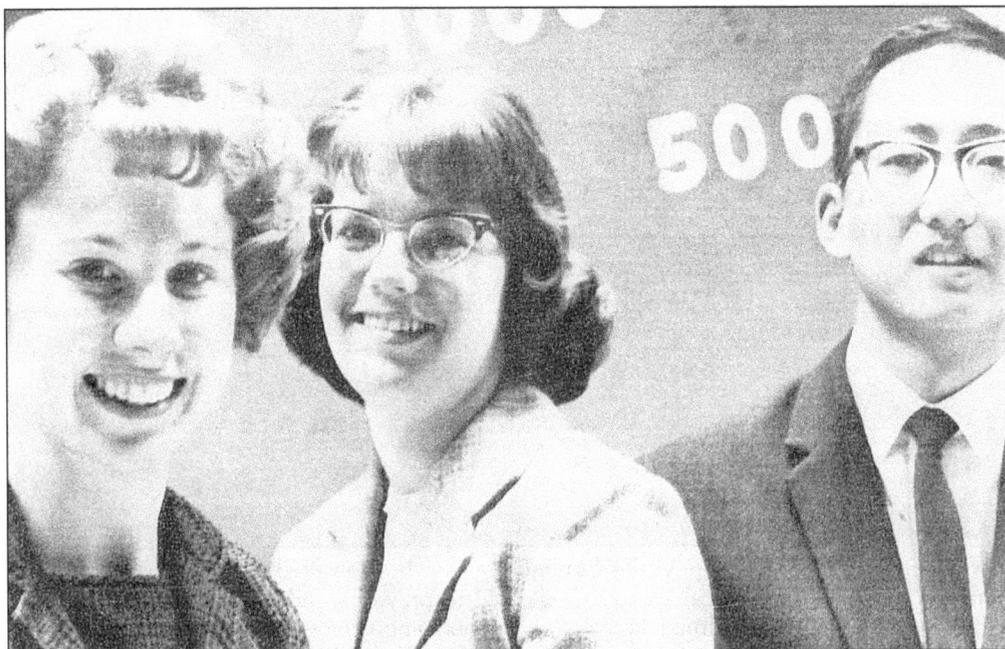

At Augustana, Dan Tsui (far right) was known for shuffling around his dorm in a beat-up terrycloth robe, getting hot water for his tea. He was also elected "Mr. Friendship" at the school's annual Friendship Fair. Dan, destined for greatness, won the coveted Novel Prize, along with a colleague professor at Princeton. Together they discovered the fluid-like behavior of electrons in extreme cold; their find may lead to new discoveries in computer chips.

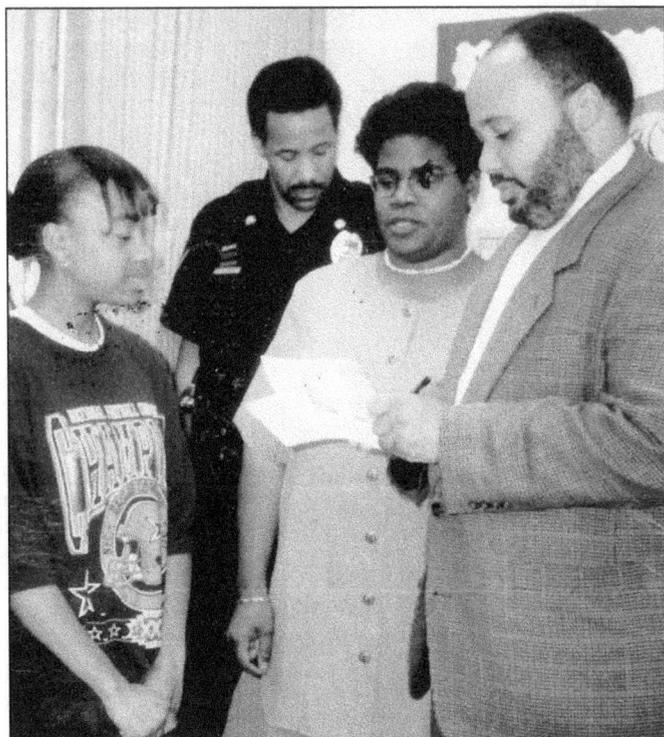

If Rock Islander Shanta Williams ever had a dream of getting a famous person's autograph, it came true in January 1996. Shanta won first place in the oratory contest at the annual Martin Luther King Jr. observances at the center named in honor of the civil rights leader. As center director Carolyn Ross looks on, Martin Luther King III, the keynote speaker, signs Shanta's award certificate.

Few buildings in the Mississippi Valley Community have been awaited with greater anticipation than the Quad City Botanical Center. Dedicated to providing unique plant collections and exhibits, increasing horticultural knowledge, encouraging ecological concern, and inspiring citizens to improve their environment, the sparkling-glass jewel case brightens up its Twenty-fifth Street and Fourth Avenue location. Its next-door neighbor, the Quad City Expo Center, features everything from sports shows to hobby displays.

In this "great unveiling" at the 1897 Dutch Colonial owned by Lewis and Casey Washington, volunteers helped strip the aluminum off to restore the original wood. Funded by Project Facelift, the house was painted in vintage, turn-of-the-century colors. It took Joe Westmoreland and his crew two days of non-stop work to finish before the city's deadline. They often worked into the night by floodlight.

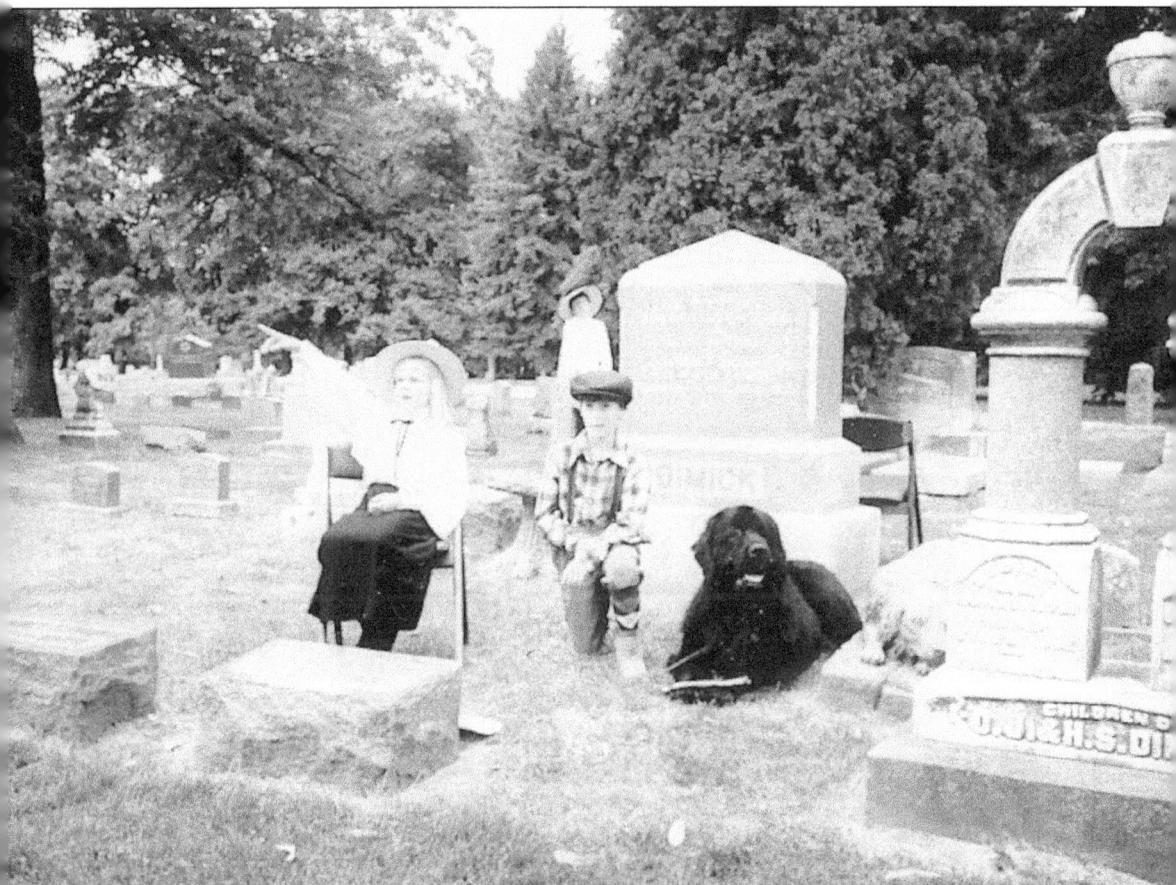

Cemeteries are a "grave business," but in the last decade they have also become a source of entertainment and education. Ashlie Jaeke, Jay Fuller, and their four-legged friend share rare information about the Otis T. Dimick family in Chippiannock Cemetery as visitors pass by. The facts are fascinating about such past notable Rock Islanders, but effort is made so that no one is "buried" under too much data.

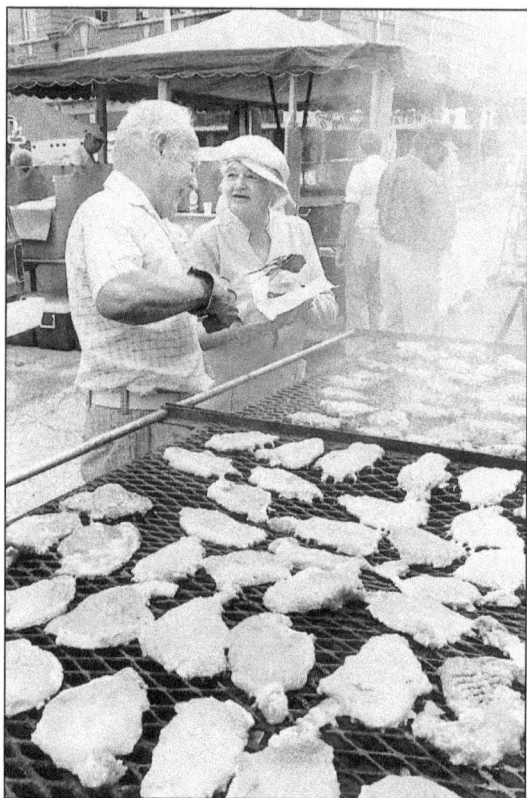

Once more the aroma of delicious pork fills the air at the annual Rock Island Summerfest. Thousands of area residents head to the District each year to enjoy the music, the food, the crafts, and each other's company for fun in the sun. Rock Islanders Carl Larson and Doris Hintze soak up the delightful atmosphere near the open-pork grill.

Friendship Manor is one of Rock Island's quality housing residences, offering many levels of care. Residents enjoy retirement living with the amenities and conveniences that allow them to continue the pursuit of happiness. Here, Verna Beckman, Helen Detweiler, Virginia Galligan, and Agnes Bauer enjoy the lovely flowers on the manor grounds while enjoying each other's company.

"Hey, look at me, I'm the star of the show!" this bald eagle atop the computer seems to be saying. Bill Day is pictured here helping a young attendee at Bald Eagle Days navigate Modern Woodmen's 'Surf the Nest' CD-Rom presentation. Modern Woodmen of America is one of the prime sponsors of Bald Eagle Days, held annually early in January when the eagles soar over the open waters near Lock and Dam 15.

For decades, Lundahl Motors made its home in downtown Moline, building up a long list of satisfied Volvo customers. Then the dealership decided to pack its wheels and head west to downtown Rock Island. A $300,000 remodeling effort in 1997 gave the business more display and repair space.

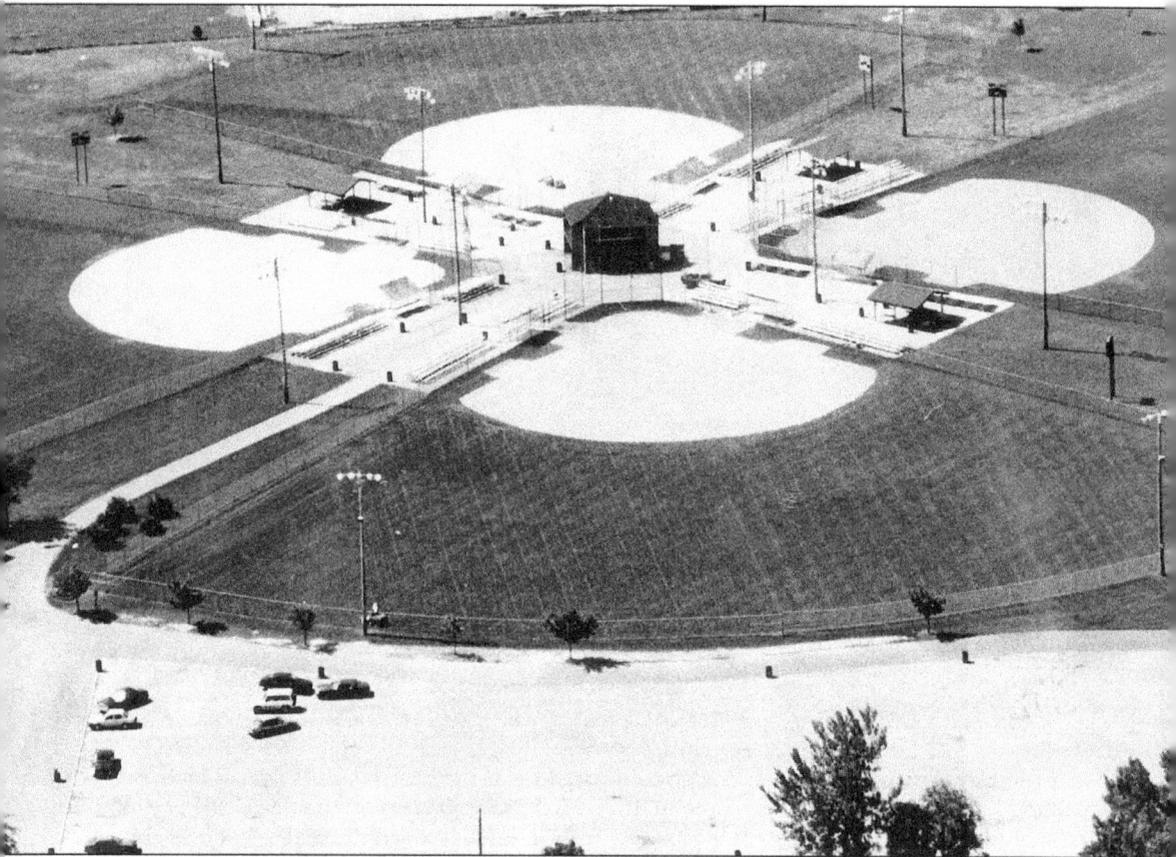

Few Rock Islanders were more respected than Alan A. Campbell. His interest and energy won him the mayor's slot in the 1970s. His untimely death snatched away a dedicated and caring city leader. This sports complex in southwestern Rock Island was named for him. "It's a suitable memorial," commented a friend, Herb Smith. "He really loved this city. This way, he'll always be a part of it."

Celebrating the bicentennial of ballooning brought Jim and Lucille Sampson to Reservoir Park in 1983 for a short ride to Saukie Golf Course. Jim says riding in a hot-air balloon was something Lucille always wanted to do, and she enjoyed everything but getting in and out of the gondola. The Sampsons were key organizers and participants in the Rock Island County Historical Society. Lucille's sudden death in November 1998 was a major blow to her family, friends, and area history enthusiasts.

Since 1933, Hunters Club has brightened Rock Island's social scene. Their char-broiled burgers are known nationwide, and the Riverboaters Jazz Band packs folks in every Friday night. New owners Greg and Sonny Farrell did not need a major snowstorm and a grease fire to help them take over the popular spot, but both applaud their "dedicated clientele and customers" for helping surmount the obstacles. A pat on the back goes to the Rock Island firemen, too, for their efforts in fighting the January 1999 blaze.

Generations of young Rock Islanders have shared the obligations and fun of being a Boy Scout or a Girl Scout. Badges are earned through dedicated service and sacrifice, instilling leadership qualities of integrity and character. The Mississippi Valley Girl Scouts, serving eastern Illinois and western Iowa, has its home office on the Rock Island river front, complete with solar energy and modern architecture.

www.ingramcontent.com/pod-product-compliance
Lightning Source LLC
Chambersburg PA
CBHW080906100426
42812CB00007B/2179

* 9 7 8 1 5 3 1 6 0 0 9 9 0 *